Put any picture you want on any state book cover. Makes a great gift. Go to www.america24-7.com/customcover

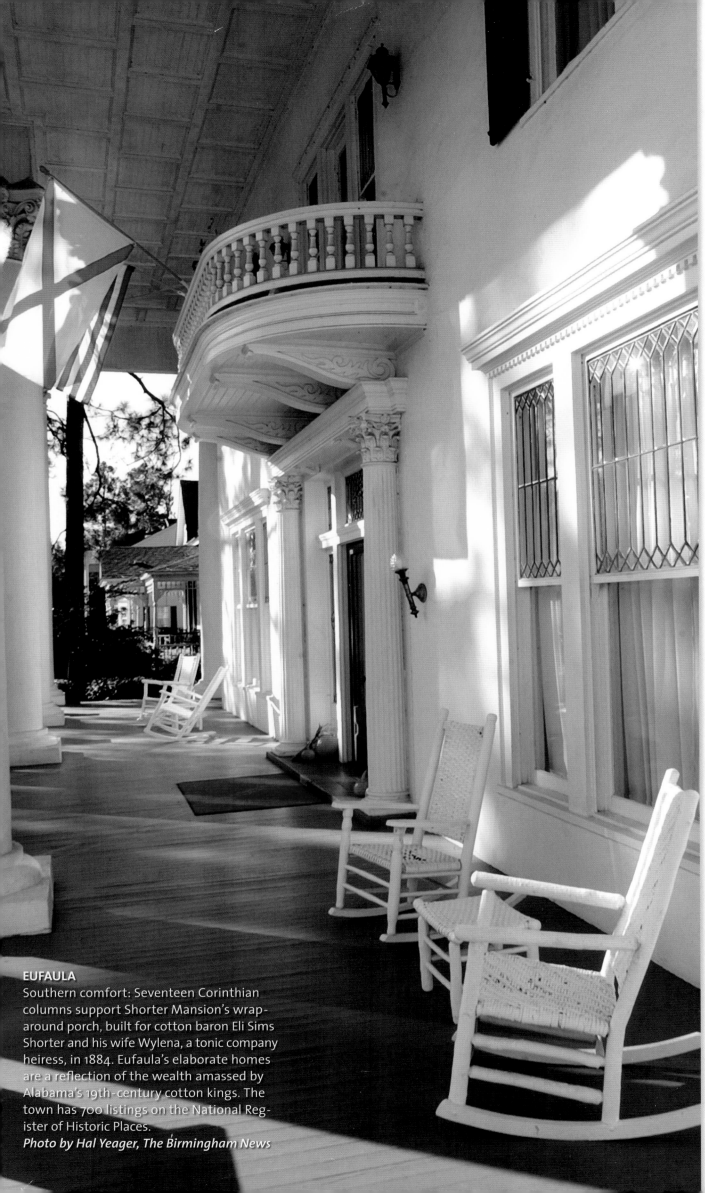

EUFAULA

Southern comfort: Seventeen Corinthian columns support Shorter Mansion's wrap-around porch, built for cotton baron Eli Sims Shorter and his wife Wylena, a tonic company heiress, in 1884. Eufaula's elaborate homes are a reflection of the wealth amassed by Alabama's 19th-century cotton kings. The town has 700 listings on the National Register of Historic Places.

Photo by Hal Yeager, The Birmingham News

Alabama 24/7 is the sequel to *The New York Times* bestseller *America 24/7* shot by tens of thousands of digital photographers across America over the course of a single week. We would like to thank the following sponsors, the wonderful people of Alabama, and the talented photojournalists who made this book possible.

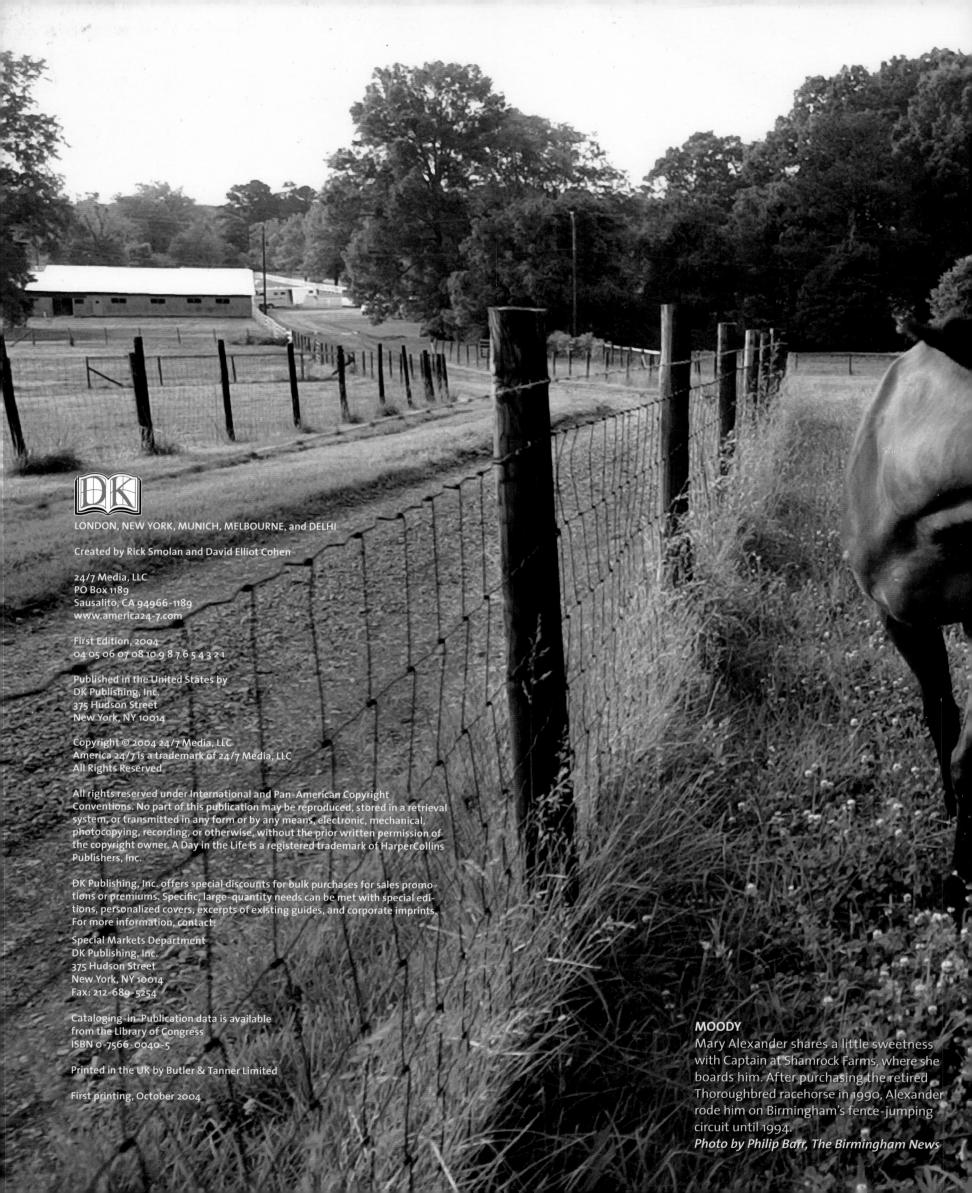

LONDON, NEW YORK, MUNICH, MELBOURNE, and DELHI

Created by Rick Smolan and David Elliot Cohen

24/7 Media, LLC
PO Box 1189
Sausalito, CA 94966-1189
www.america24-7.com

First Edition, 2004
04 05 06 07 08 10 9 8 7 6 5 4 3 2 1

Published in the United States by
DK Publishing, Inc.
375 Hudson Street
New York, NY 10014

DK Publishing, Inc. offers special discounts for bulk purchases for sales promo-
tions or premiums. Specific, large-quantity needs can be met with special edi-
tions, personalized covers, excerpts of existing guides, and corporate imprints.
For more information, contact:

Special Markets Department
DK Publishing, Inc.
375 Hudson Street
New York, NY 10014
Fax: 212-689-5254

Cataloging-in-Publication data is available
from the Library of Congress
ISBN 0-7566-0040-5

Printed in the UK by Butler & Tanner Limited

First printing, October 2004

MOODY
Mary Alexander shares a little sweetness
with Captain at Shamrock Farms, where she
boards him. After purchasing the retired
Thoroughbred racehorse in 1990, Alexander
rode him on Birmingham's fence-jumping
circuit until 1994.
Photo by Philip Barr, The Birmingham News

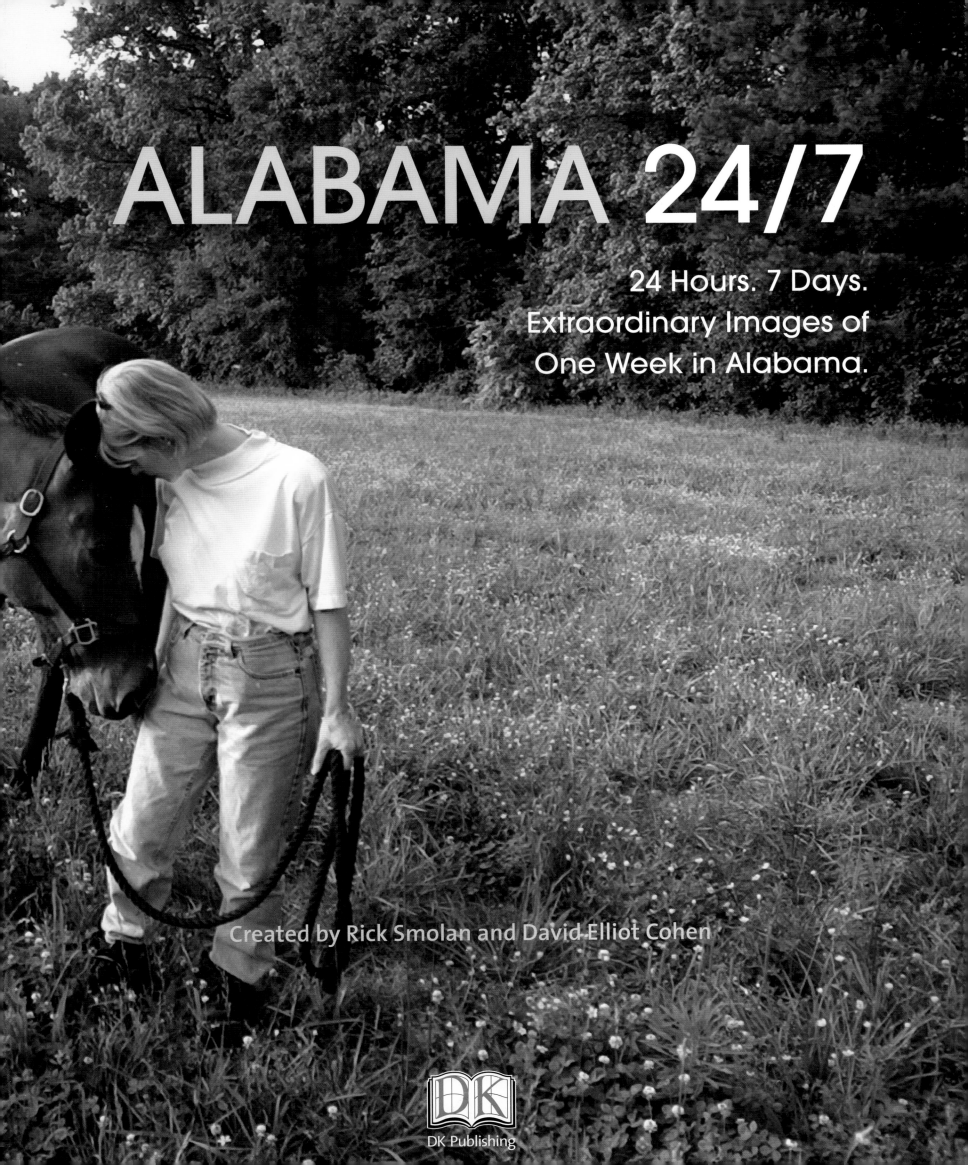

ALABAMA 24/7

24 Hours. 7 Days.
Extraordinary Images of
One Week in Alabama.

Created by Rick Smolan and David Elliot Cohen

DK Publishing

About the America 24/7 Project

A hundred years hence, historians may pose questions such as: What was America like at the beginning of the third millennium? How did life change after 9/11 and the ensuing war on terrorism? How was America affected by its corporate scandals and the high-tech boom and bust? Could Americans still express themselves freely?

To address these questions, we created *America 24/7*, the largest collaborative photography event in history. We invited Americans to tell their stories with digital pictures. We asked them to shoot a visual memoir of their lives, families, and communities.

During one week in May 2003, more than 25,000 professionals and amateurs shot more than a million pictures. These images, sent to us via the Internet, compose a panoramic yet highly intimate view of Americans in celebration and sadness; in action and contemplation; at work, home, and school. The best of these photographs, more than 6,000, are collected in 51 volumes that make up the *America 24/7* series: the landmark national volume *America 24/7*, published to critical acclaim in 2003, and the 50 state books published in 2004.

Our decision to make *America 24/7* an all-digital project was prompted by the fact that in 2003 digital camera sales overtook film camera sales. This techno-logical evolution allowed us to extend the project to a huge pool of photographers. We were thrilled by the response to our challenge and moved by the insight offered into American life. Sometimes, the amateurs outshot the pros—even the Pulitzer Prize winners.

The exuberant democracy of images visible throughout these books is a revela-tion. The message that emerges is that now, more than ever, America is a supersized idea. A dreamspace, where individuals and families from around the world are free to govern themselves, worship, read, and speak as they wish. Within its wide margins, the polyglot American nation manages to encompass an inexplicably complex yet workable whole. The pictures in this book are dedicated to that idea.

—*Rick Smolan and David Elliot Cohen*

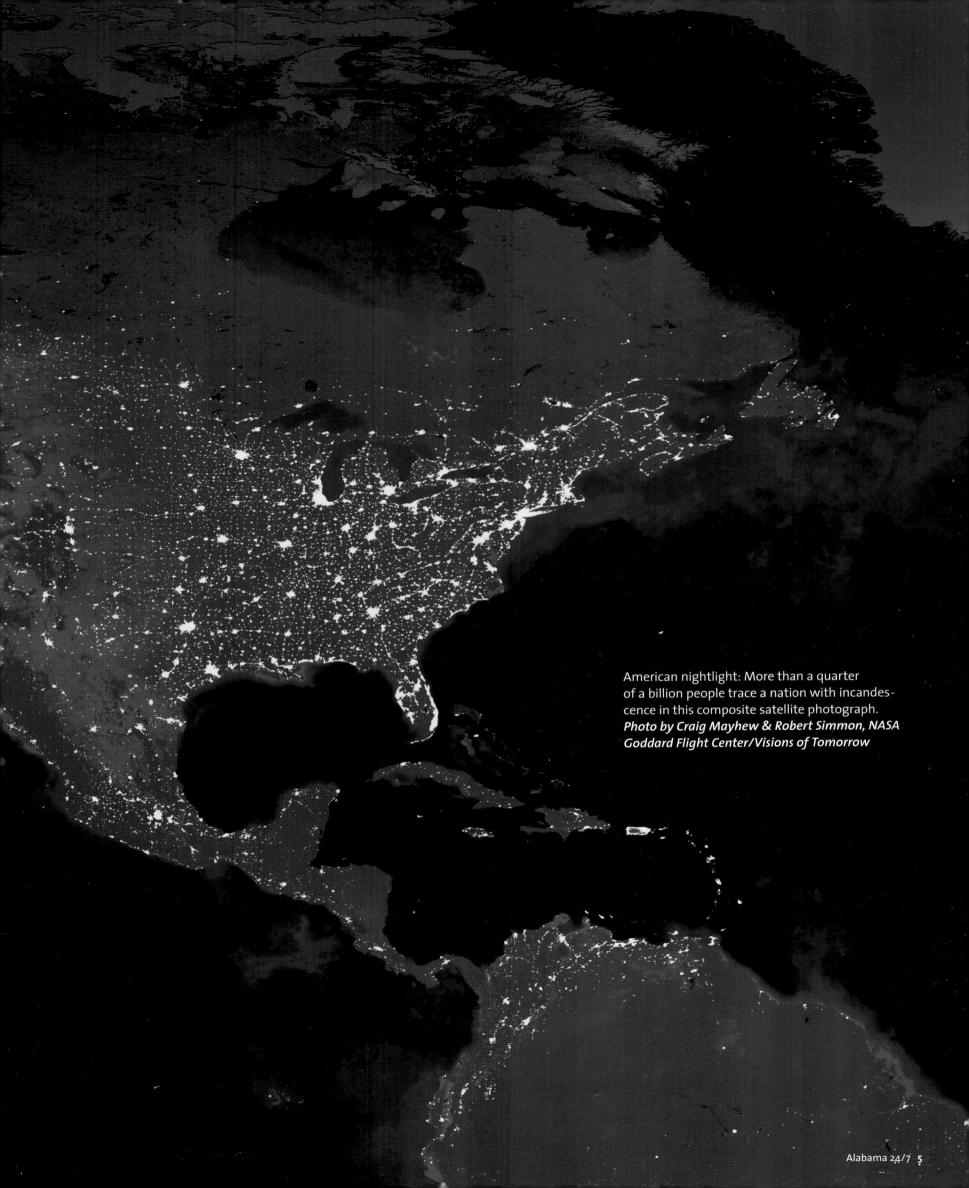

American nightlight: More than a quarter of a billion people trace a nation with incandescence in this composite satellite photograph.
Photo by Craig Mayhew & Robert Simmon, NASA Goddard Flight Center/Visions of Tomorrow

Salvation in Alabama

By Robin DeMonia

As soft as the sway of a front-porch rocker and as rowdy as the roar at Talladega's speedway—that's Alabama. And here, whether you're watching the grass grow or watching fast cars go, certain principles hold true: Family. Community. Church. Hard work. Tradition.

To live in Alabama is to grapple with the poisonous offspring of racism and rancor—some defend the Confederacy, even now—and to walk daily with the ghosts of those martyred for civil rights in places like Birmingham and Selma. Yet, for all the pain it embodies and all the forgetting it encourages, our past binds us in soulful ways, too. You feel it in the backyard gardens we tend, in the old songs we sing, in the woodlands and creeks where we hunt and fish. You see it, too, in the rock-hard faith that is our basis for hope.

Okay, maybe Chief Justice Roy Moore was stubborn and un-American in his sponsorship of the Ten Commandments, but he and his defiance of the U.S. Constitution are gone for now. In Alabama, we simply don't see religion as something from which people need protection. It's salvation. It's love. It's people who have almost nothing giving to those who have even less. It's a way of life that's both simple and full of contradictions. Recently, Alabama voters rejected a plan that would have raised taxes on many but eased taxes on the poor. Republican Governor Bob Riley tried to sell the plan with scriptural commands to "do right by the least of these," but Alabamians weren't buying. Another contradiction: Though we won't easily give our money to our government, we unflinchingly lay down our lives in our nation's wars. An

BON SECOUR
Oyster and shrimp fishermen idle on Bon Secour Bay, waiting for a soupy morning fog to move offshore. Two brothers from Montreal established the fishing village in 1702; it has been a shellfish harvesting and processing hub ever since.
Photo by Hal Yeager, The Birmingham News

Alabamian, CIA agent Johnny "Mike" Spann, was the first American to die in Afghanistan.

Even in times of peace, it's getting harder to keep to ourselves. The world closes in every day. Not that it's all bad, this global economy. Alabamians whose ancestors scratched out a living on farms now earn good wages building cars for Mercedes and Honda. At the same time, those plying old trades—shrimping in Mobile Bay, making socks in Fort Payne—are getting squeezed out of their lives by overseas competition.

It's a time of opportunity and apprehension. Some grasp the possibilities: The University of Alabama School of Medicine has earned a national reputation for research and clinical care, thanks to a faculty as diverse as the United Nations. But others sink into the paralyzing fears and low expectations that bubble just beneath the surface.

Alabama is a heartbreaker. But, ah, her beauty fills even a broken heart! Prepare to be captivated—from the blinding white beaches of Gulf Shores, to the lush wonders of Little River Canyon, to all the good folks who live along the way.

To look at Alabama's people is to hear them sing their music—the plaintive wail of Hank Williams, the old-time Gospel hymns wafting through the pines, the allegro of laughter, chatter, and love when friends and families get together.

That's my Alabama. Glad you stopped by.

Cullman native ROBIN DEMONIA *is an editorial writer at* The Birmingham News.

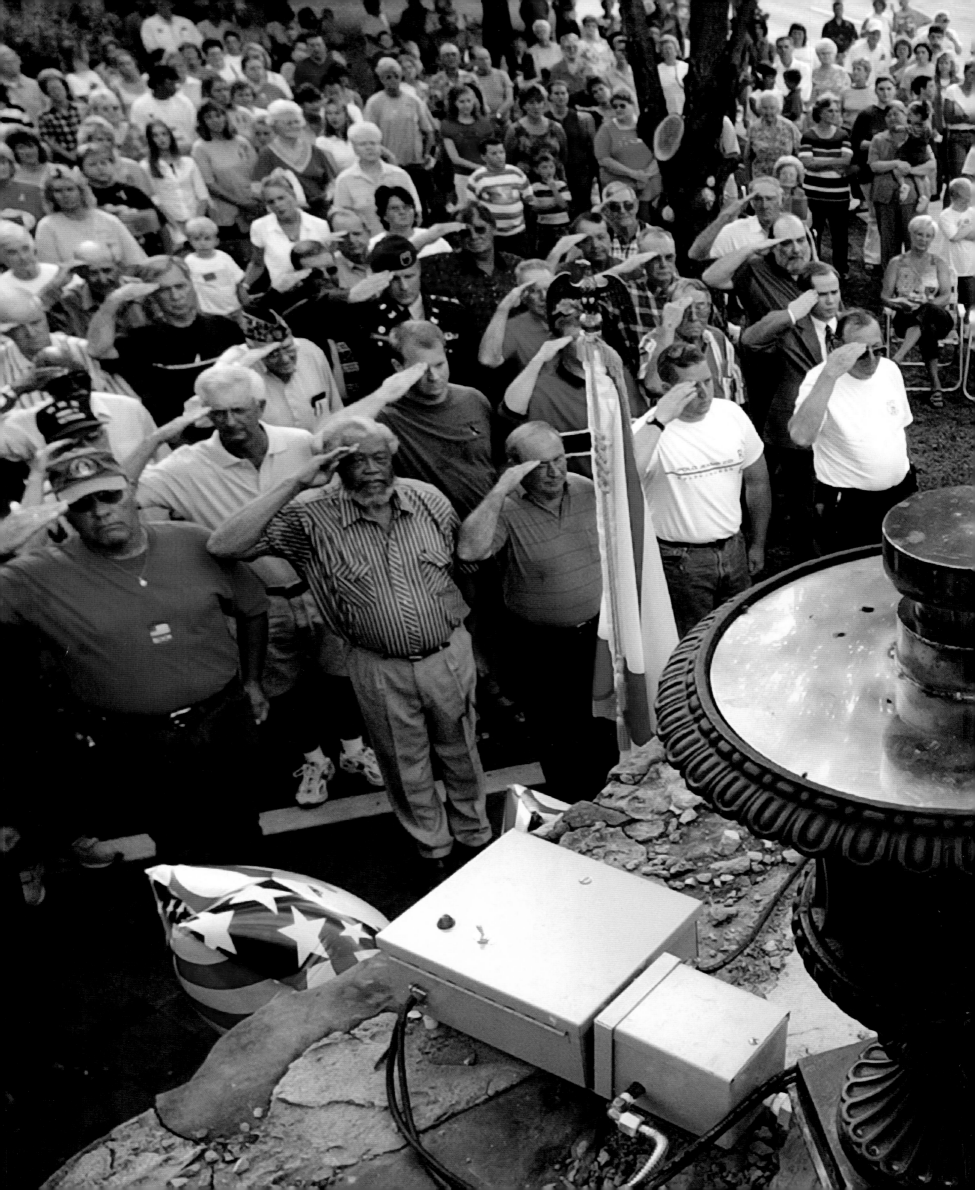

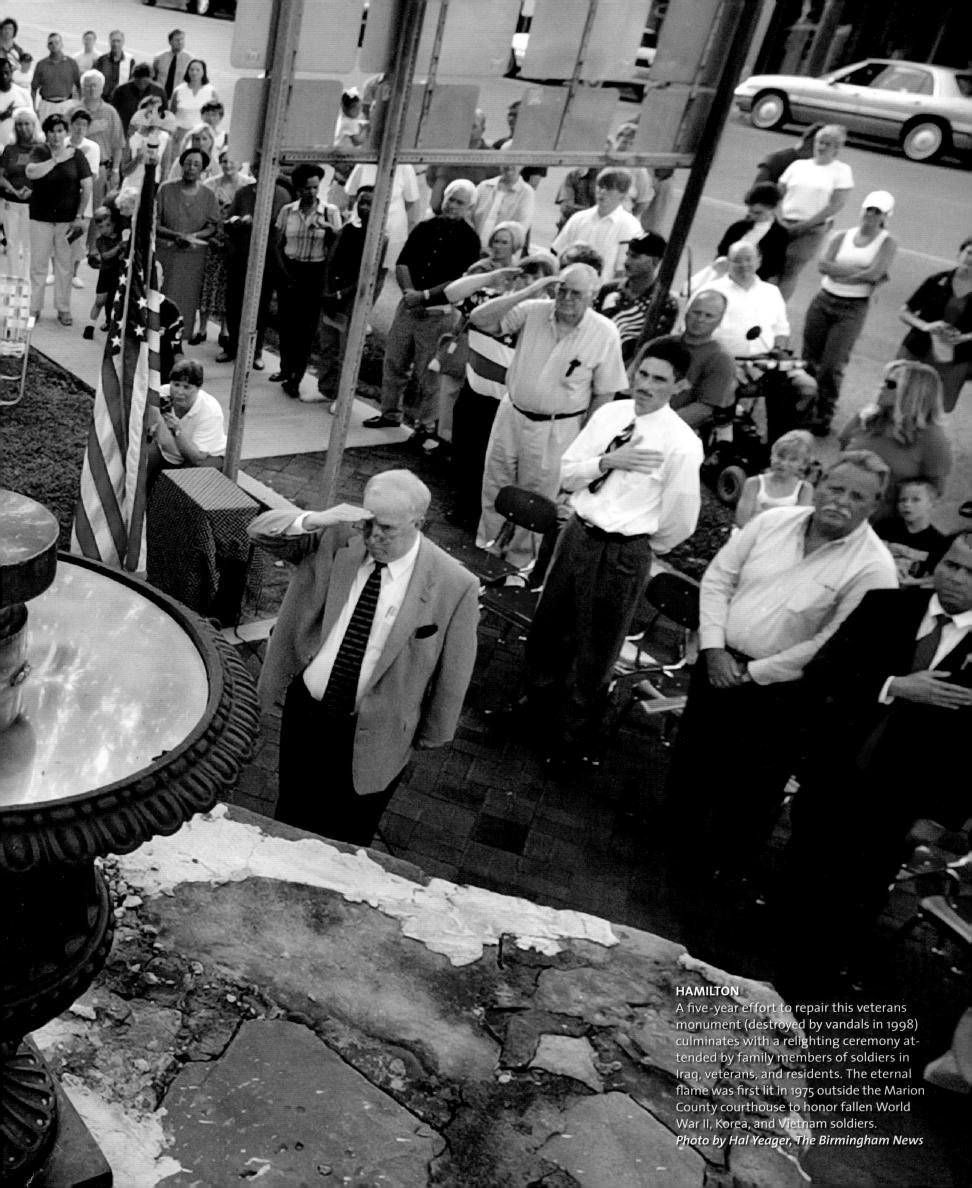

HAMILTON

A five-year effort to repair this veterans monument (destroyed by vandals in 1998) culminates with a relighting ceremony attended by family members of soldiers in Iraq, veterans, and residents. The eternal flame was first lit in 1975 outside the Marion County courthouse to honor fallen World War II, Korea, and Vietnam soldiers.

Photo by Hal Yeager, The Birmingham News

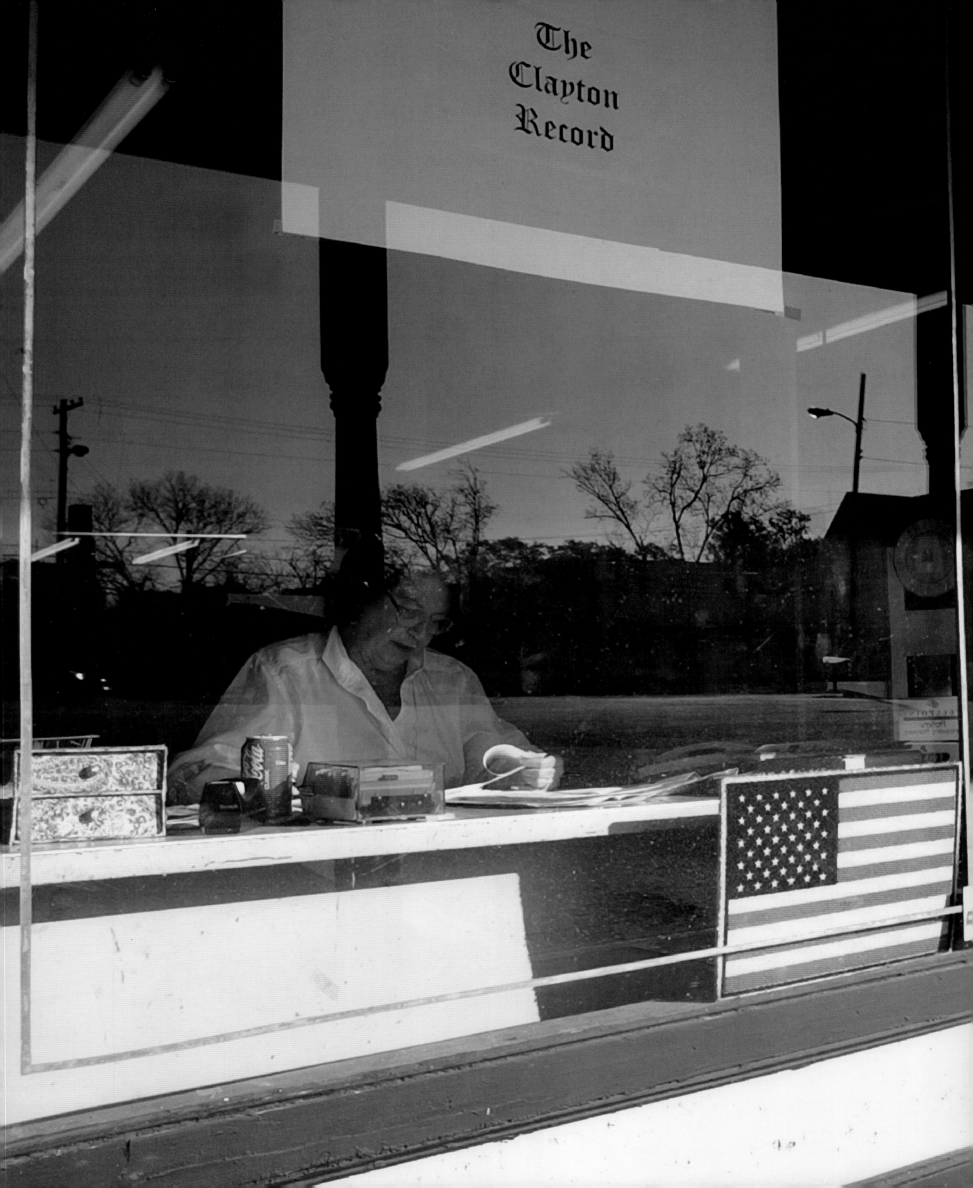

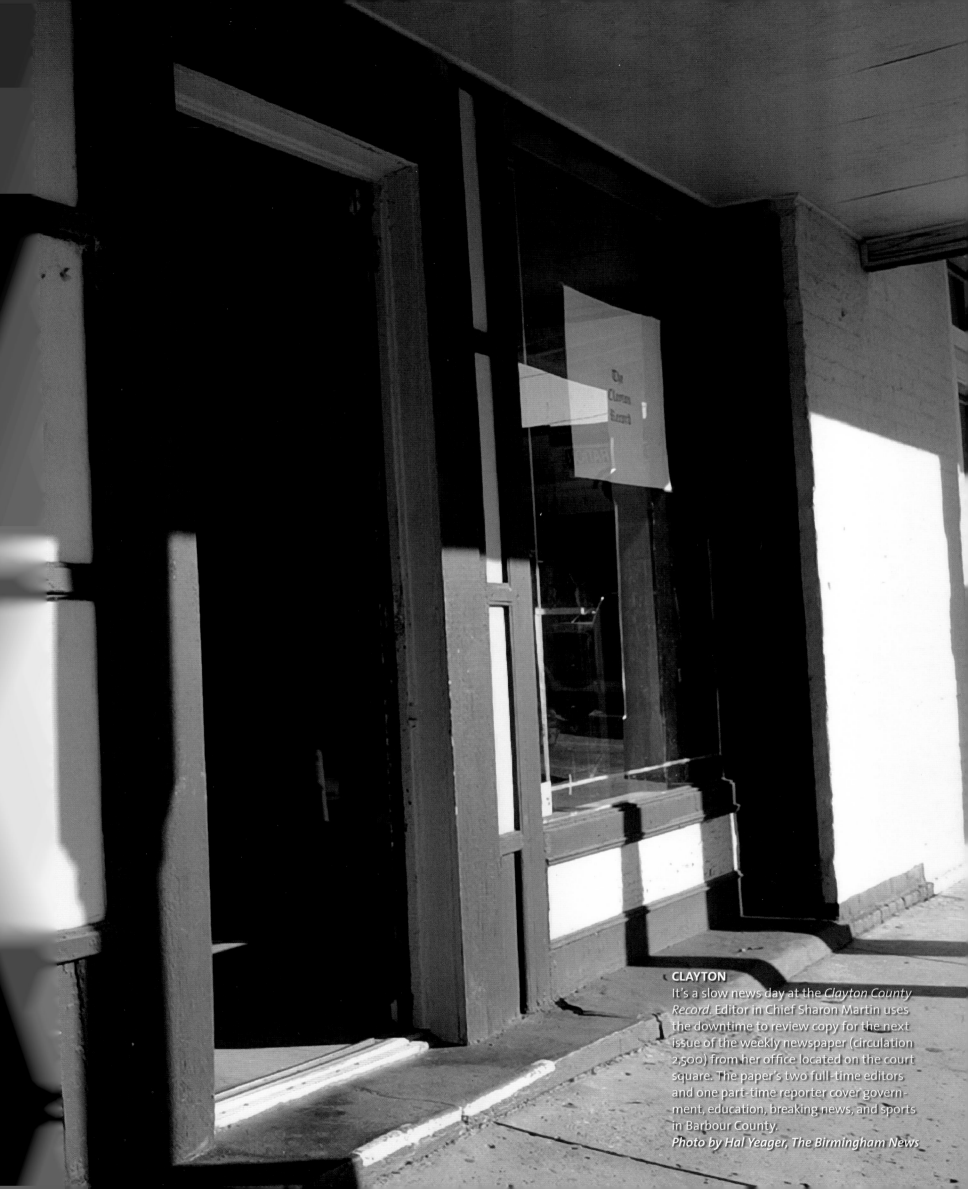

CLAYTON

It's a slow news day at the *Clayton County Record*. Editor in Chief Sharon Martin uses the downtime to review copy for the next issue of the weekly newspaper (circulation 2,500) from her office located on the court square. The paper's two full-time editors and one part-time reporter cover government, education, breaking news, and sports in Barbour County.

Photo by Hal Yeager, The Birmingham News

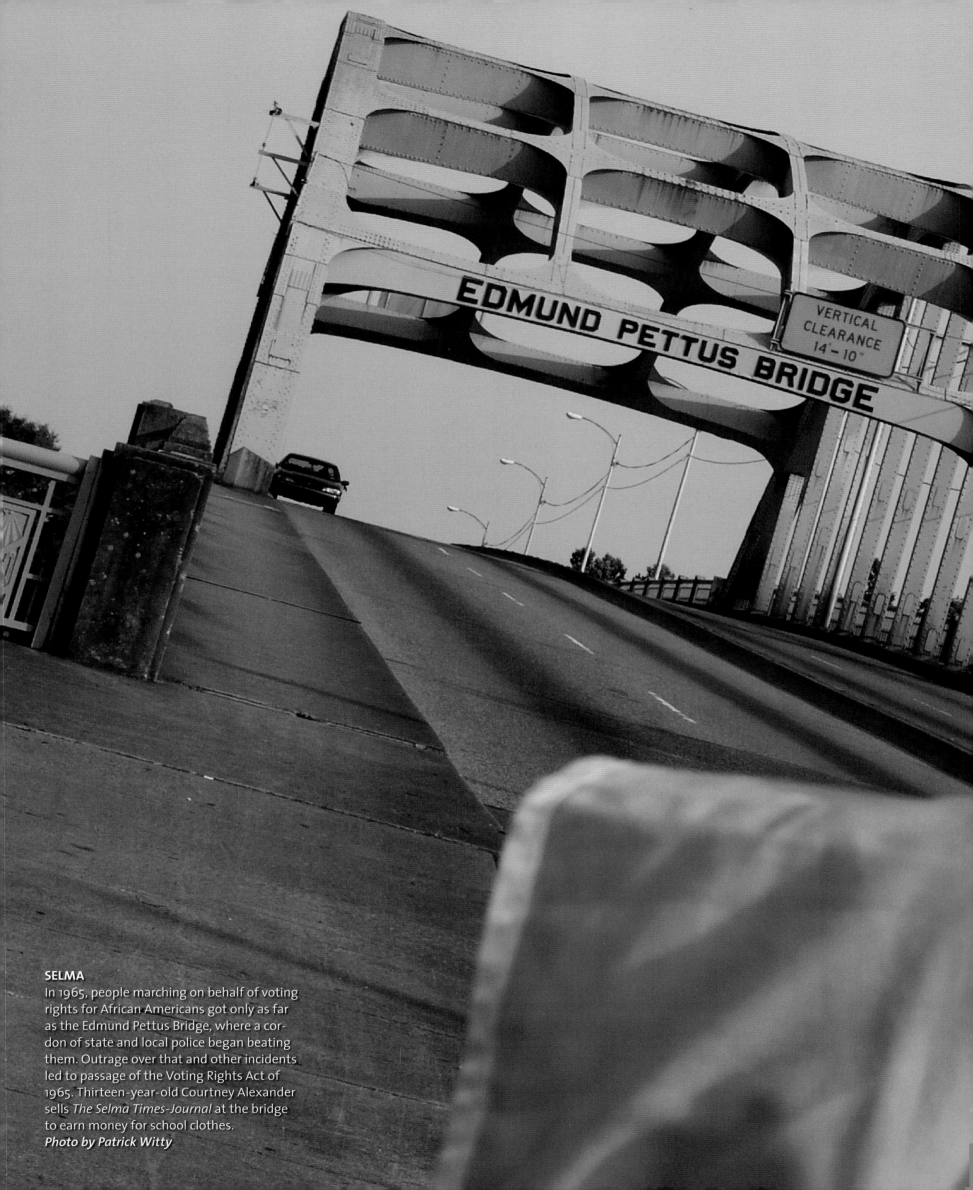

SELMA

In 1965, people marching on behalf of voting rights for African Americans got only as far as the Edmund Pettus Bridge, where a cordon of state and local police began beating them. Outrage over that and other incidents led to passage of the Voting Rights Act of 1965. Thirteen-year-old Courtney Alexander sells *The Selma Times-Journal* at the bridge to earn money for school clothes.
Photo by Patrick Witty

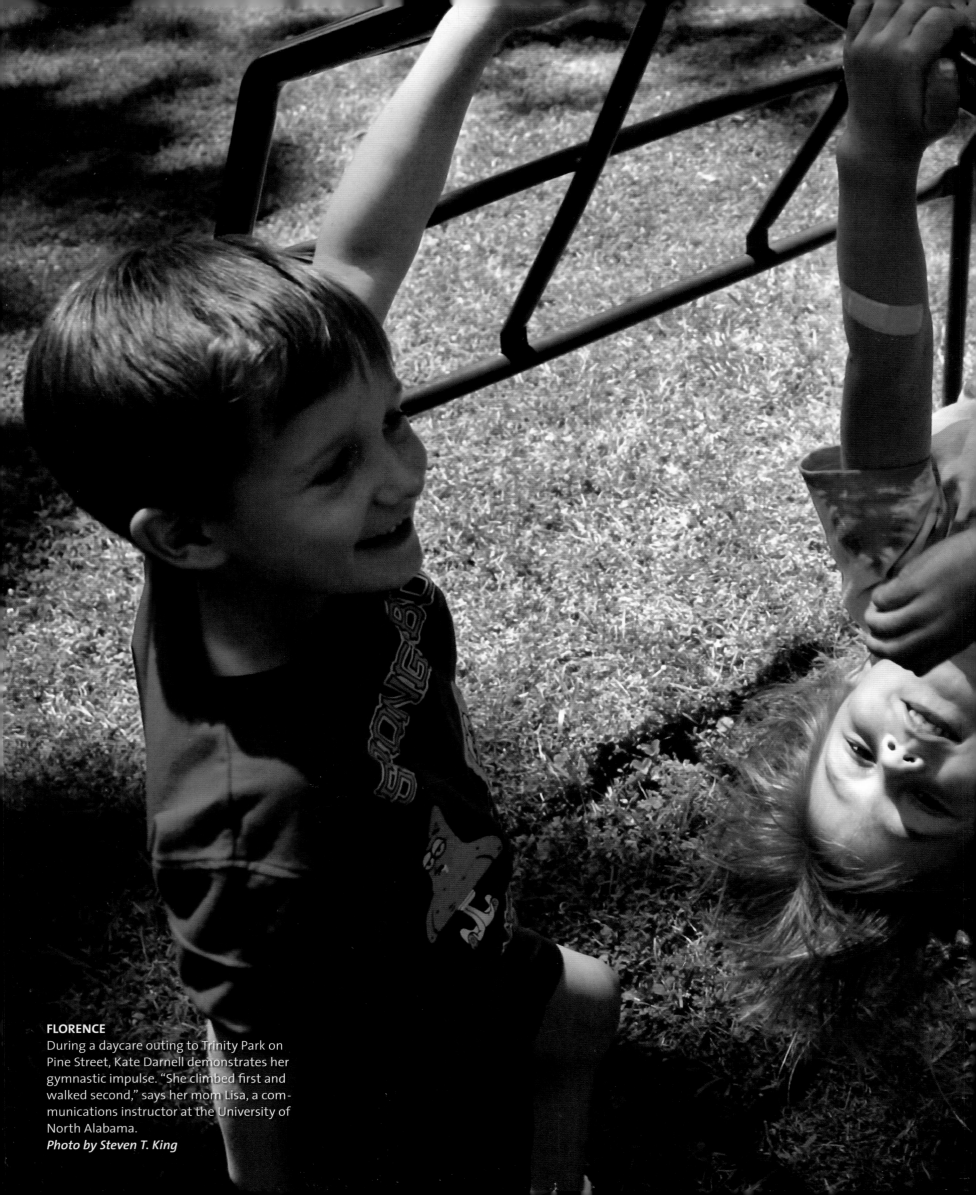

FLORENCE
During a daycare outing to Trinity Park on Pine Street, Kate Darnell demonstrates her gymnastic impulse. "She climbed first and walked second," says her mom Lisa, a communications instructor at the University of North Alabama.
Photo by Steven T. King

Hearth & Home

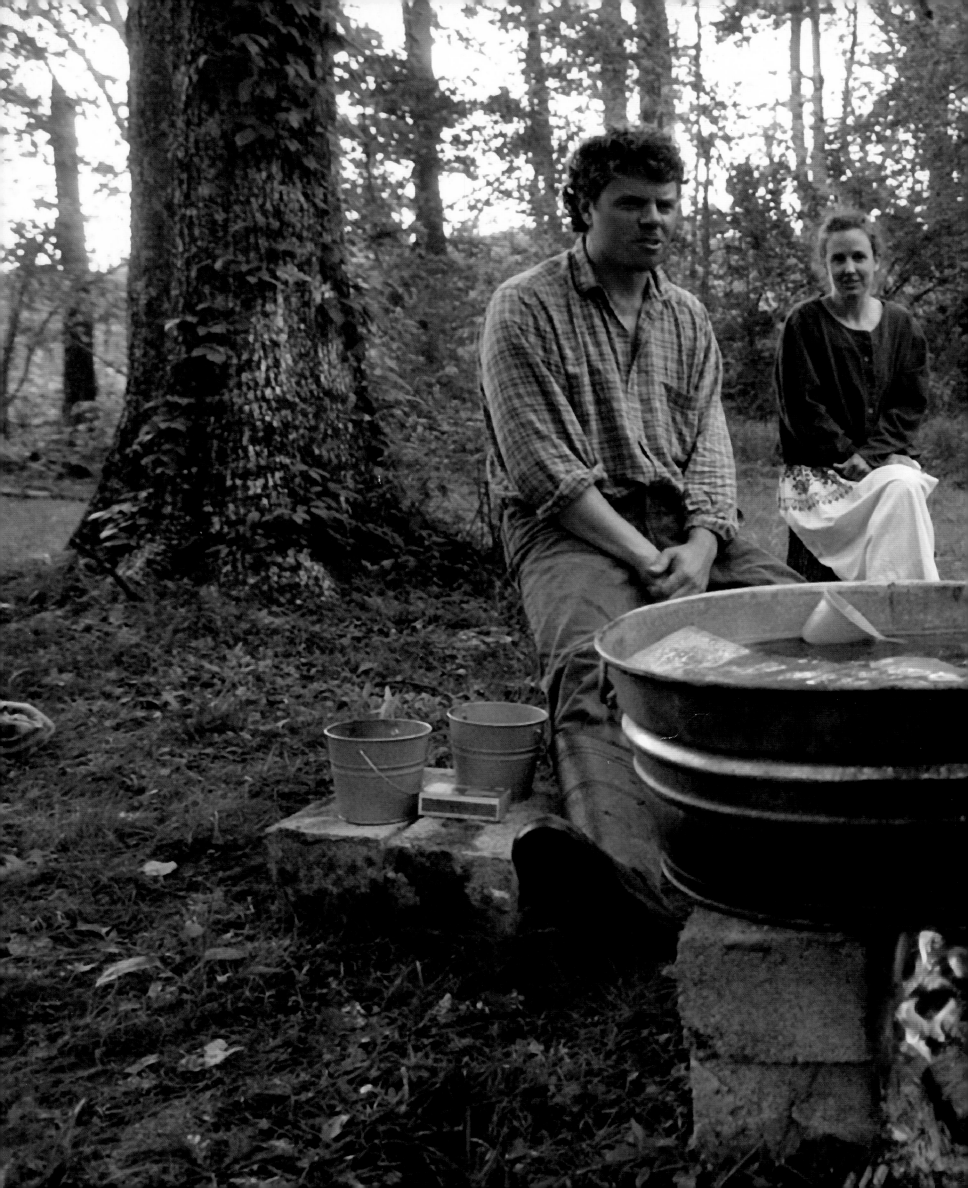

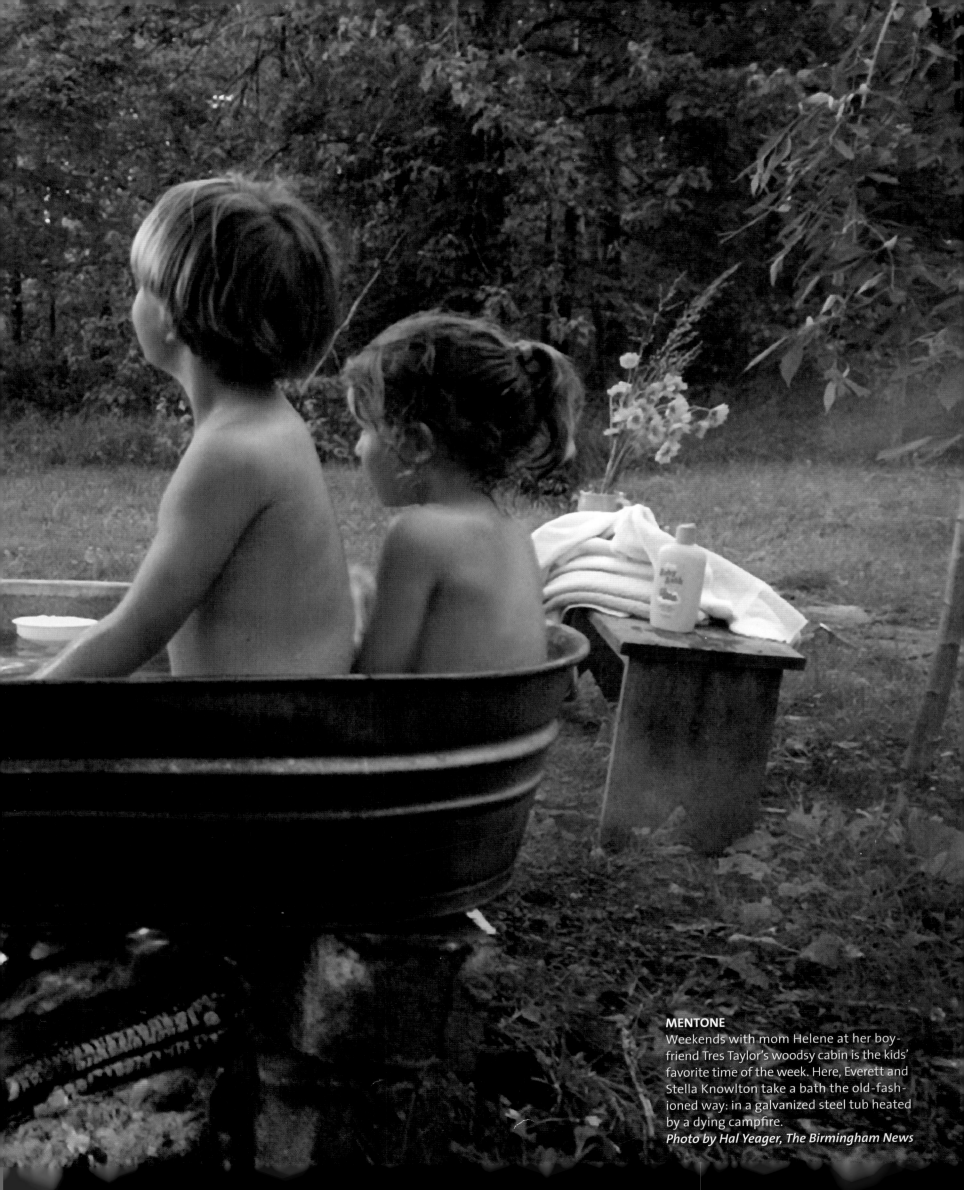

MENTONE

Weekends with mom Helene at her boy-
friend Tres Taylor's woodsy cabin is the kids'
favorite time of the week. Here, Everett and
Stella Knowlton take a bath the old-fash-
ioned way: in a galvanized steel tub heated
by a dying campfire.
Photo by Hal Yeager, The Birmingham News

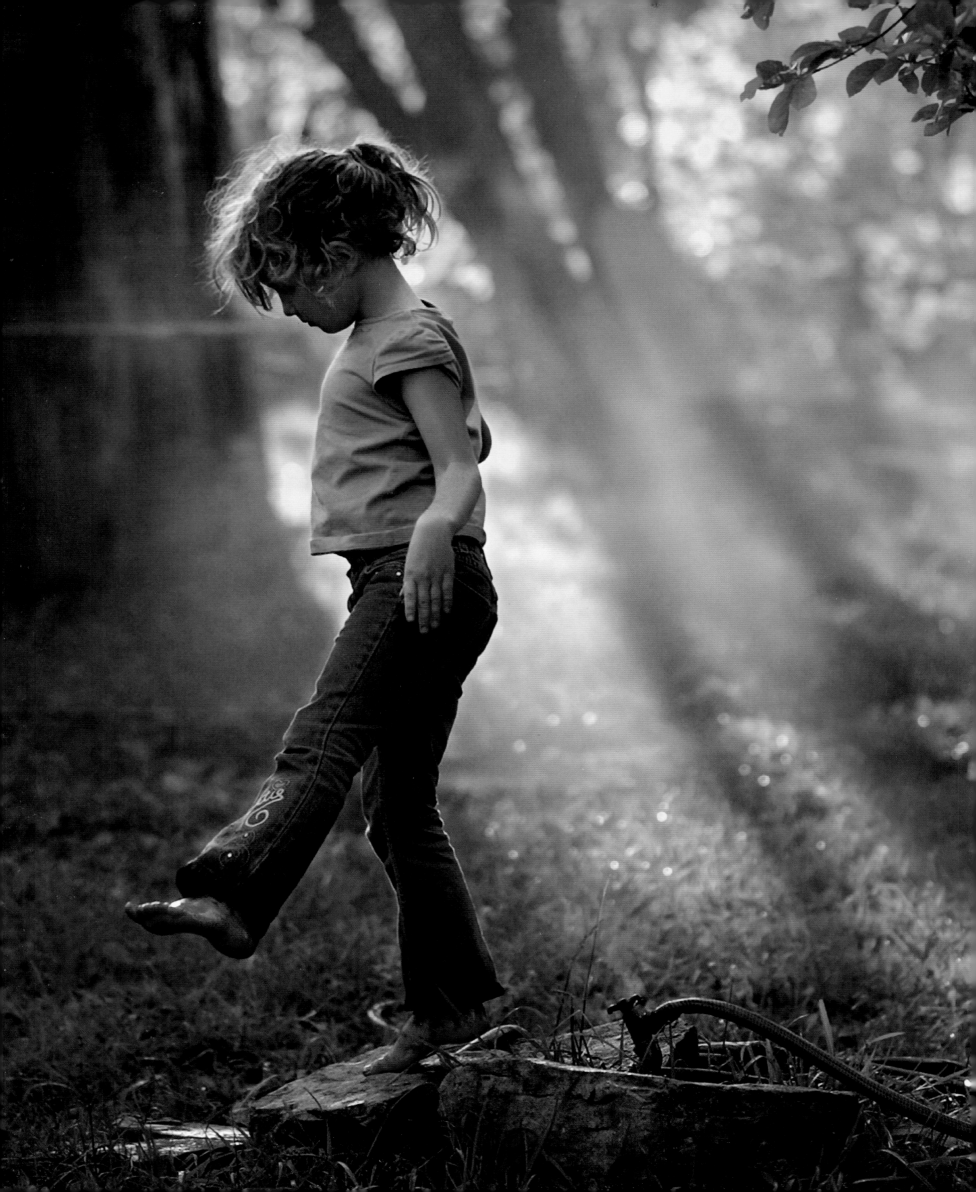

MENTONE

Sweet Home Alabama: The forests and fields of rural northern Alabama are home to the fairies and elves of Stella Knowlton's imagination. Weekend visits to a cabin in the woods give Stella a taste of what life was like in the old days, when entertainment consisted of picking wildflowers, catching fireflies, and chasing dreams.
Photos by Hal Yeager, The Birmingham News

MENTONE

Helene Knowlton readies a Southern feast of fried okra, cornbread, fried chicken, and lemonade. Stella and Everett (under table) worked up an appetite playing in the shallows of a nearby river while Tres Taylor, a folk artist, painted in the yard of their vacation cabin. "It's really precious time when we're here," says Knowlton.

FLORENCE

John and Joan Lane pray every evening with their children: Mary Elizabeth, 3, Anne Holland and Jeffrey, 5, and Thomas, 11. Another son, the triplet of Anne Holland and Jeffrey, died. The Lanes, who are Episcopalian, have taken to praying at his bed.
Photo by Steven T. King

MOBILE

"Ecstatic" best describes Thomas Quinn's feelings about the birth of his son, who was two months premature. He and his wife Anita endured a frightening wait getting to this happy point. Anita had amniocentesis, which caused her water to break at 16 weeks, forcing her into bed for the rest of her pregnancy.
Photo by Bill Starling, Mobile Register

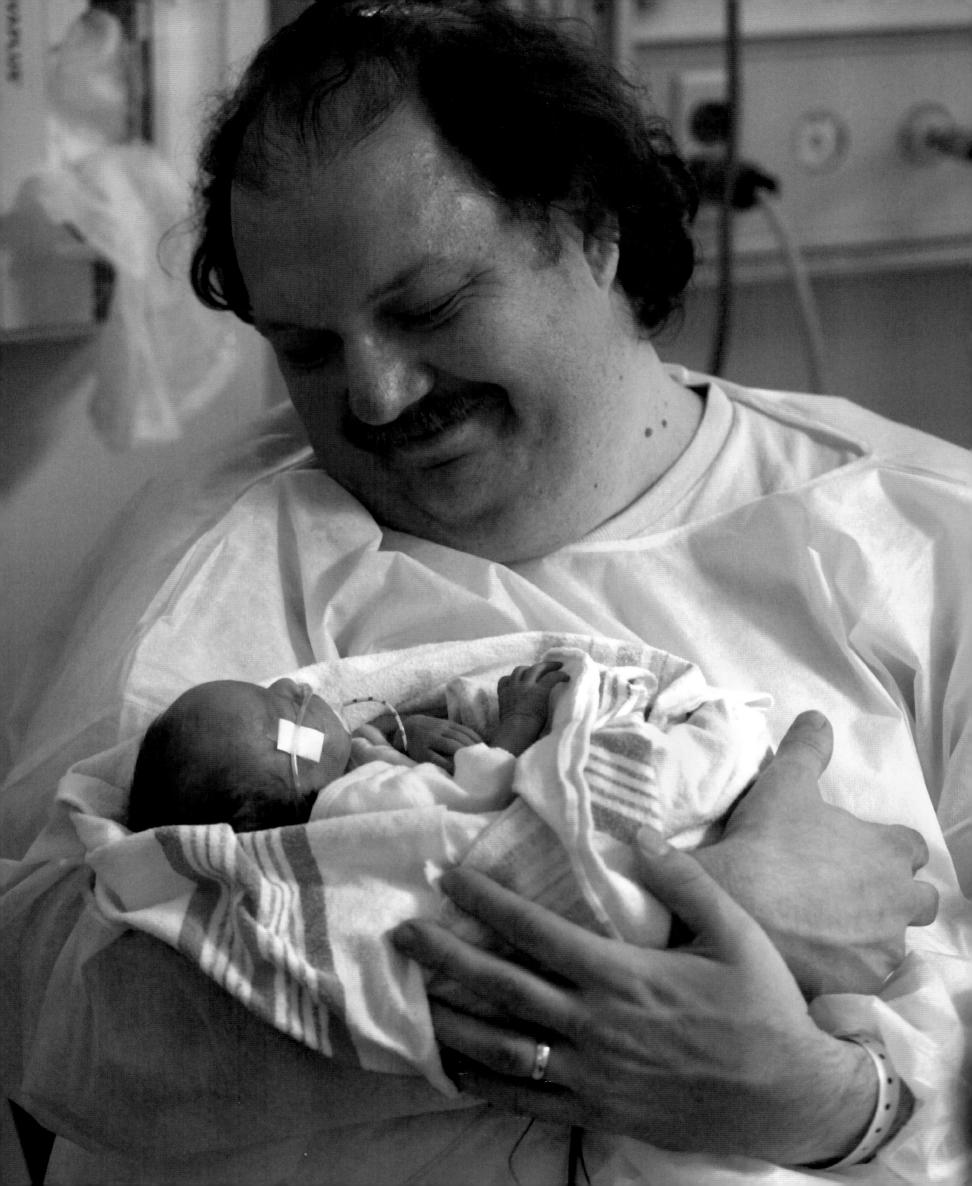

HAMILTON

Eyeglass bandit Allicyn Loveless fakes out her babysitter, Lawson Cook, with a glance across the room and a simultaneous swipe for his specs. Cook looks after the 2-year-old four days a week while her mother attends classes at University of North Alabama in Lawrence. Allicyn's father, an Army National Guardsman, was killed during combat training at Fort Benning, Georgia, in April.
Photo by Hal Yeager, The Birmingham News

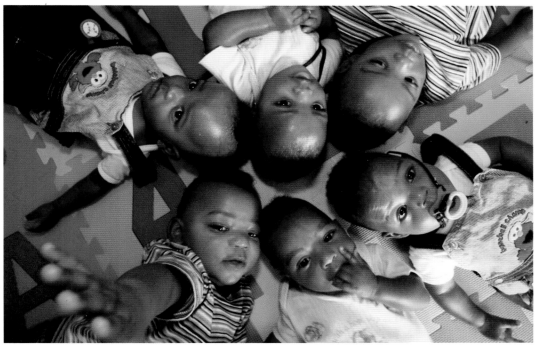

BIRMINGHAM

Weighing from 1 pound, 3 ounces to 1 pound, 12 ounces when they were born, the 10-month-old Harris sextuplets are thriving. Luckily, the two girls (Kiera and Kalynne) and four boys (Kaleb, Kobe, Kieran, and Kyle) were delivered in the 27th week of pregnancy. That gave them an 80 percent chance of survival.
Photo by Tamika Moore, The Birmingham News

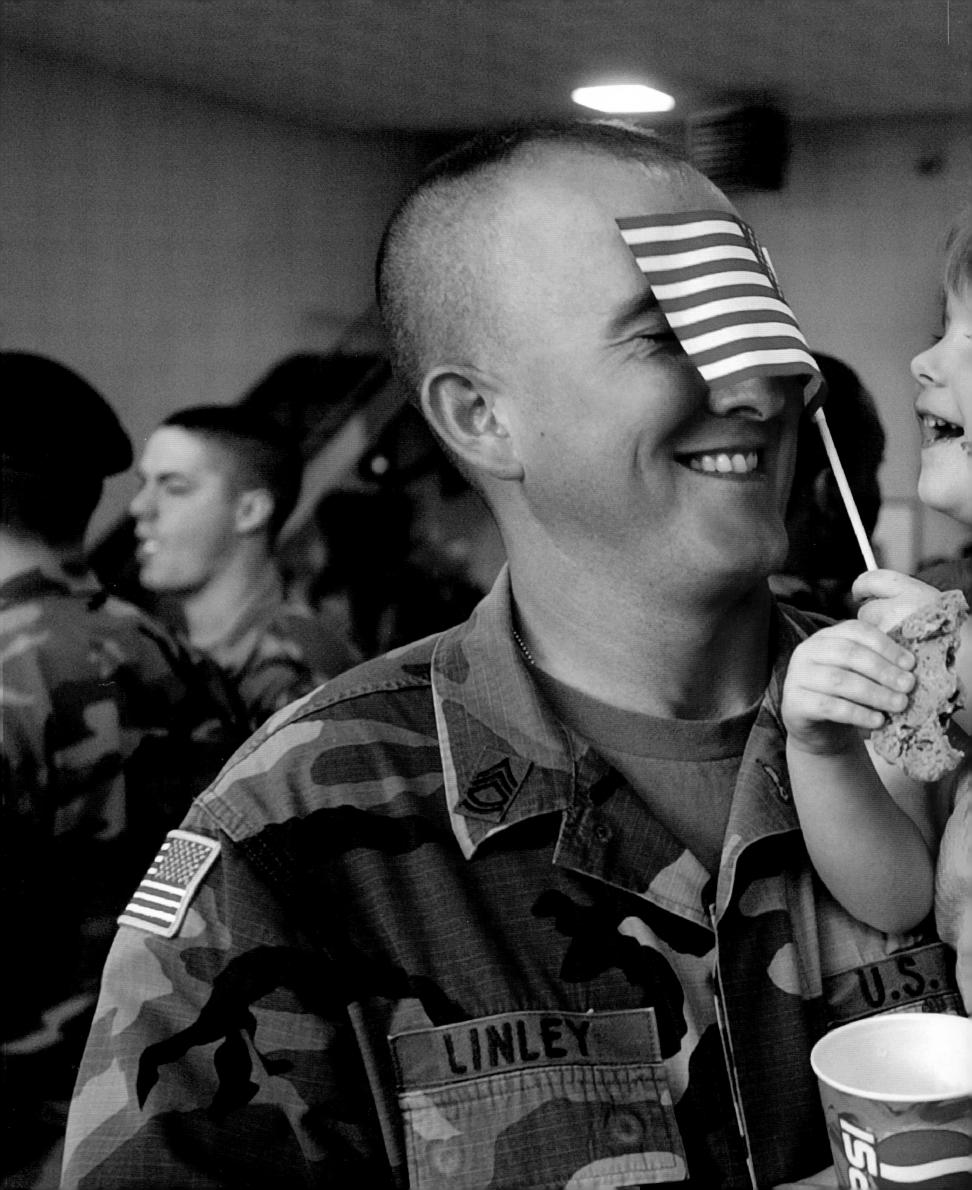

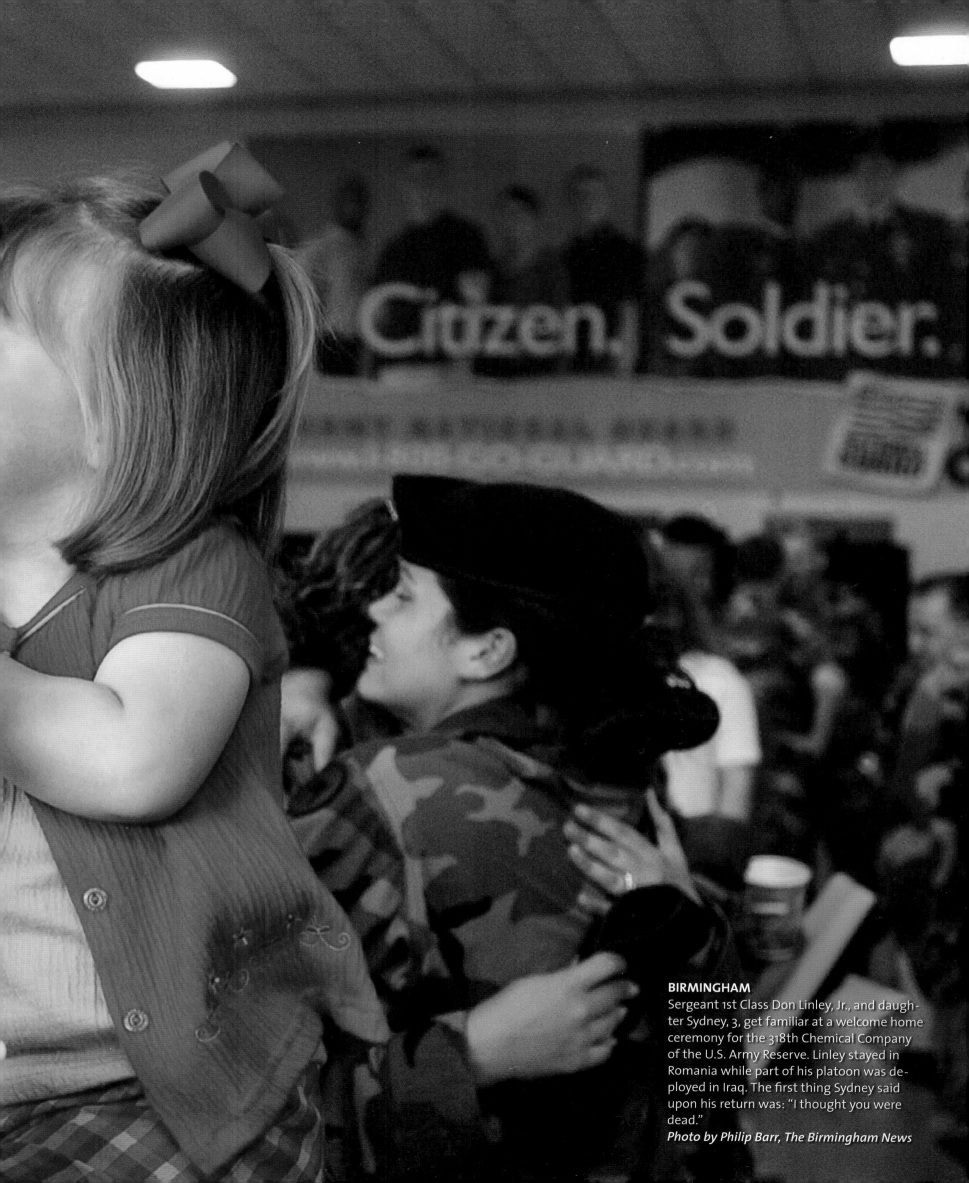

BIRMINGHAM

Sergeant 1st Class Don Linley, Jr., and daughter Sydney, 3, get familiar at a welcome home ceremony for the 318th Chemical Company of the U.S. Army Reserve. Linley stayed in Romania while part of his platoon was deployed in Iraq. The first thing Sydney said upon his return was: "I thought you were dead."

Photo by Philip Barr, The Birmingham News

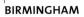

BIRMINGHAM

Shampoo for Saaboo: Chloe Hill helps her pooch beat the heat with a cold bath in front of her house.

Photo by Philip Barr, The Birmingham News

BROOKSIDE

At her grandparents' house, which was inundated by floodwaters from nearby Five Mile Creek, Mary Ann Garrett helps her mother Martha Ann salvage belongings. Local and federal officials are working to buy out the low-lying houses in this struggling coal mining town.
Photo by Christine Prichard

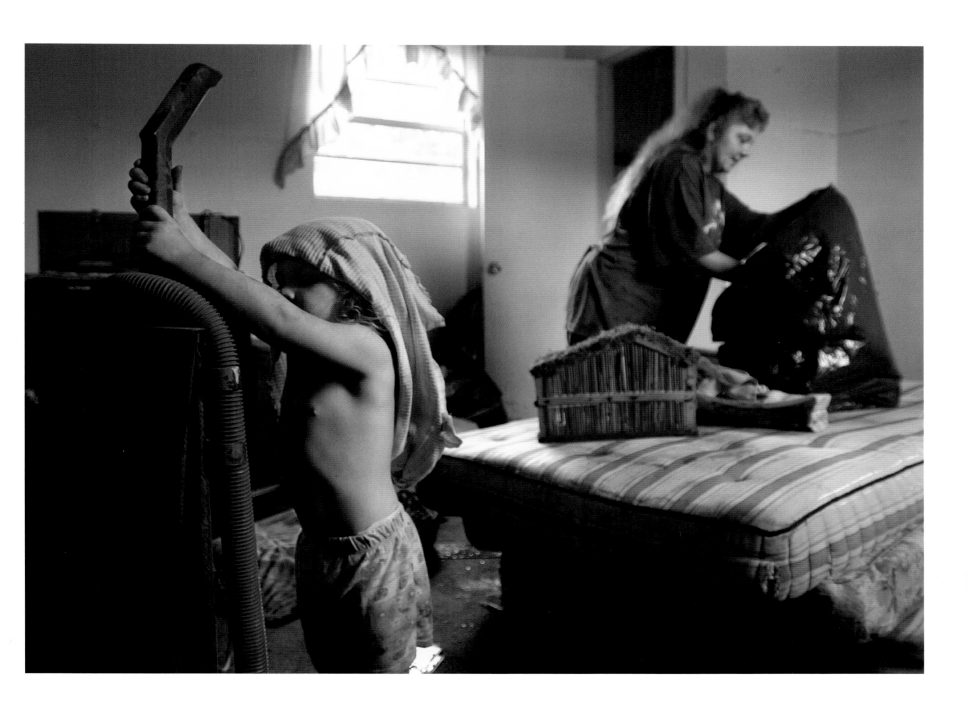

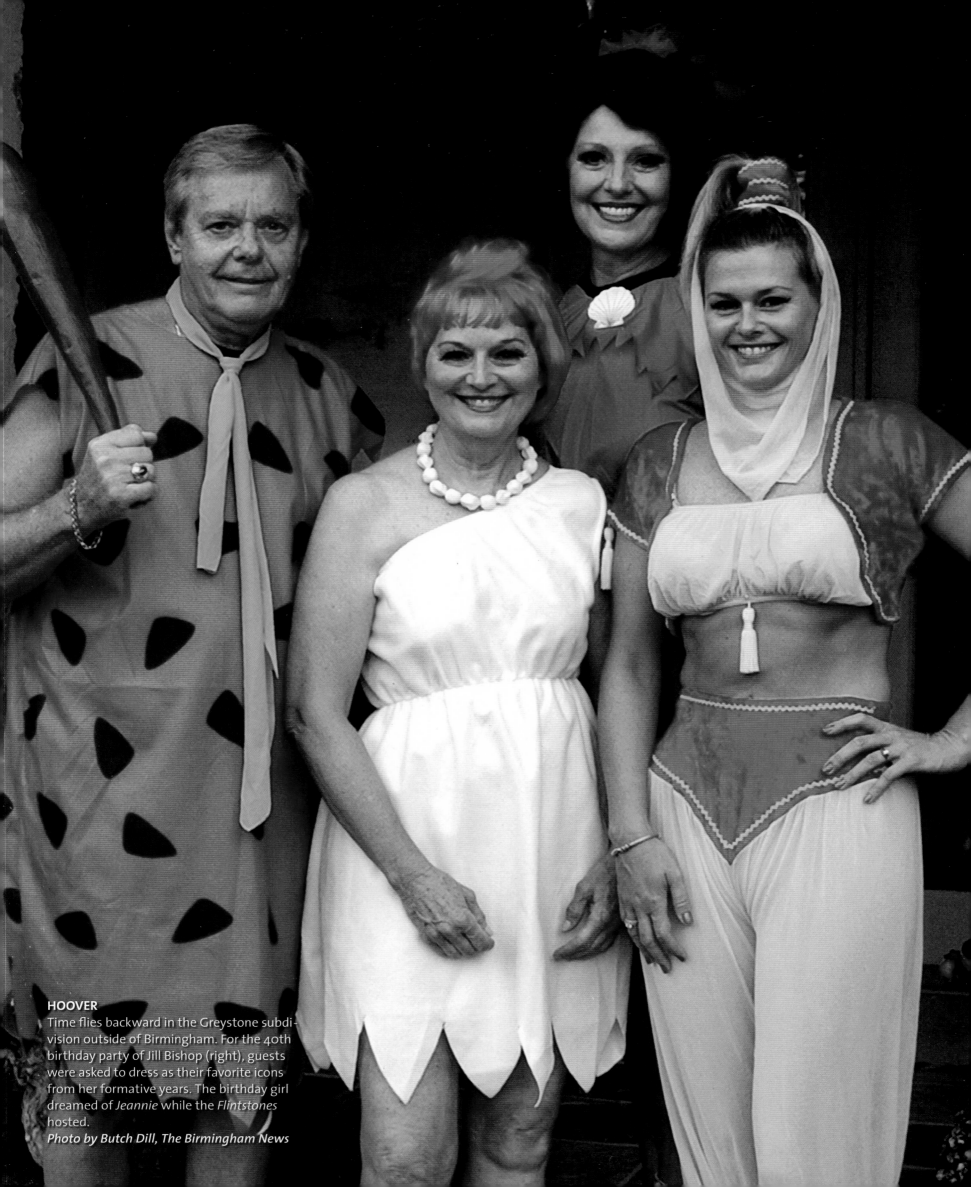

HOOVER

Time flies backward in the Greystone subdivision outside of Birmingham. For the 40th birthday party of Jill Bishop (right), guests were asked to dress as their favorite icons from her formative years. The birthday girl dreamed of *Jeannie* while the *Flintstones* hosted.

Photo by Butch Dill, The Birmingham News

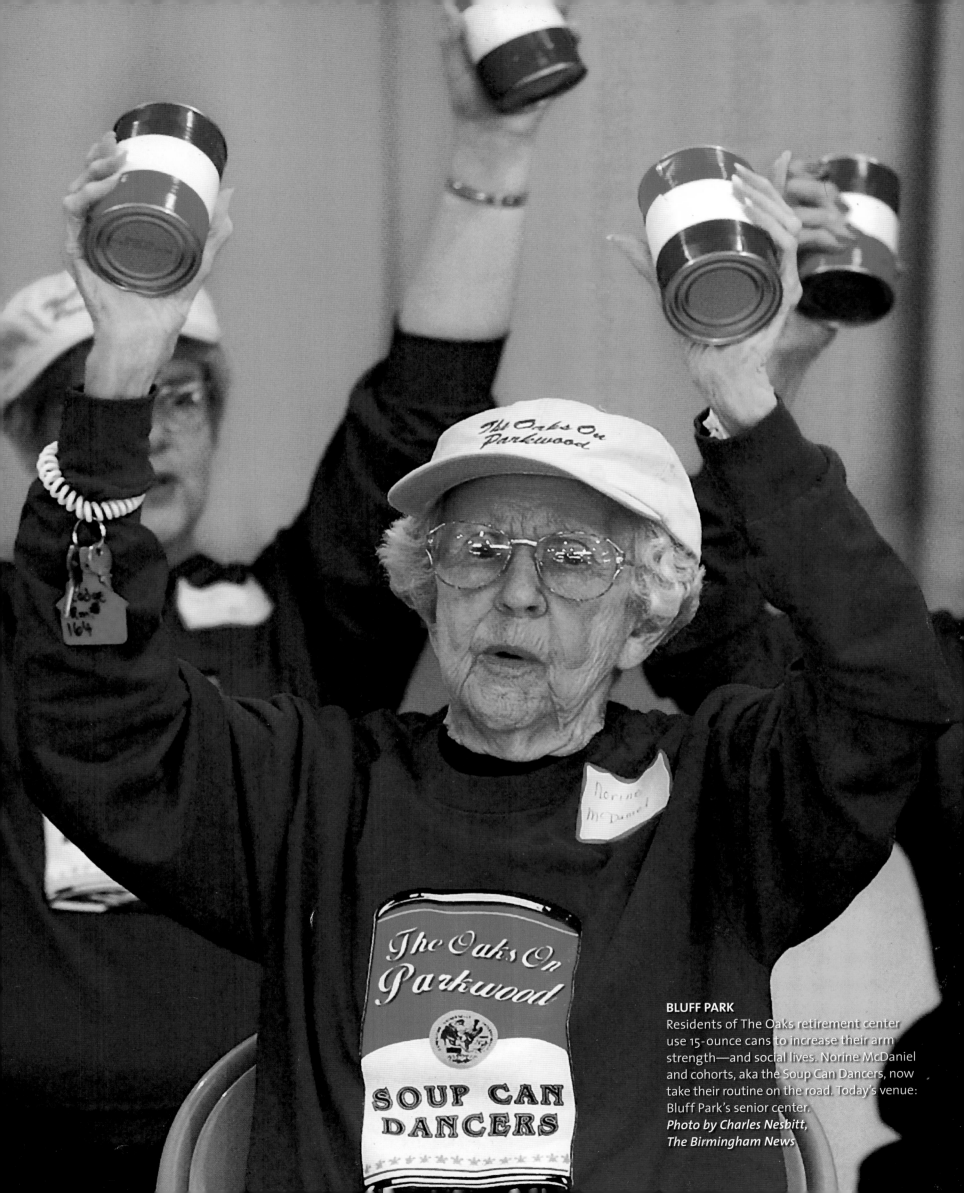

BLUFF PARK
Residents of The Oaks retirement center use 15-ounce cans to increase their arm strength—and social lives. Norine McDaniel and cohorts, aka the Soup Can Dancers, now take their routine on the road. Today's venue: Bluff Park's senior center.
Photo by Charles Nesbitt,
The Birmingham News

BESSEMER

At 14, Catherine Brown quit high school to have a child. It took her 25 years to muster the courage to return, but just 14 months to receive her degree. Now a mother of three, Brown relishes her diploma after the Bessemer Adult and Community Education commencement.
Photo by Joe Songer,
The Birmingham News

TUSCALOOSA

Delta Sigma Theta sisters line up for a group photo. The sorority was founded by Howard University women who wanted to use their collective strength to promote academic excellence and provide assistance to those in need. Its first public act was marching for women's suffrage in Washington, D.C., in March 1913.
Photo by Philip Barr,
The Birmingham News

TUSCALOOSA

More than 1,400 undergraduates and nearly 800 graduate students gather in the University of Alabama's Coleman Coliseum en route to their next step in life. The state university was founded in Tuscaloosa in 1831.
Photo by Philip Barr,
The Birmingham News

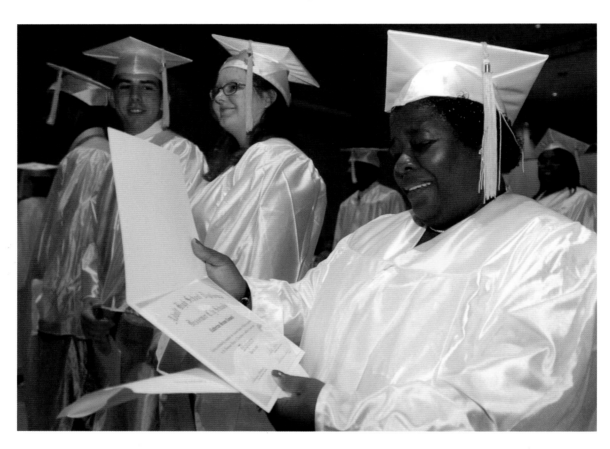

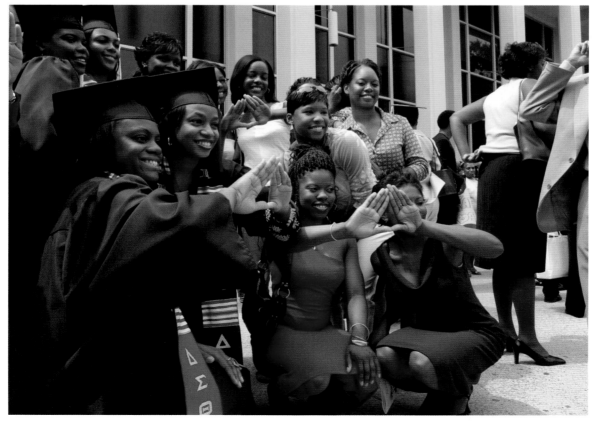

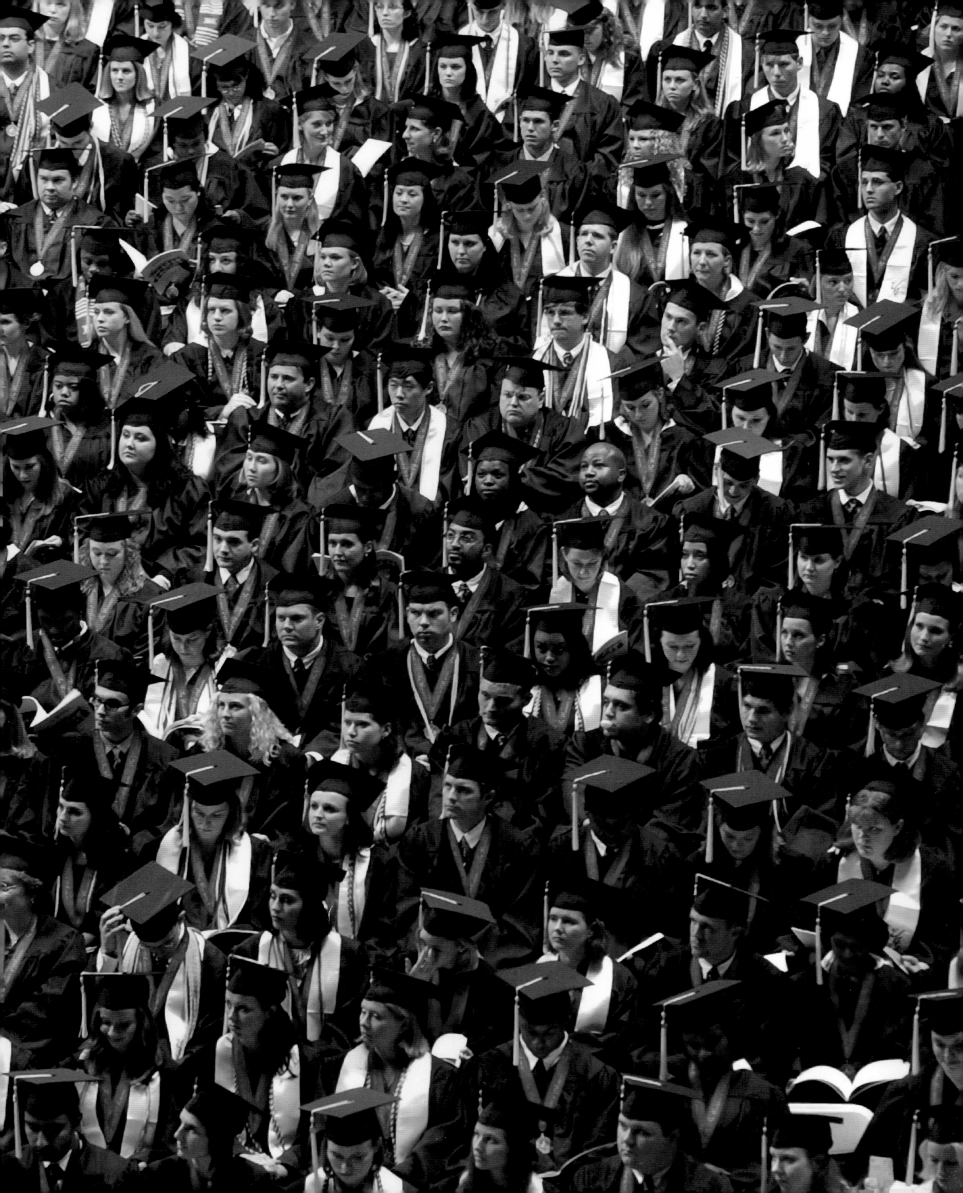

MAGNOLIA SPRINGS
Retirees Margaret and Jack Epperson delay their trip home to Florence, Alabama, with a cup of coffee on the front porch of the Magnolia Springs Bed and Breakfast.
Photo by Beverly Taylor, The Birmingham News

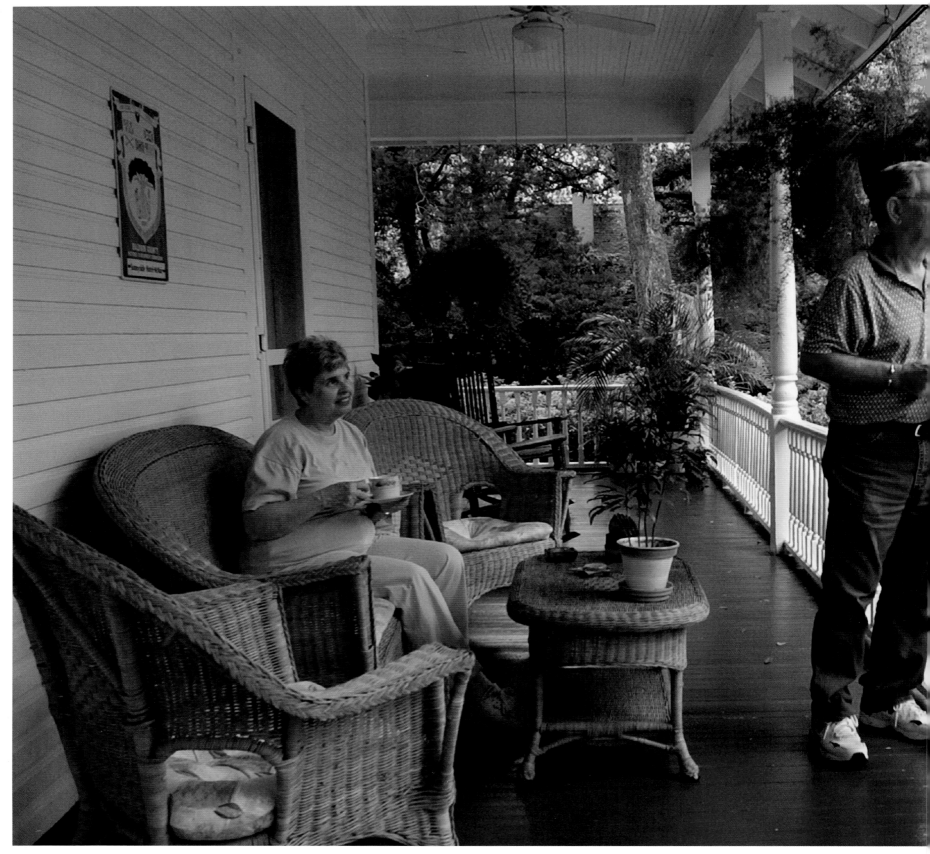

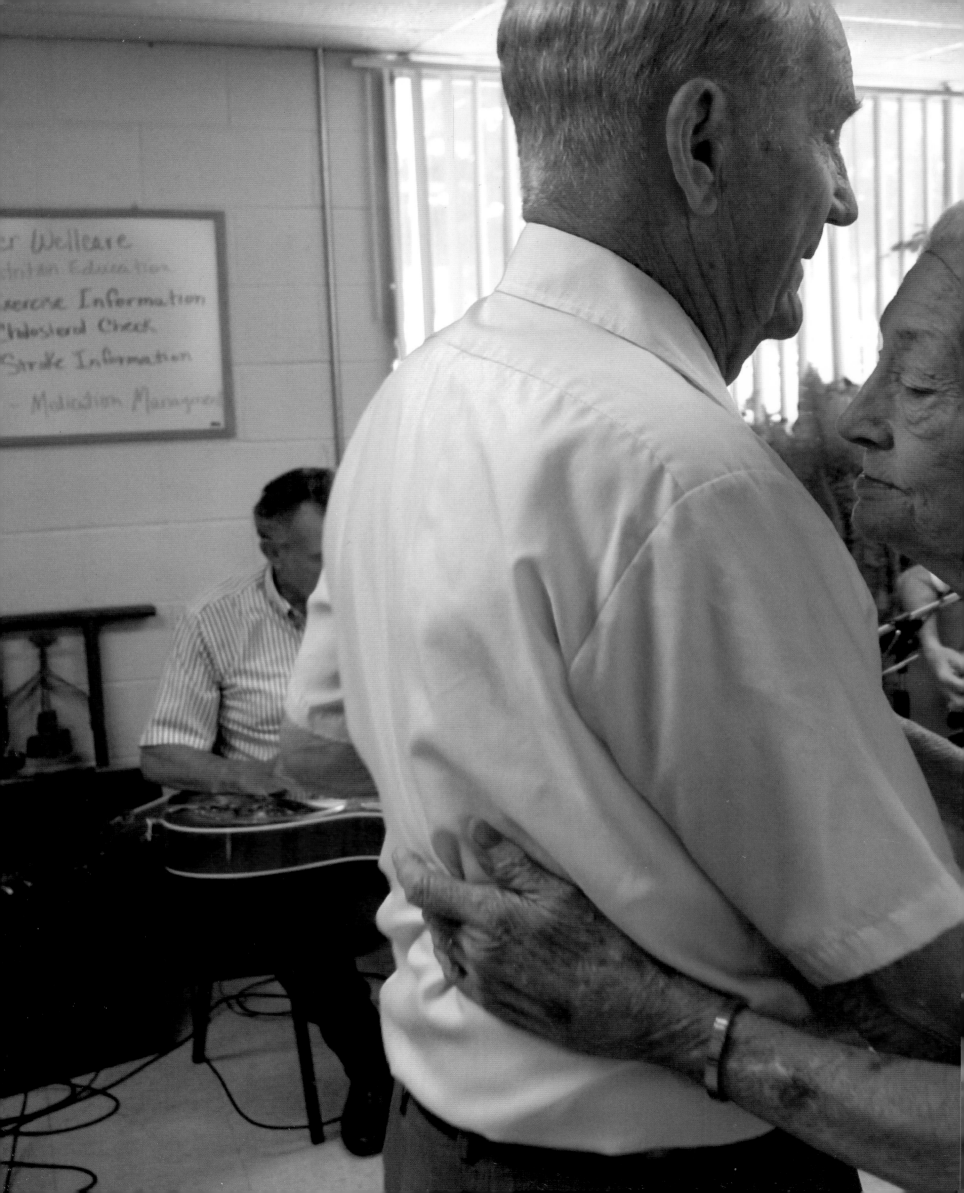

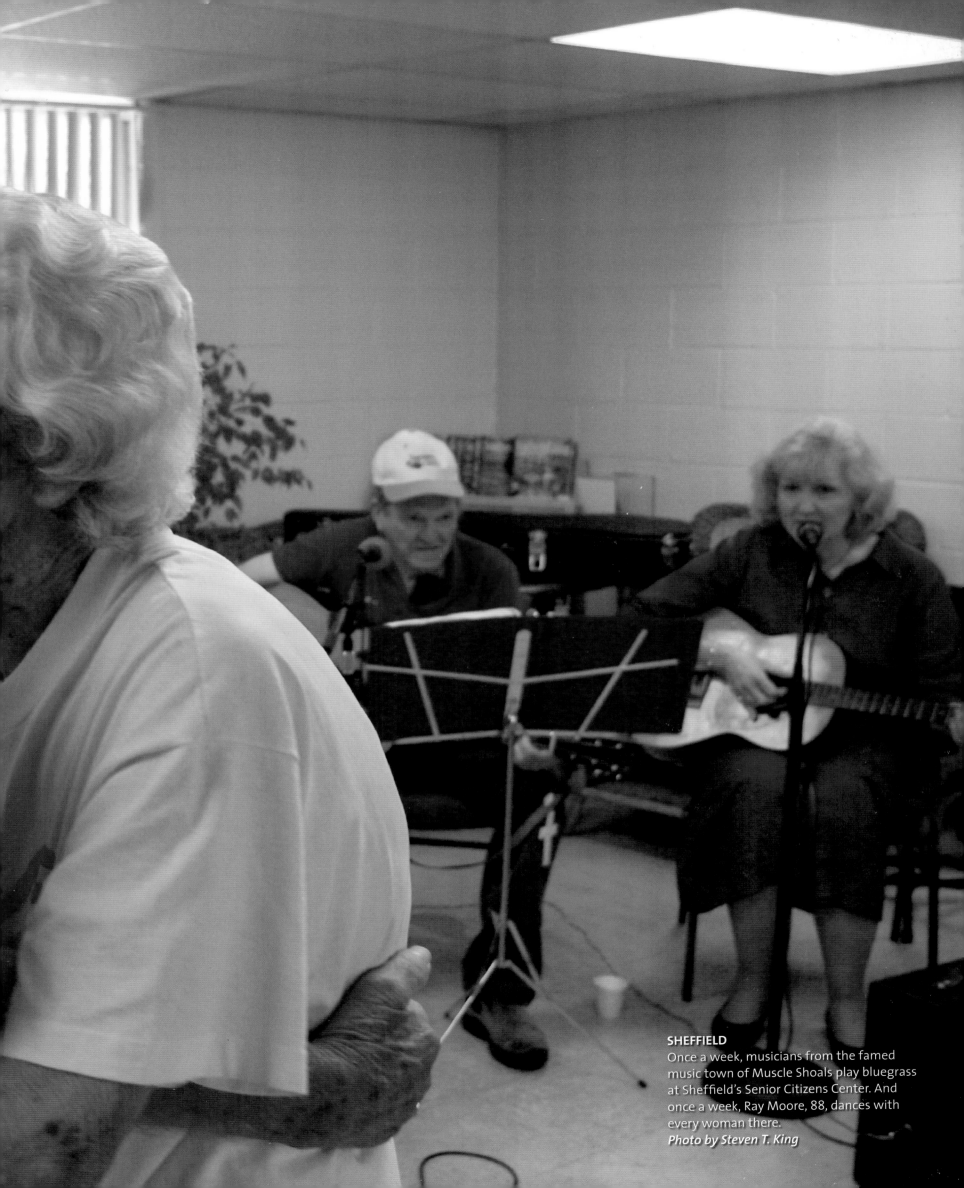

SHEFFIELD
Once a week, musicians from the famed music town of Muscle Shoals play bluegrass at Sheffield's Senior Citizens Center. And once a week, Ray Moore, 88, dances with every woman there.
Photo by Steven T. King

The year 2003 marked a turning point in the history of photography: It was the first year that digital cameras outsold film cameras. To celebrate this unprecedented sea change, the *America 24/7* project invited amateur photographers—along with students and professionals—to shoot and, via the Internet, submit digital images. Think of it as audience participation. Their visions of community are interspersed with the professional frames throughout this book. On the following four pages, however, we present a gallery produced exclusively by amateur photographers.

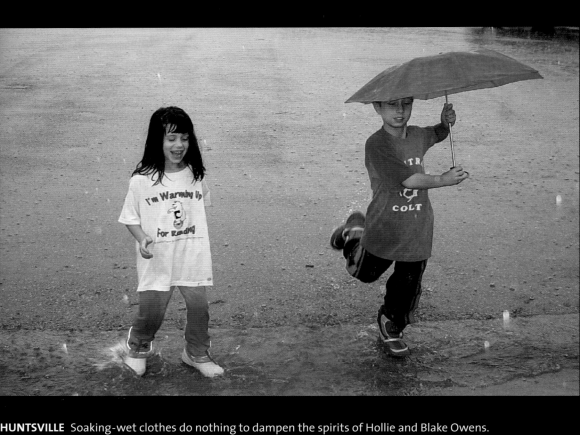

HUNTSVILLE Soaking-wet clothes do nothing to dampen the spirits of Hollie and Blake Owens. *Photo by David Owens*

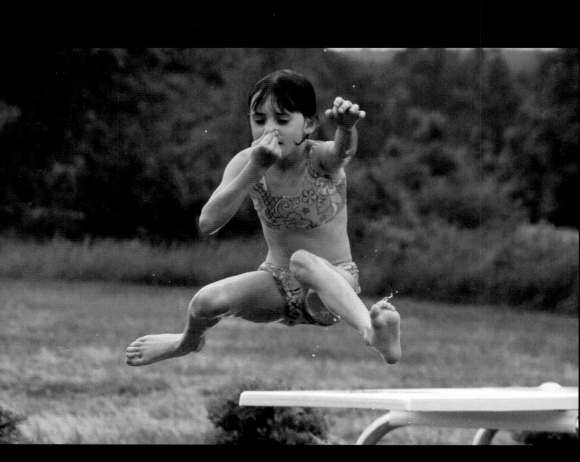

MOUNDVILLE On a muggy Saturday afternoon, Chandler Brooke Dare cools off in a friend's backyard swimming pool after a softball game. *Photo by Austin Dare*

HUNTSVILLE On many a Monday morning, registered nurse Julie Willis breakfasts with her father, Glenn Nettleton, at Aunt Eunice's Country Kitchen. This morning, he snapped her picture. ***Photo by Glenn Nettleton***

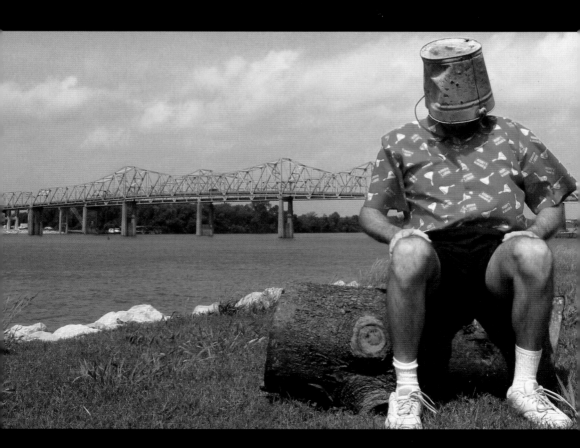

HUNTSVILLE Sitting by the Tennessee River, amateur photographer Mark Schlapbach fancies he's been cloned nto his favorite, sometimes-bucket-wearing childhood TV character, Gomer Pyle. ***Photo by Mark Schlapbach***

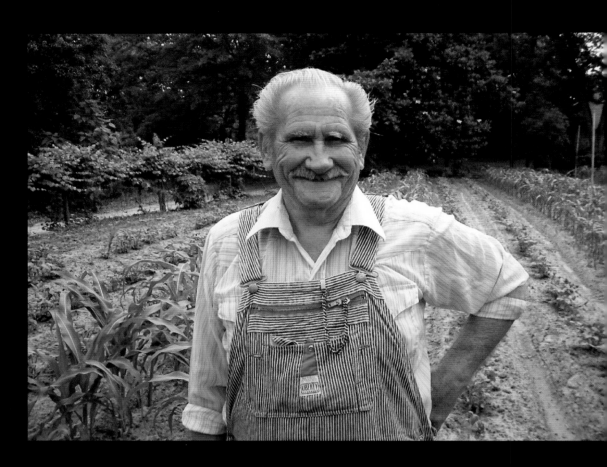

LADONIA For nearly 40 years, Fred Davis has been growing corn, squash, strawberries, potatoes, tomatoes, okra, and a whole lot more on his 10-acre farm. His big customers are friends and neighbors.
Photo by Dallas Smith

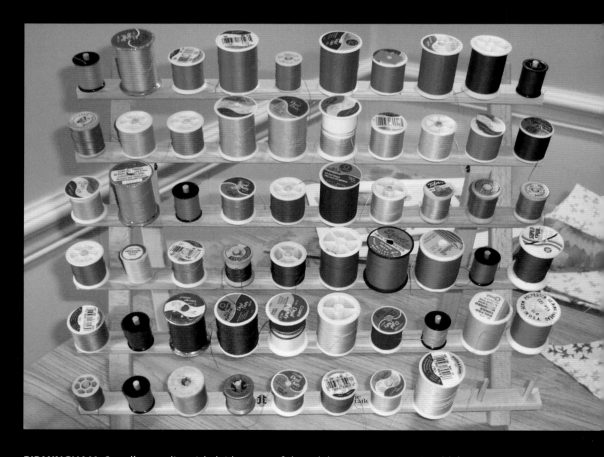

BIRMINGHAM Spool's paradise: A kaleidoscope of thread decorates Marion Gamble's sewing room.
Photo by Will Gamble

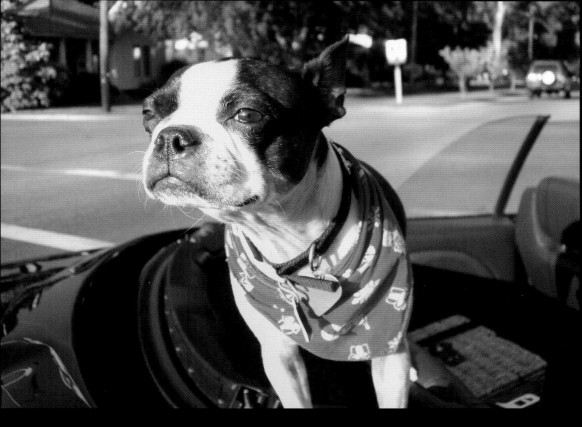

HUNTSVILLE Dixie, a 7-year-old Boston Terrier, guards a picnic basket and its contents, which she occasionally shares with her human companions. *Photo by Eric Schwartz*

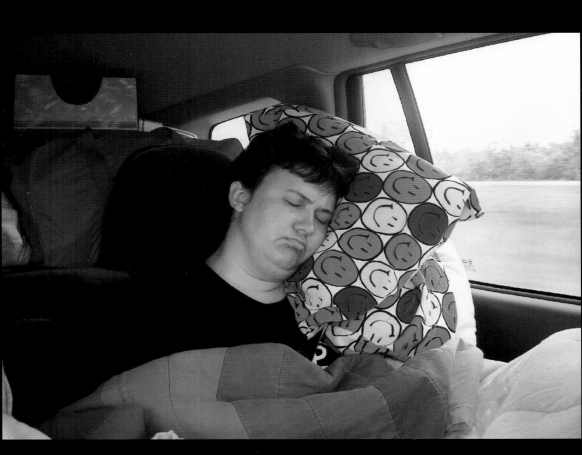

INTERSTATE 65 On the car ride home after a week's vacation on Dauphin Island, Shelley Atkinson—even in sleep—displays her feelings about leaving the sun-swept beaches of the barrier island behind. *Photo by Donna Dougan*

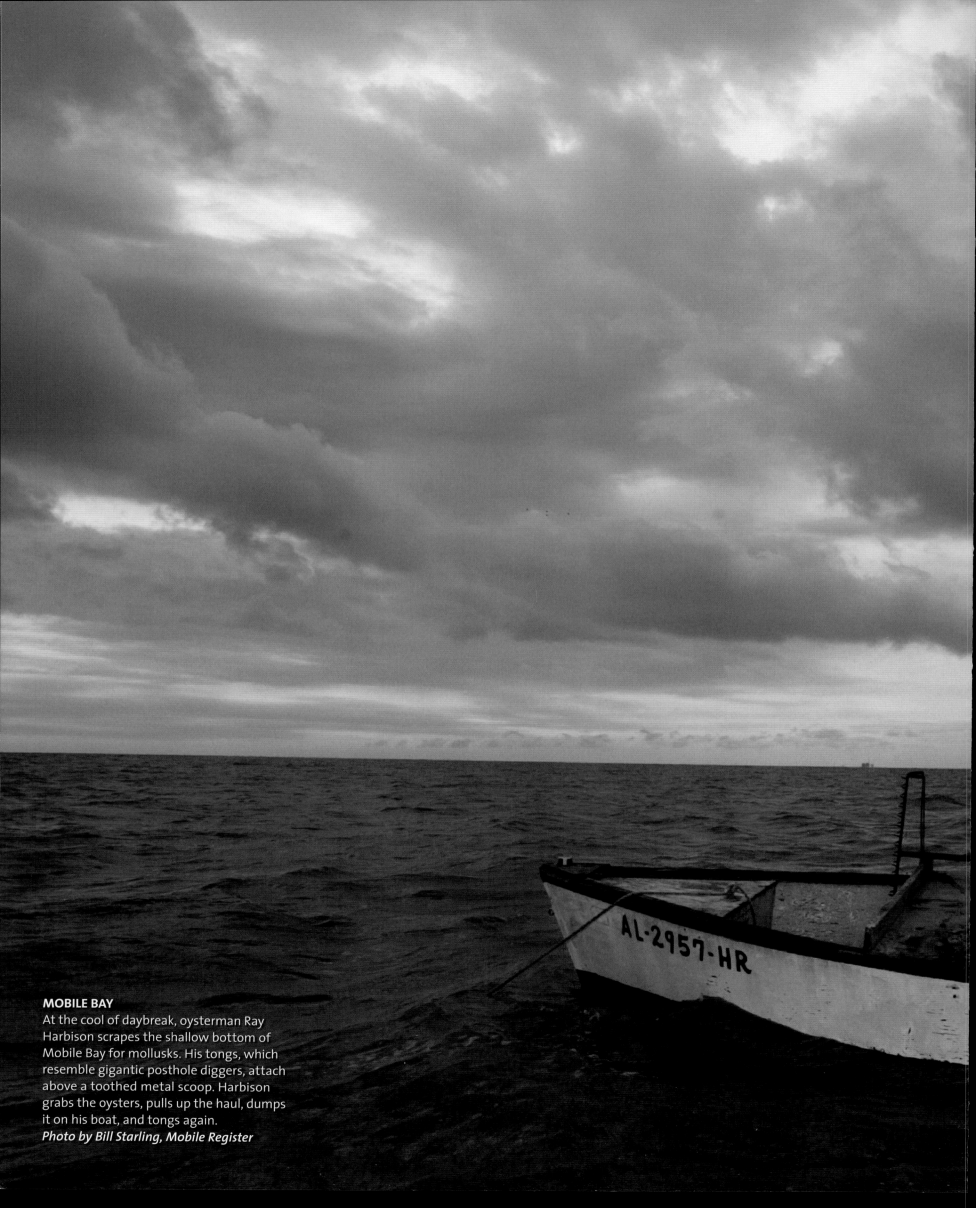

MOBILE BAY

At the cool of daybreak, oysterman Ray Harbison scrapes the shallow bottom of Mobile Bay for mollusks. His tongs, which resemble gigantic posthole diggers, attach above a toothed metal scoop. Harbison grabs the oysters, pulls up the haul, dumps it on his boat, and tongs again.

Photo by Bill Starling, Mobile Register

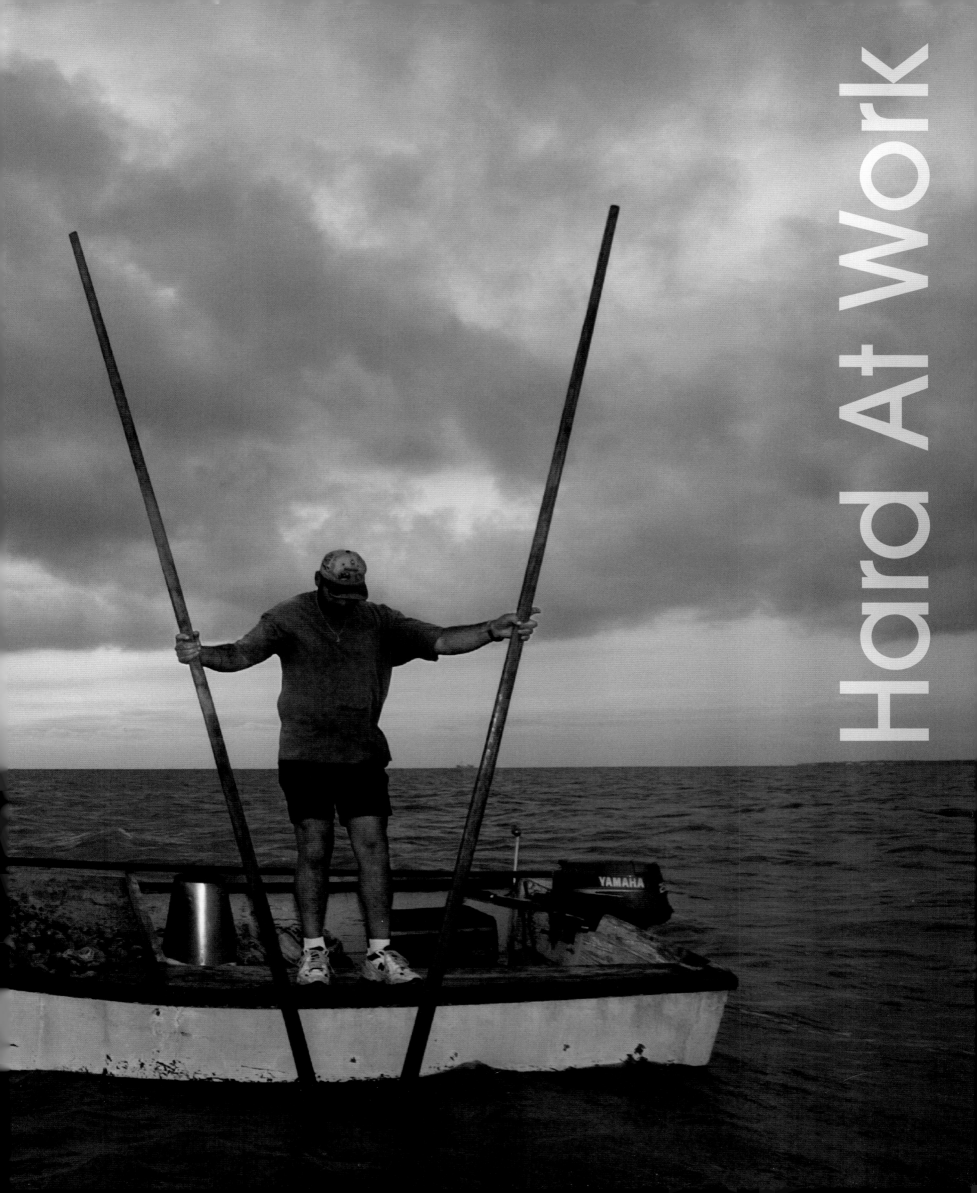

Hard At Work

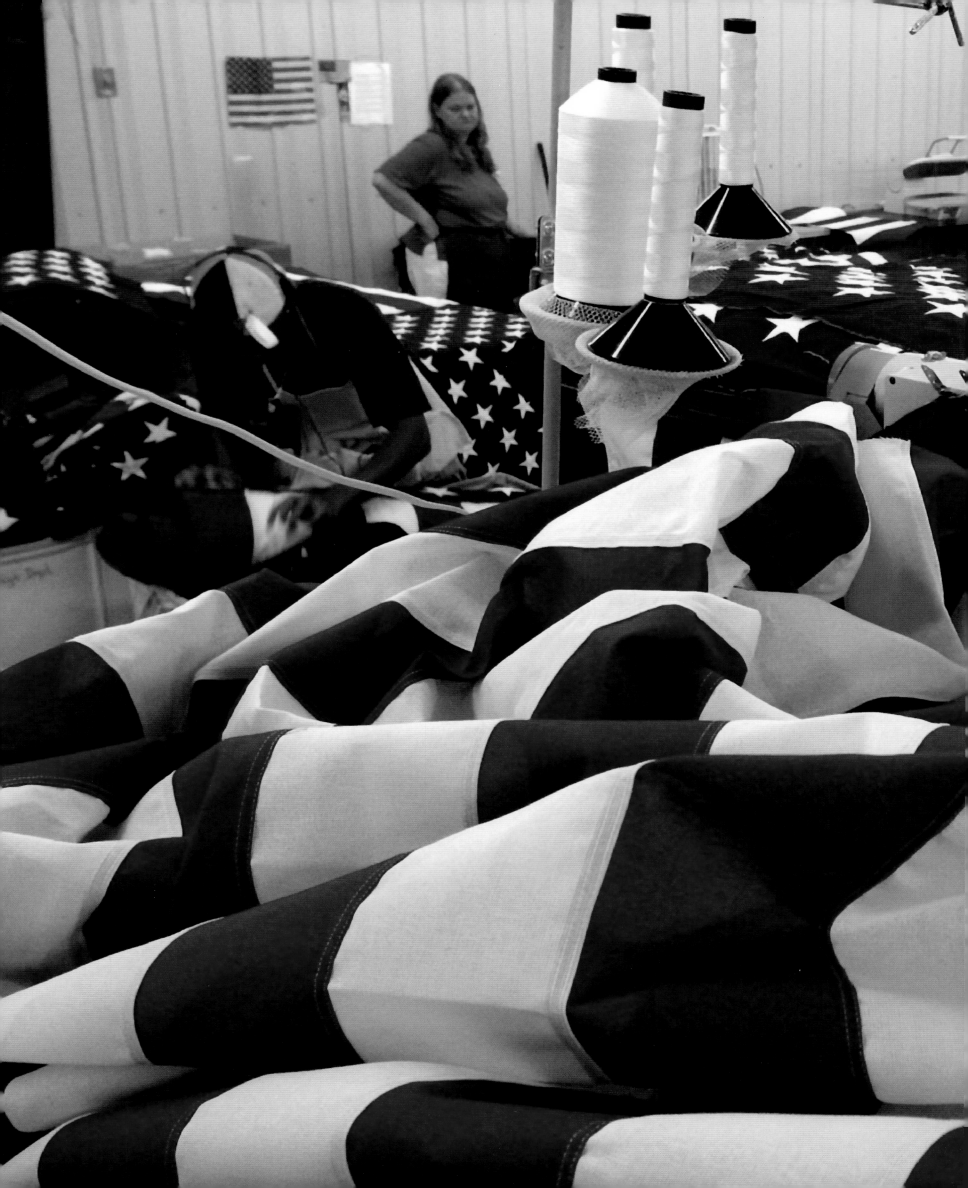

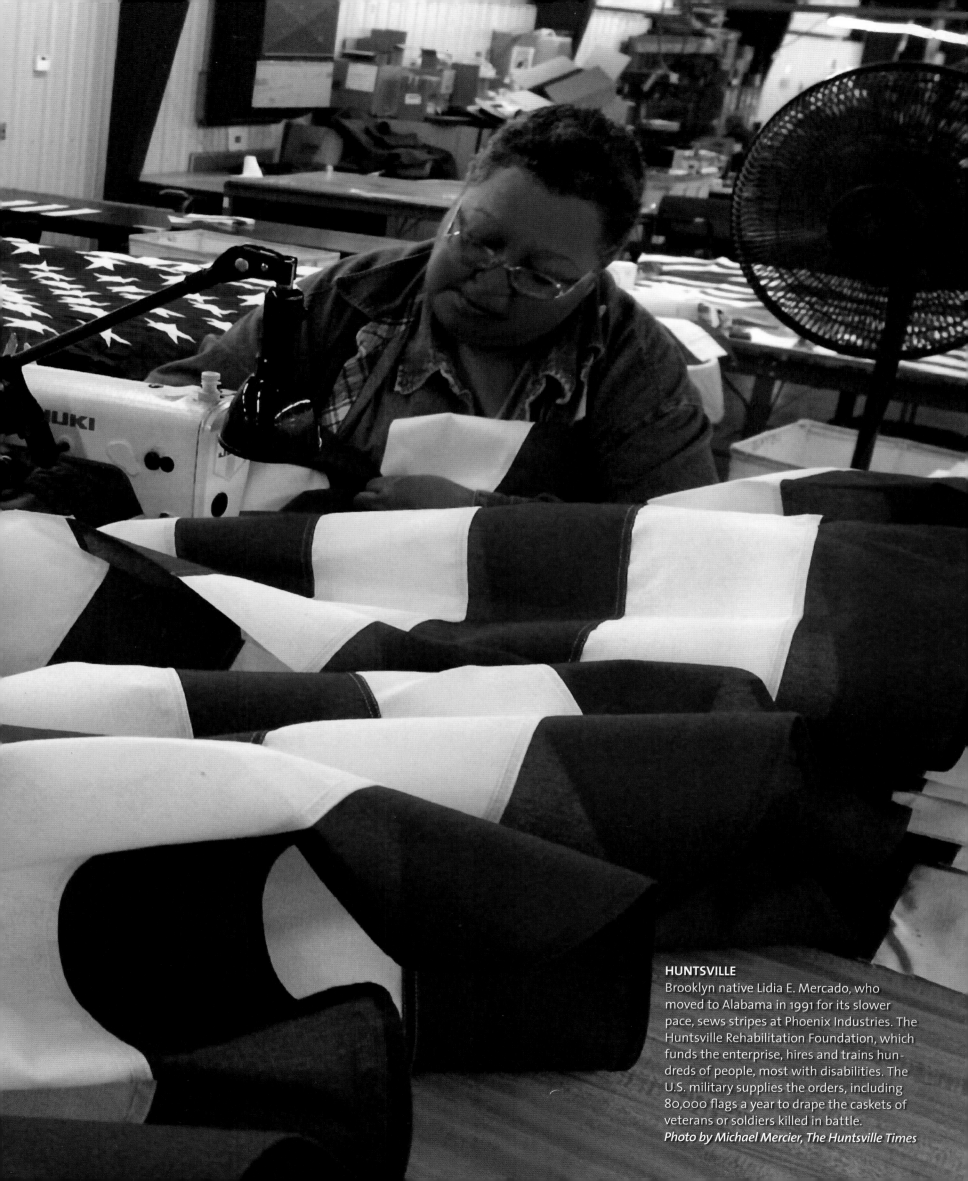

HUNTSVILLE

Brooklyn native Lidia E. Mercado, who moved to Alabama in 1991 for its slower pace, sews stripes at Phoenix Industries. The Huntsville Rehabilitation Foundation, which funds the enterprise, hires and trains hundreds of people, most with disabilities. The U.S. military supplies the orders, including 80,000 flags a year to drape the caskets of veterans or soldiers killed in battle.

Photo by Michael Mercier, The Huntsville Times

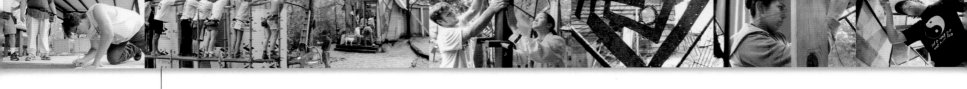

ANNISTON

Carpenters with a cause: Habitat for Humanity workers steady the wall of a home-in-progress. One dividend of the work is the opportunity to labor alongside former President Jimmy Carter. Some 2,700 volunteers pitched in to erect 36 new houses for low-income residents in the Anniston area.

Photos by Hal Yeager, The Birmingham News

ANNISTON

"To deal with individual human needs at the everyday level can be noble sometimes," former President Jimmy Carter once said. He has been walking the walk with the Habitat for Humanity program since 1984. The 78-year-old, who served as the 39th president from 1977 to 1981, hammered nails in 88-degree heat during the "blitz build" weekend.

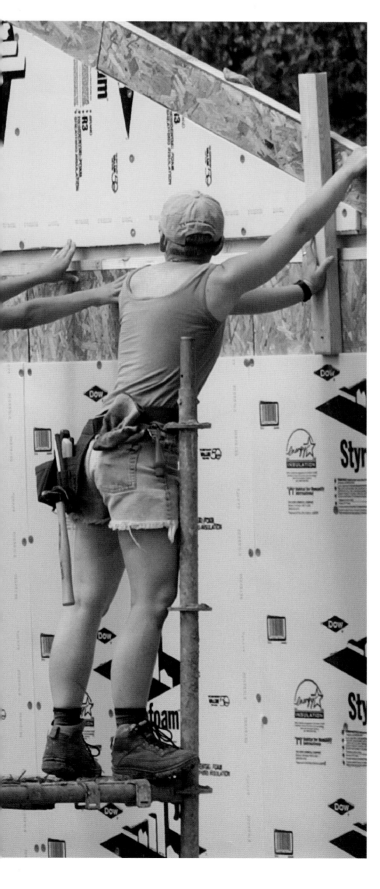

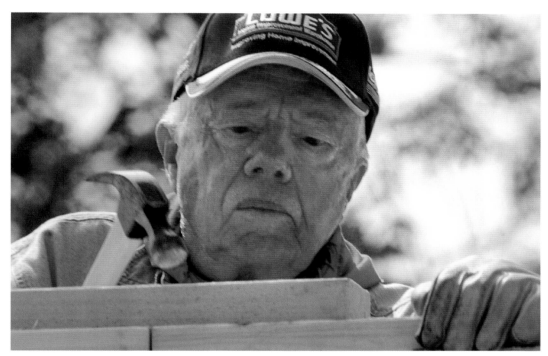

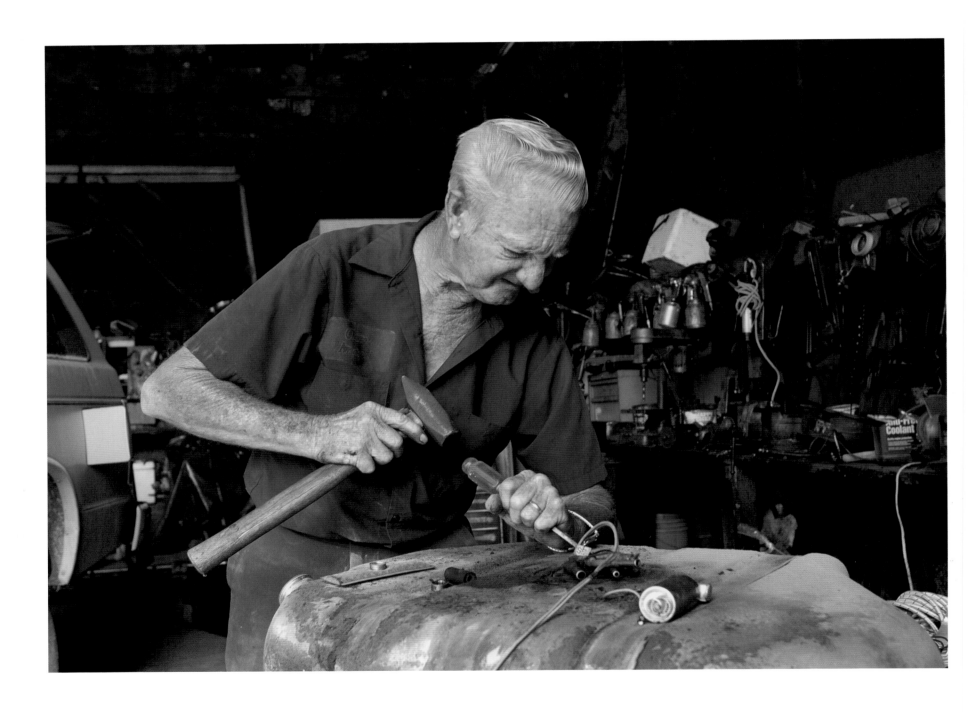

WING

A recalcitrant fuel pump gets a jab from mechanic Leo Mock. For 40 years, the semiretiree has been working on neighbors' trucks and cars at his shop—located about 10 yards from his house in Wing (pop. 300).
Photo by Richard Pearson

MONTGOMERY

An Air National Guard pilot conducts a preflight check of his F-16C. Training at the 187th fighter wing base has stepped up since the war with Iraq began in March 2003. Since then, 6,200 Alabama Army and Air National Guard personnel have been activated, and 4,500 remain on active duty.
Photo by Hal Yeager, The Birmingham News

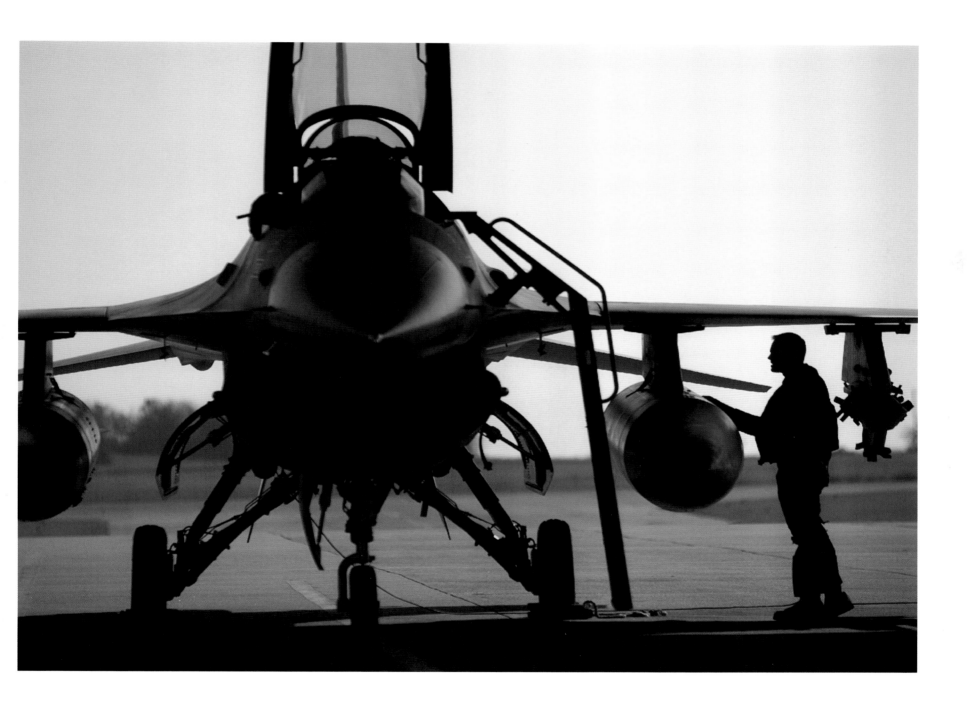

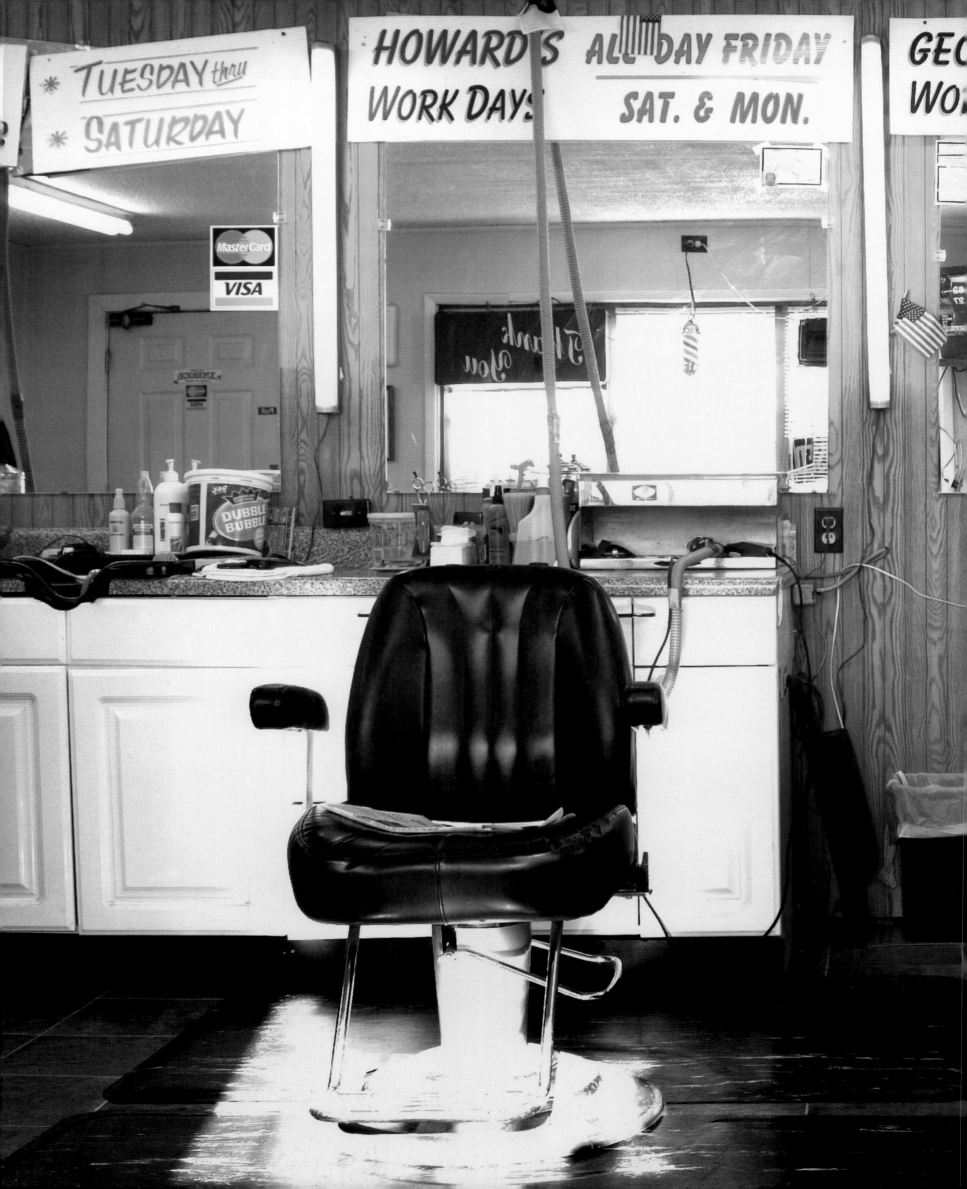

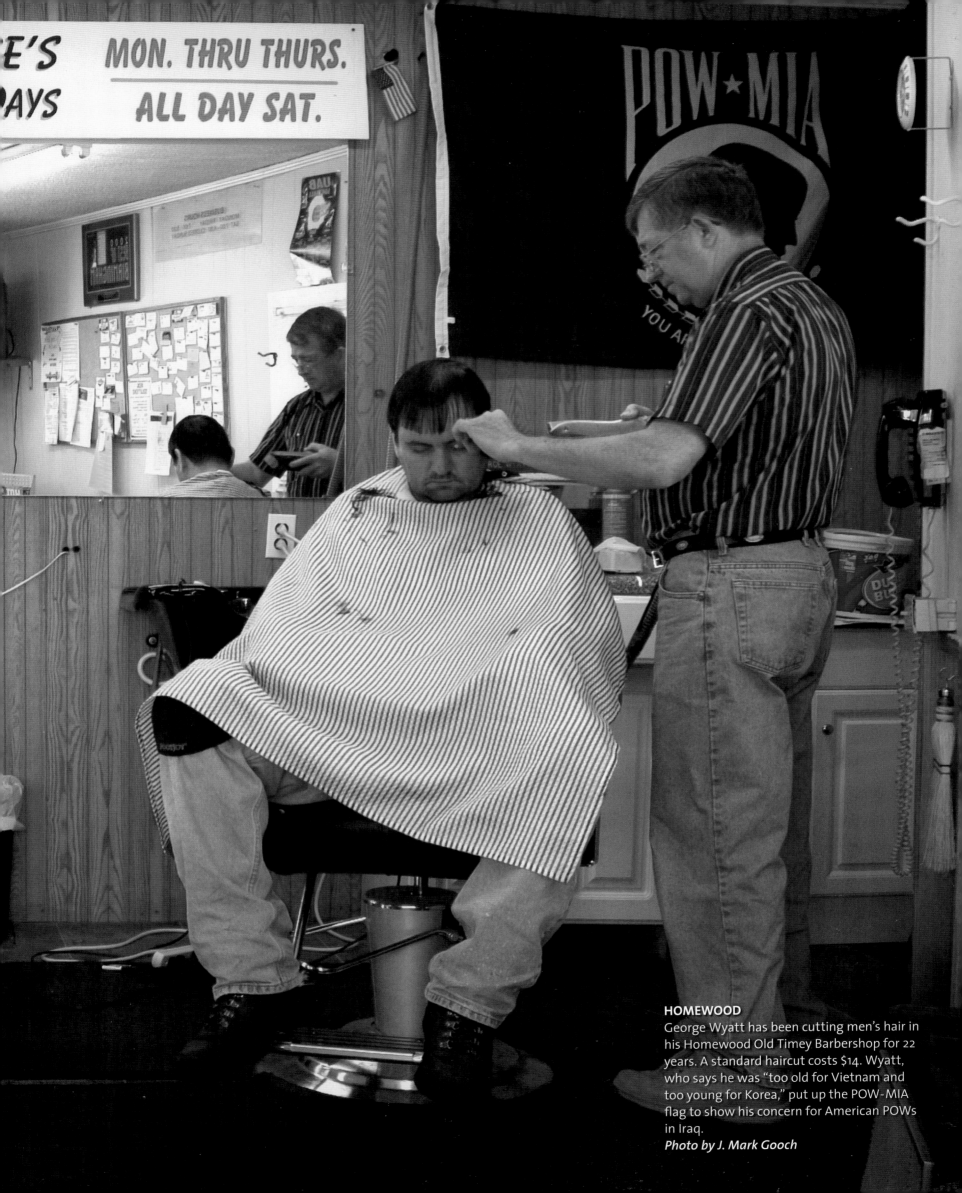

HOMEWOOD

George Wyatt has been cutting men's hair in his Homewood Old Timey Barbershop for 22 years. A standard haircut costs $14. Wyatt, who says he was "too old for Vietnam and too young for Korea," put up the POW-MIA flag to show his concern for American POWs in Iraq.

Photo by J. Mark Gooch

FORT PAYNE

Fort Payne is known as the Sock Capital of the World—and with good reason. There are more than 150 sock mills located in DeKalb County, mostly in and around Fort Payne. In a Prewett Associated Mills lab, Tina Birmingham examines a few of the 6 million pairs the consortium produces each week.

Photos by Gary Tramontina

Sock it to me: Elizabeth Ellis threads a knitting machine at Prewett Associated Mills. Spools feed yarn into the machines, which produce the socks and send them to a sorting area via vacuum tube.

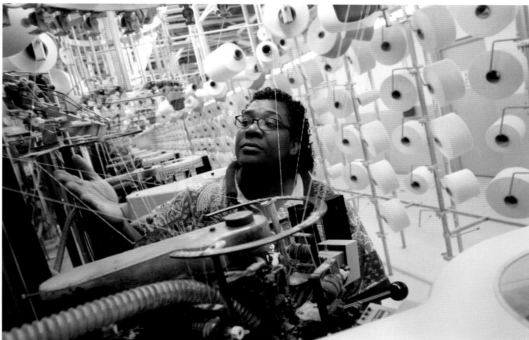

WEDOWEE
Po-Man Pride pickled quail eggs are sold at gas stations and truck stops across the country. Each day, owner Paul Ward and two employees boil and peel up to 7,000 eggs. An 8-ounce jar (13 to 15 eggs) sells for around $4.
Photo by Philip Barr, The Birmingham News

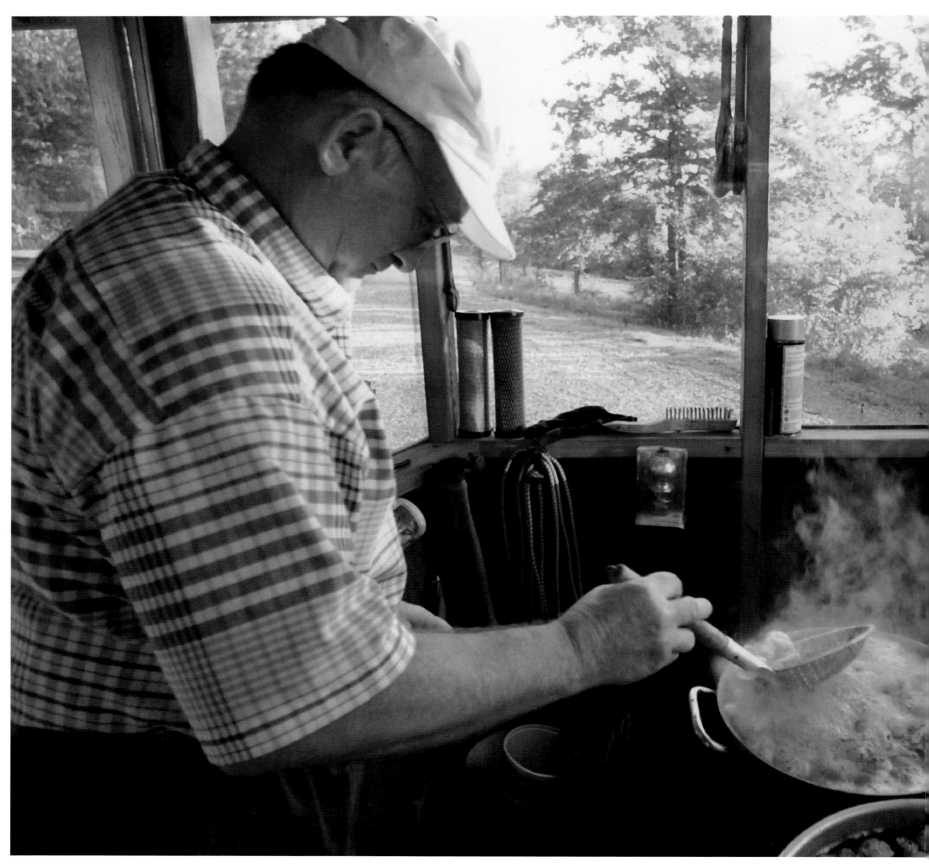

TALLADEGA

Teddy Latham empties a batch of molten iron into molds for street lamp bases at the Talladega Foundry. Iron casting can be hot, dangerous work; temperatures inside the foundry frequently reach more than 100 degrees.

Photo by Hal Yeager, The Birmingham News

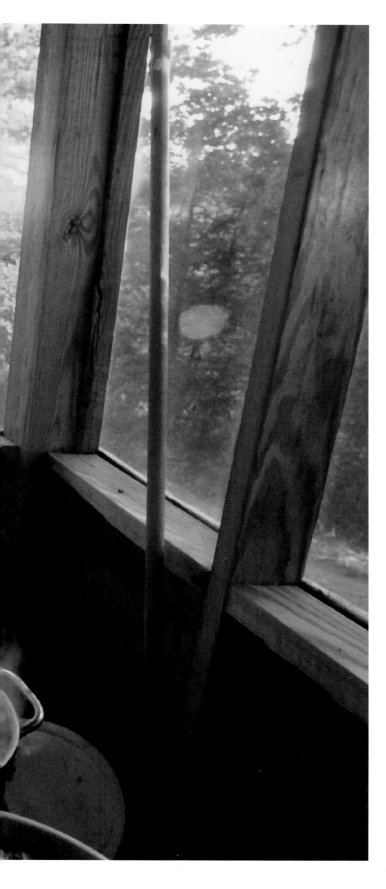

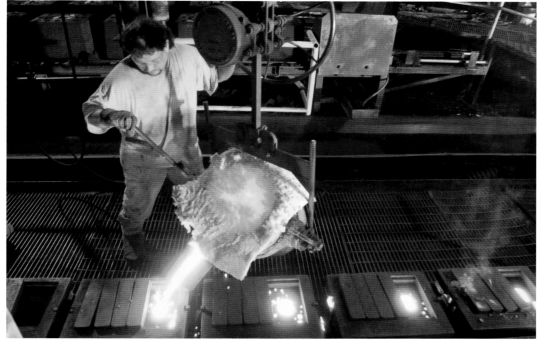

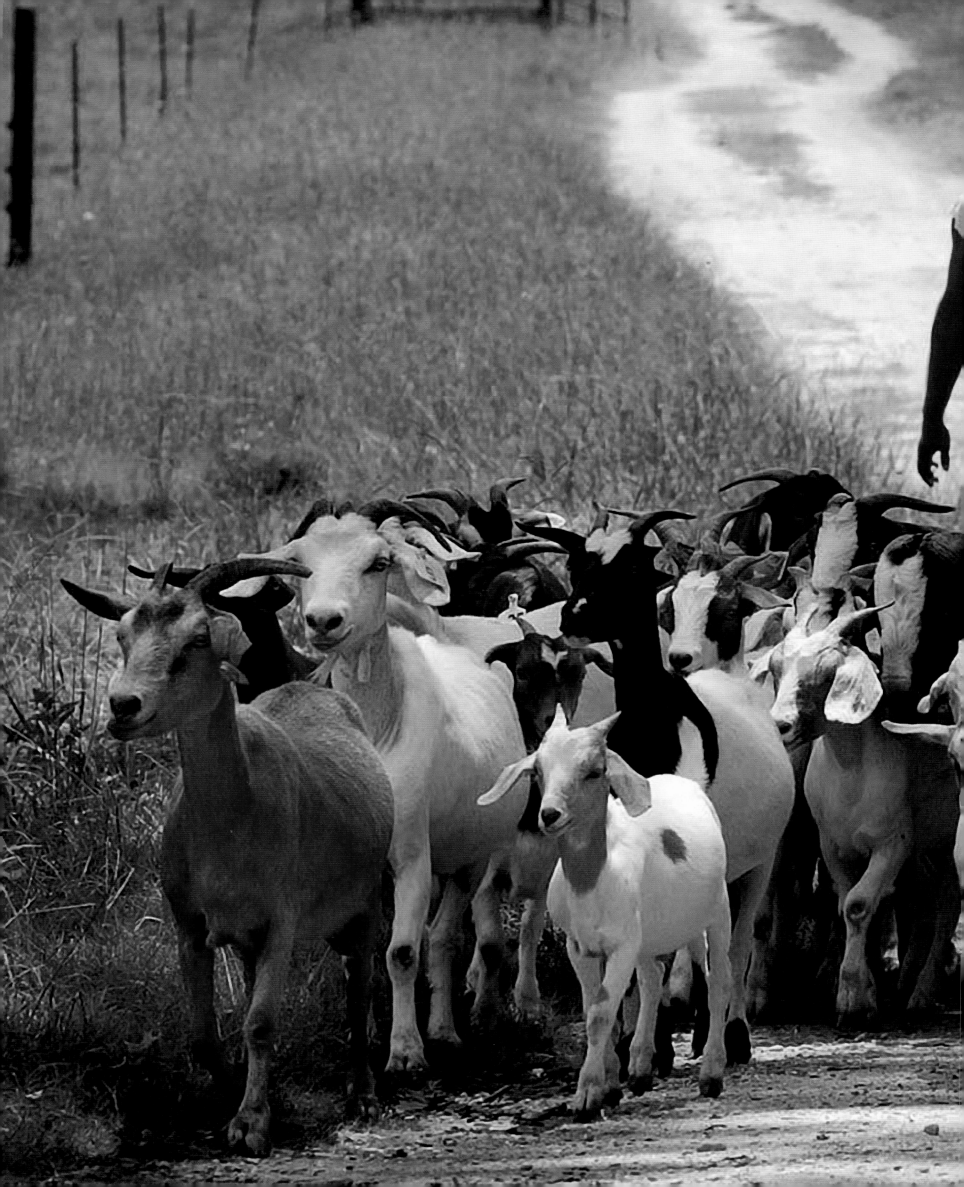

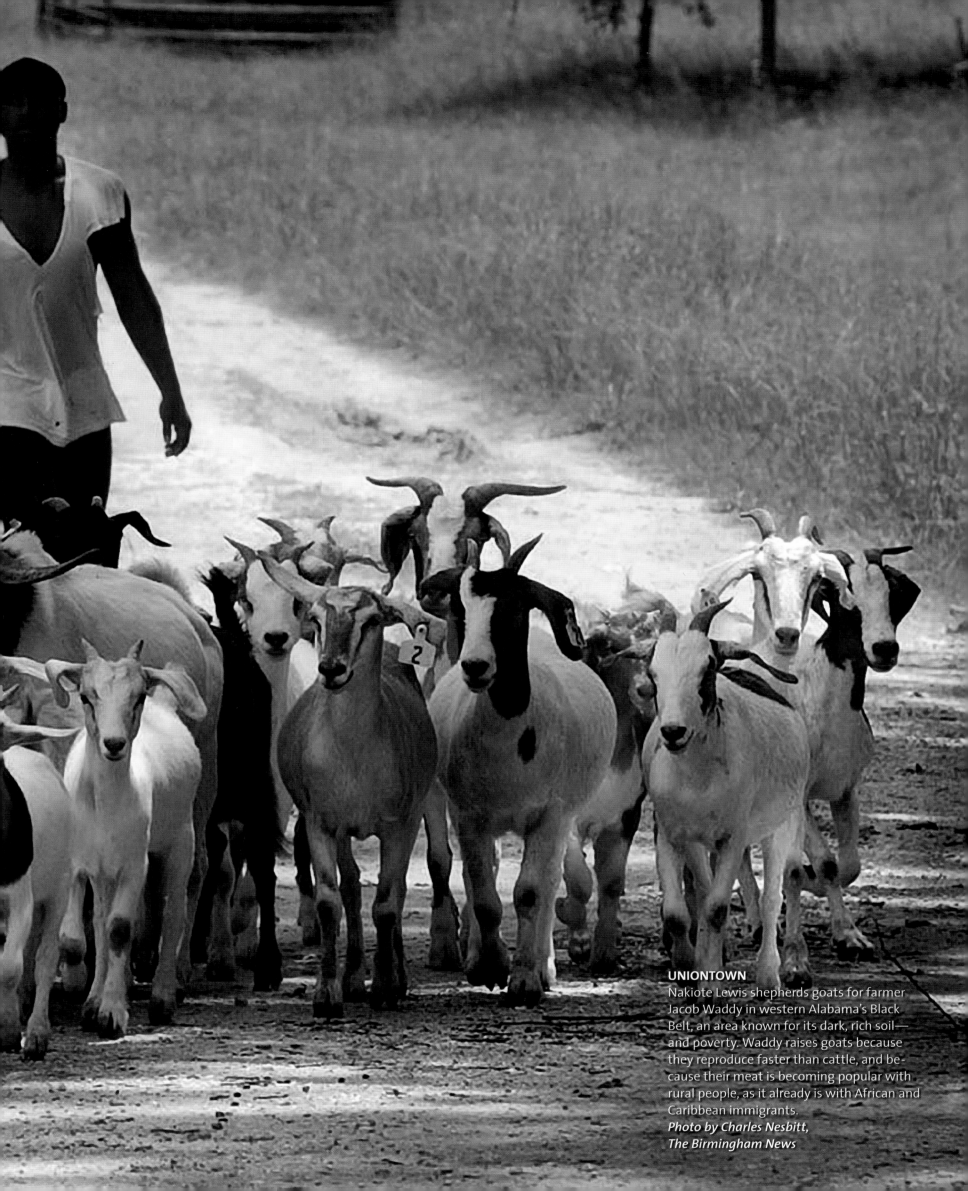

UNIONTOWN
Nakiote Lewis shepherds goats for farmer Jacob Waddy in western Alabama's Black Belt, an area known for its dark, rich soil—and poverty. Waddy raises goats because they reproduce faster than cattle, and because their meat is becoming popular with rural people, as it already is with African and Caribbean immigrants.
Photo by Charles Nesbitt,
The Birmingham News

After being tested for a skin allergy, Shea, a 6-month-old pit bull, stretches for a kiss from Dr. Tommy Johnson at the Argo Animal Clinic. "She posed for that. She just loves the camera," says Amber Leopard who bottle-fed the pup after its mother prematurely stopped nursing. "Now she thinks I'm her mother."

Photos by Joe Songer, The Birmingham News

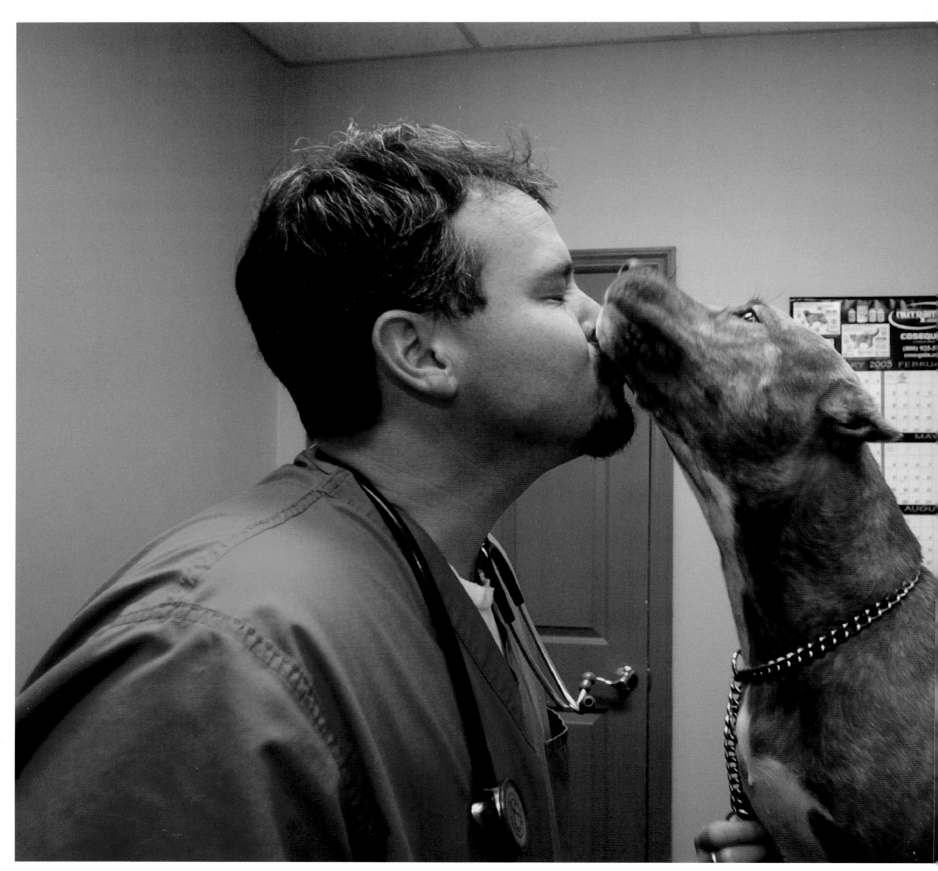

ARGO

Large and small animal veterinarian Dr. Philip Gleason performs a rectal palpitation. During his four-year tenure at the Argo Animal Clinic, founded in 1997 by his partner Dr. Tommy Johnson, Gleason has nursed back to health many creatures from goats to a goldfish with a bacterial infection.

ARGO

While Dr. Gleason washes his hands after checking 50 cows for pregnancy, Dr. Johnson examines a French limousine cow in a squeeze shoot. Johnson restrains the animals to vaccinate and deworm them.

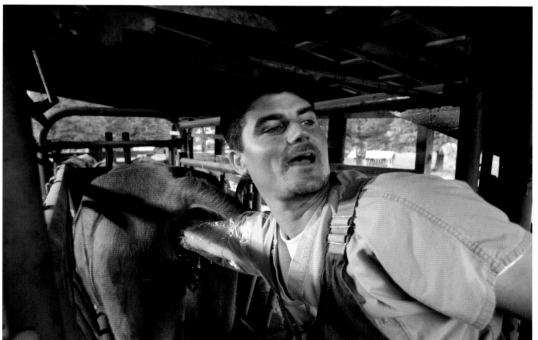

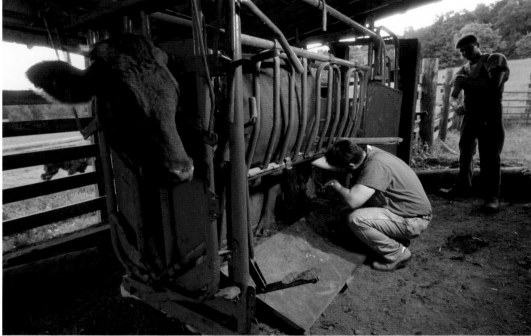

TARRANT

On Pinson Valley Parkway, David Boothe of Lamar Outdoor Advertising pastes down a United Way advertisement. Local artists Rorie Scroggins and Jonathan Riodan produced the illustrations.
Photo by Jerry Ayres, The Birmingham News

HOMEWOOD

An artist whose teaching jobs dried up in the wake of 9/11, Pat Snow reinvented his career and opened a candle shop in 2003. Daedalus Candles sells everything from $1 tea candles to $50 3-foot tapers, all handmade in Snow's finishing room.
Photo by Karim Shamsi-Basha, Portico Magazine

The calm before the curtain: Waiting to go on, actors Dan Kyle, Tomé Reinhardt, Jeremy Renta, and Norman Feguson relax backstage on opening night of *Little Mary Sunshine*. The musical spoof of turn-of-the-century operettas is a production of Birmingham's Terrific New Theatre company, founded in 1986.

Photo by Karim Shamsi-Basha, Portico Magazine

INDIAN SPRINGS
Fiddler on the computer. At Indian Springs boarding school, sophomore Ian Hayes programs the lighting sequence for a school production of *Fiddler on the Roof*.
Photo by Steve Barnette, The Birmingham News

BIRMINGHAM
During a performance of the musical *Cabaret*, Kit Kat Girl Melissa Bailey takes a break backstage at the Levite Jewish Community Center. Bailey, who also teaches dance and works as a collections administrator at the corporate offices of Papa John's Pizza, is dressed for her favorite dance number, "Two Ladies."
Photo by Karim Shamsi-Basha, Portico Magazine

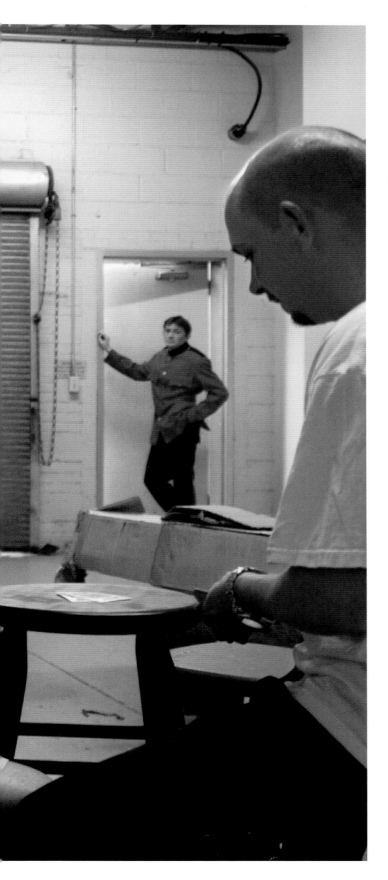

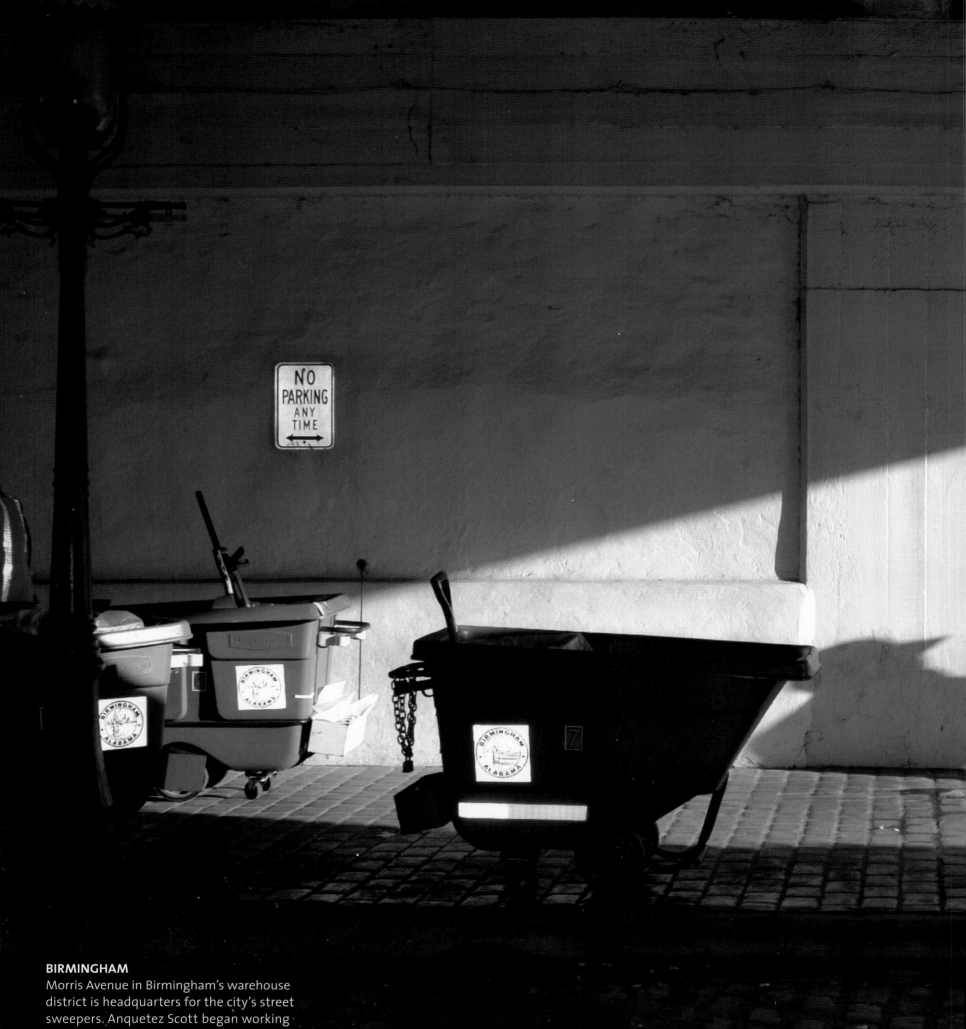

BIRMINGHAM

Morris Avenue in Birmingham's warehouse district is headquarters for the city's street sweepers. Anquetez Scott began working the 6 a.m. shift five years ago at 17, and hasn't missed a day. "For a young man, it gives me a start in life." He began the job to help support his mom and to build a resume that might one day lead to police work.
Photo by J. Mark Gooch

GADSDEN

A plot of plastic flowers awaits customers at the nation's longest yard sale. The annual event stretches 450 miles (yes, miles) from Gadsden to Covington, Kentucky. Buyers have nine days to make up their minds.

Photo by Charles Nesbitt, The Birmingham News

TALLADEGA

His Highness Hubcap Harry, aka Harvey Jack Harry, checks over his inventory—thousands of hubcaps collected from salvage yards and road-sides. The 93-year-old sells used caps from his home on Jackson Trace Road, on the outskirts of town.

Photo by Hal Yeager, The Birmingham News

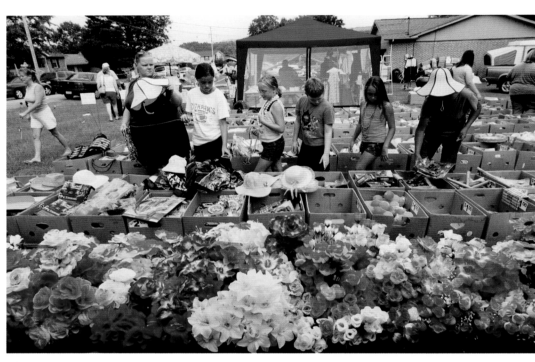

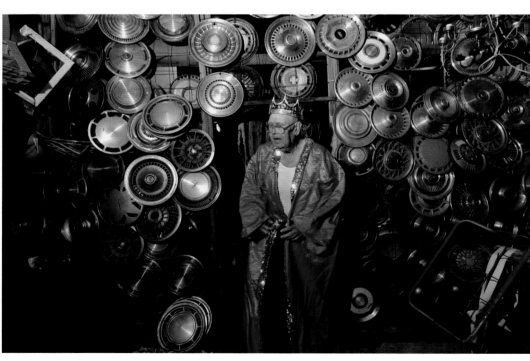

Chic Wigs manager Loraine McDonald says most of her customers need a wig because of hair loss from illness. Others in need include transsexuals and cross-dressers, so McDonald put a rainbow flag at the door to signal that they're welcome. She gladly helps, cries with, and laughs with everyone. "When they come in the door," she says, "they're family."

Photo by Steve Barnette, The Birmingham News

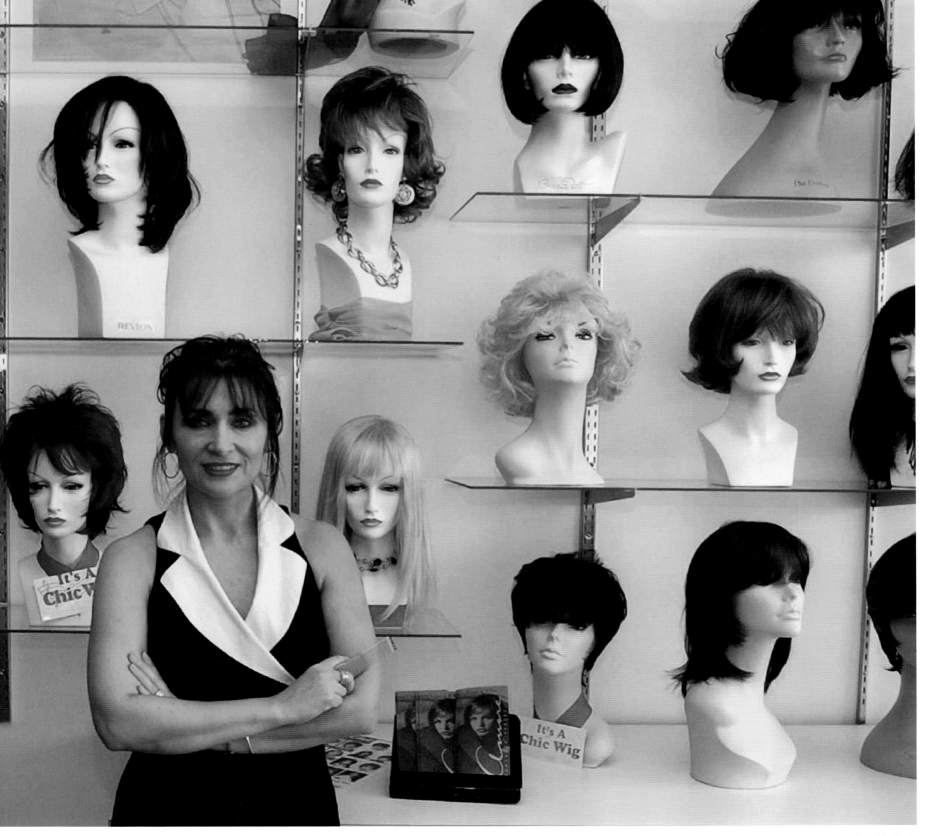

Dogs stay free: The Sheraton Birmingham now allows dogs in the rooms, if they weigh 15 pounds or less. To introduce the pet-friendly policy, the hotel held a grooming session for dogs adopted from the Birmingham Humane Society. Kristi Hancock of Nall-Daniels Animal Hospital in Homewood trims the nails of Bella, the charming companion of a Sheraton employee.
Photo by Beverly Taylor, The Birmingham News

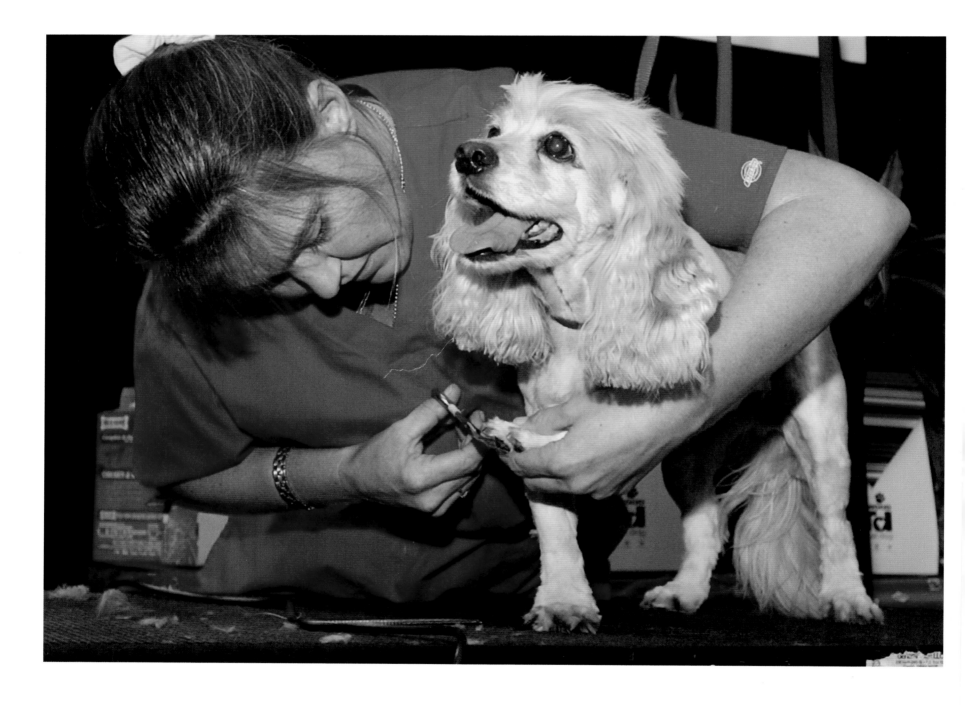

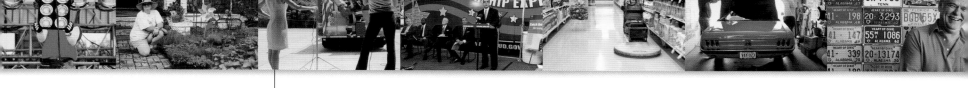

BIRMINGHAM

Firefighter Steve Hicks flexes his pecs for the 2004 Handsome Heroes calendar, a fundraising tool to benefit Kid One Transport. Started by former firefighter Russell Jackson, KOT transports needy children and expectant women to distant medical care. Since 1997, 5,000 women and children have hitched KOT rides in 27 counties.
Photo by Tamika Moore, The Birmingham News

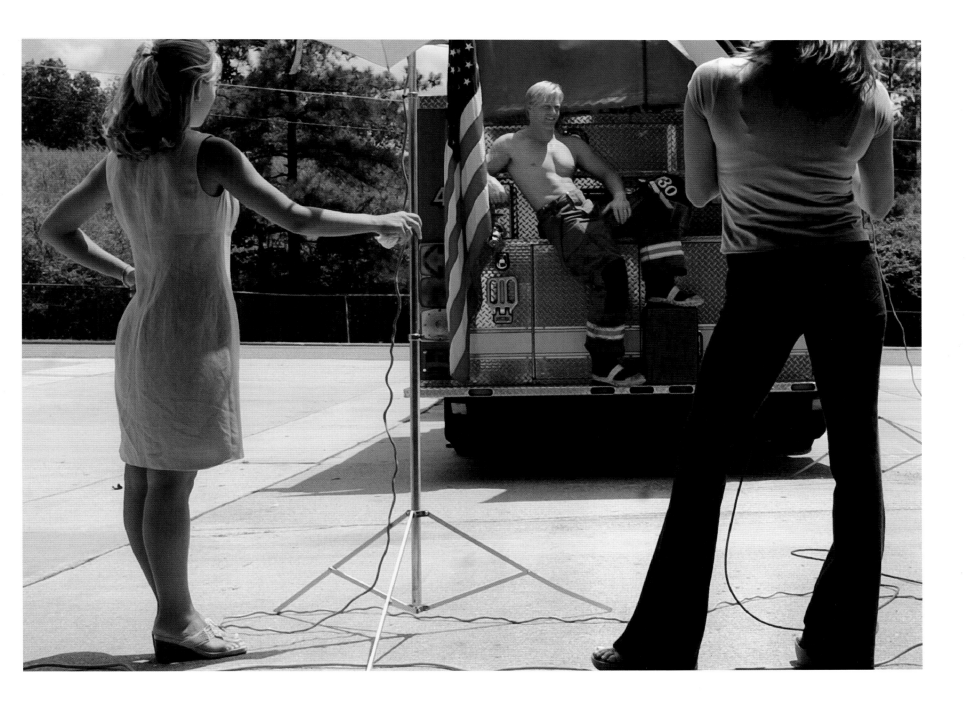

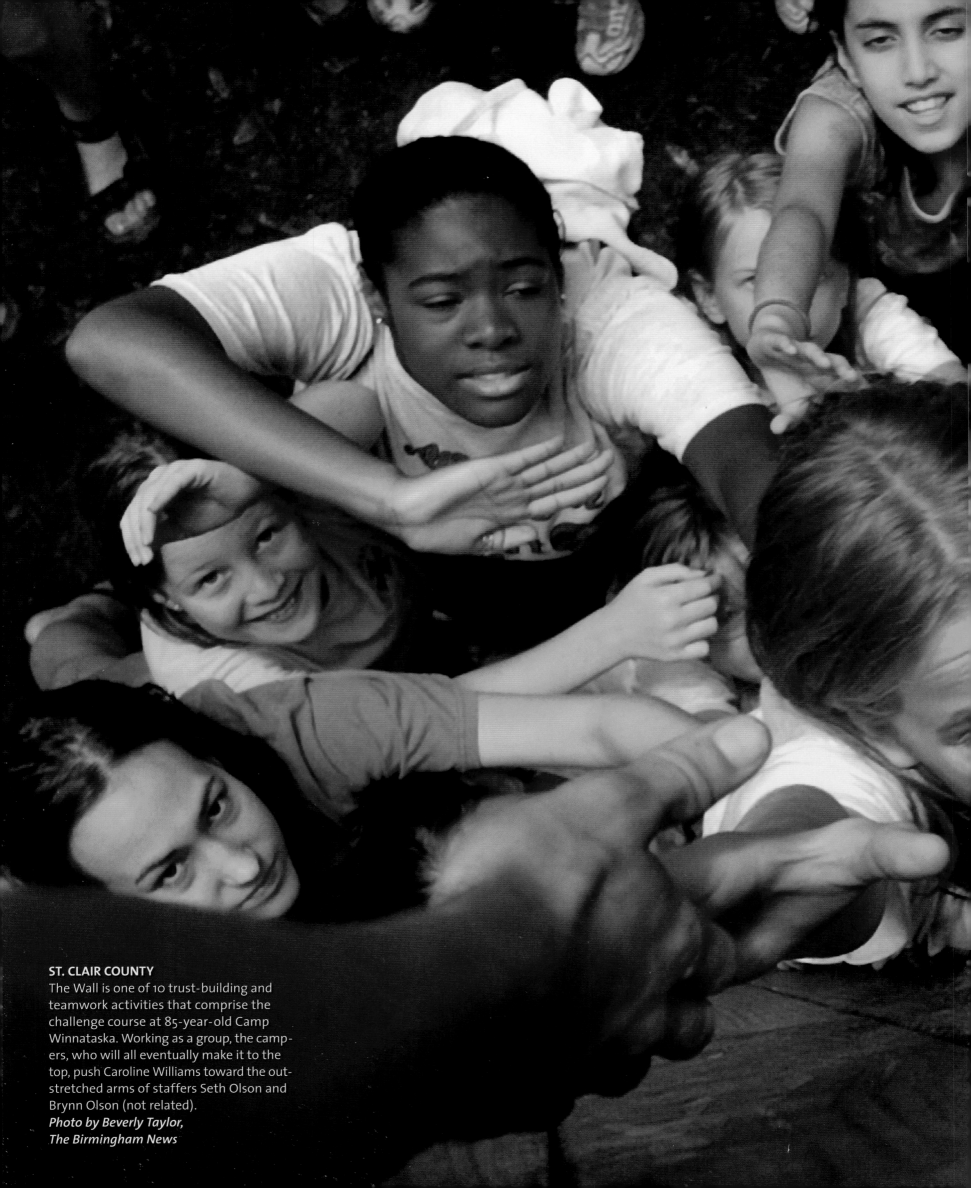

ST. CLAIR COUNTY
The Wall is one of 10 trust-building and teamwork activities that comprise the challenge course at 85-year-old Camp Winnataska. Working as a group, the campers, who will all eventually make it to the top, push Caroline Williams toward the outstretched arms of staffers Seth Olson and Brynn Olson (not related).
Photo by Beverly Taylor,
The Birmingham News

Alabama At Play

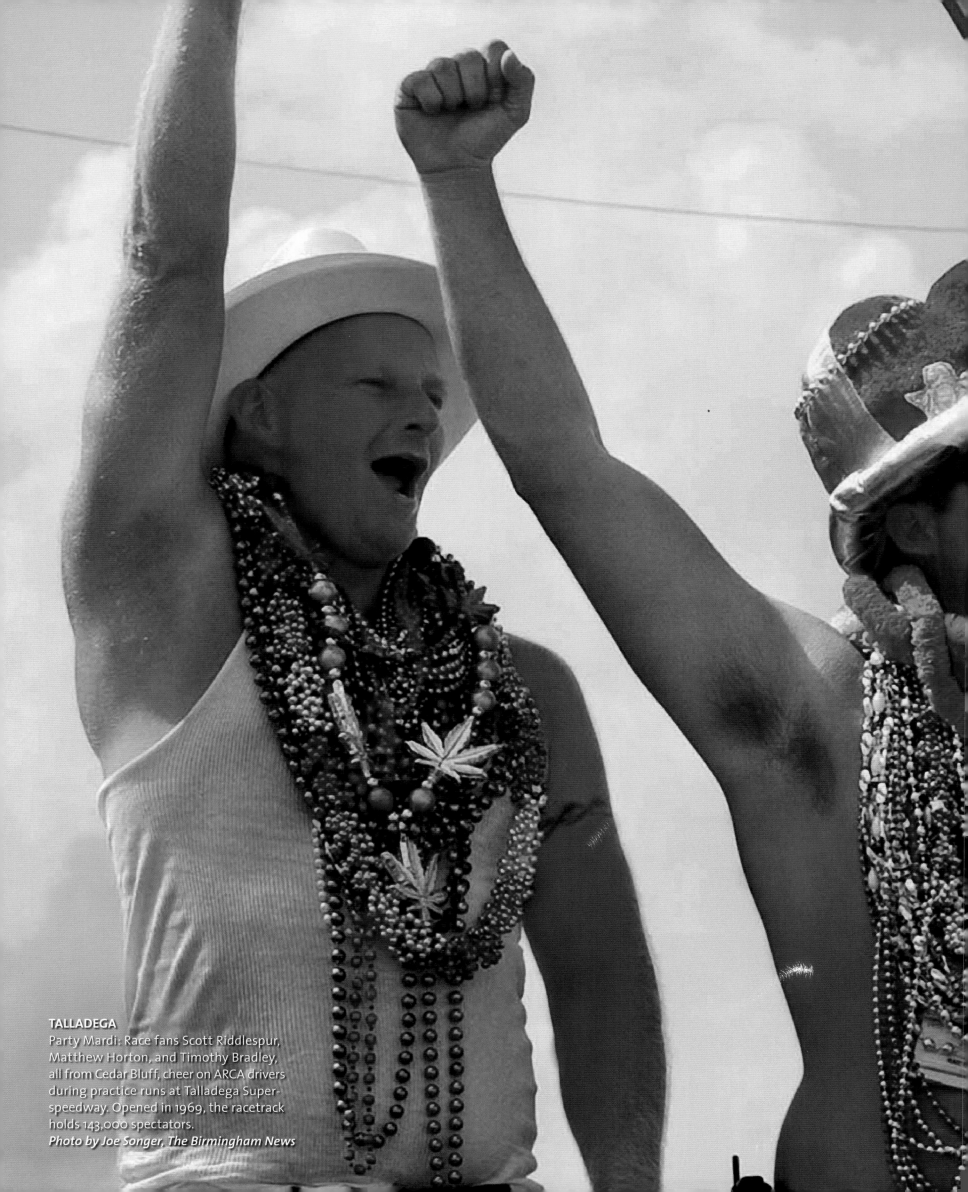

TALLADEGA
Party Mardi: Race fans Scott Riddlespur,
Matthew Horton, and Timothy Bradley,
all from Cedar Bluff, cheer on ARCA drivers
during practice runs at Talladega Super-
speedway. Opened in 1969, the racetrack
holds 143,000 spectators.
Photo by Joe Songer, The Birmingham News

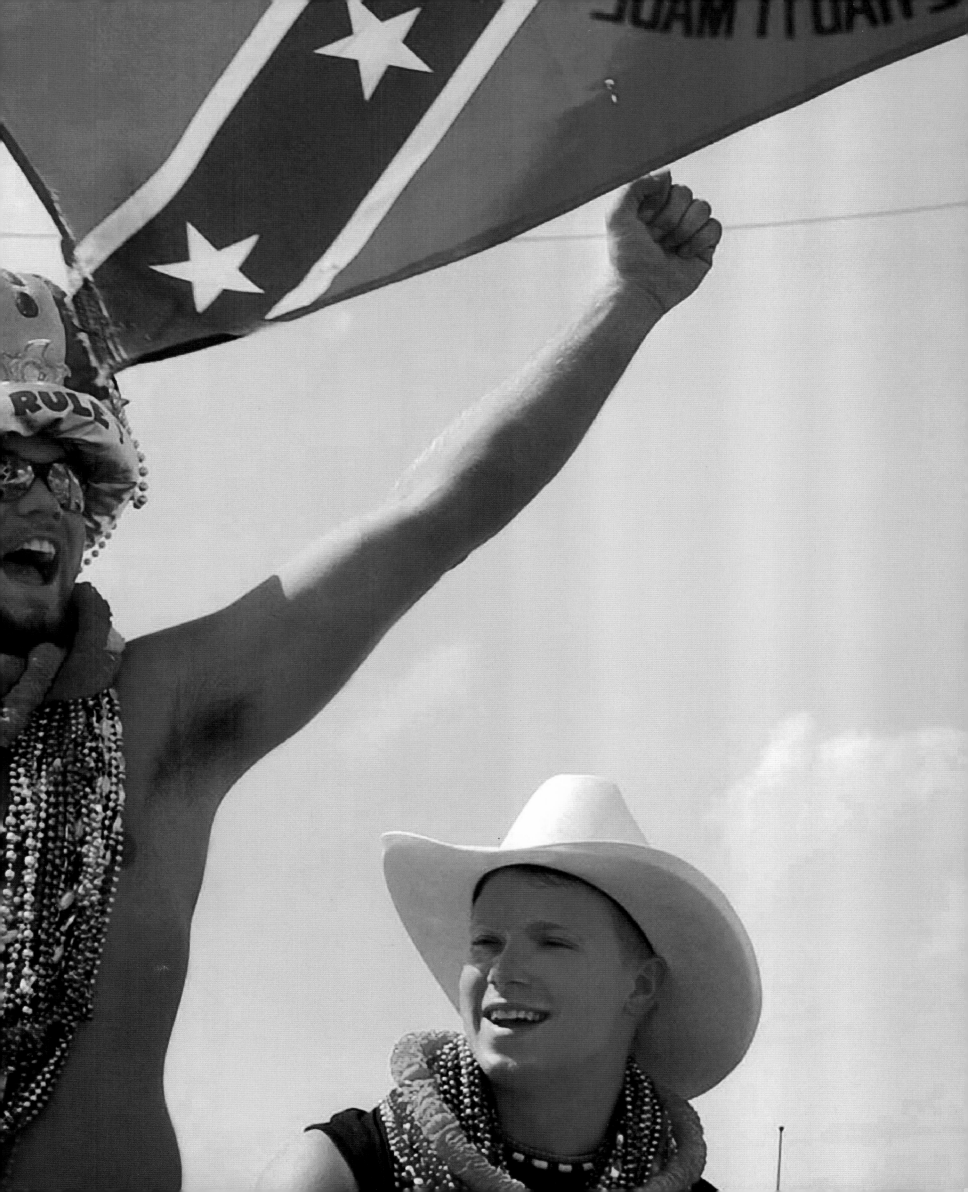

HOOVER

In a game against the Vanderbilt Commodores, Auburn Tigers' center fielder Javon Moran flips after missing a fly ball. The Southeastern Conference baseball tournament was held at Auburn's Hoover Metropolitan Stadium.

Photos by Mark Almond, The Birmingham News

HELENA

"I just wanted to throw Frisbees to the dogs to meet girls," says David DeMent, "then I found out I had this Michael Jordan dog." Flyin' Nash, a Texas Heeler, caught his first Frisbee when he was just 7 months old.

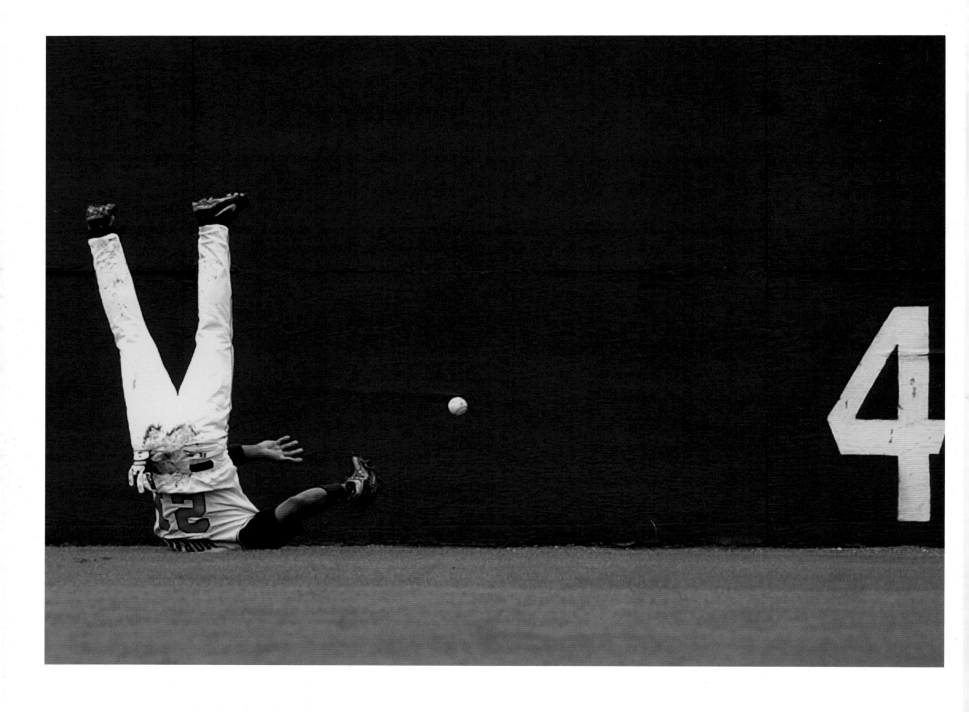

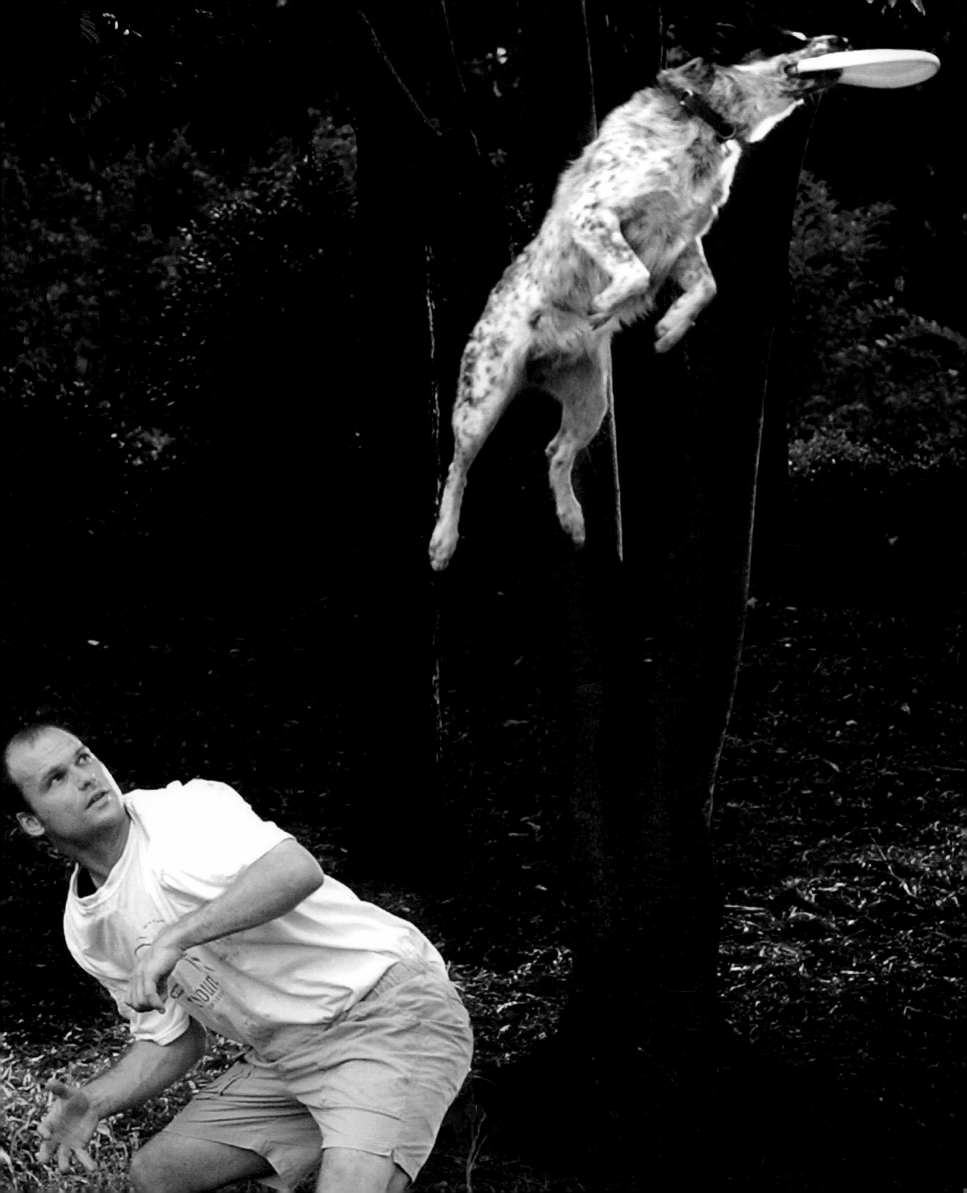

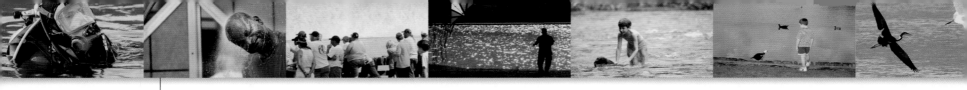

BIRMINGHAM

In exchange for the kids reading a set number of books, teachers at EPIC (Educational Programs for Individual Children) agreed to wrestle in a wading pool filled with chocolate pudding. Talk about incentive! After holding up his end of the bargain, PE aide Greg Dawson gets a rinse.
Photo by Charles Nesbitt, The Birmingham News

BESSEMER

On the brink: Twelve-year-old Kaela Brinkman composes herself before plummeting down a nine-story water slide. It's the latest attraction at Visionland, which calls itself "Alabama's First Theme Park."

Photo by Steve Barnette, The Birmingham News

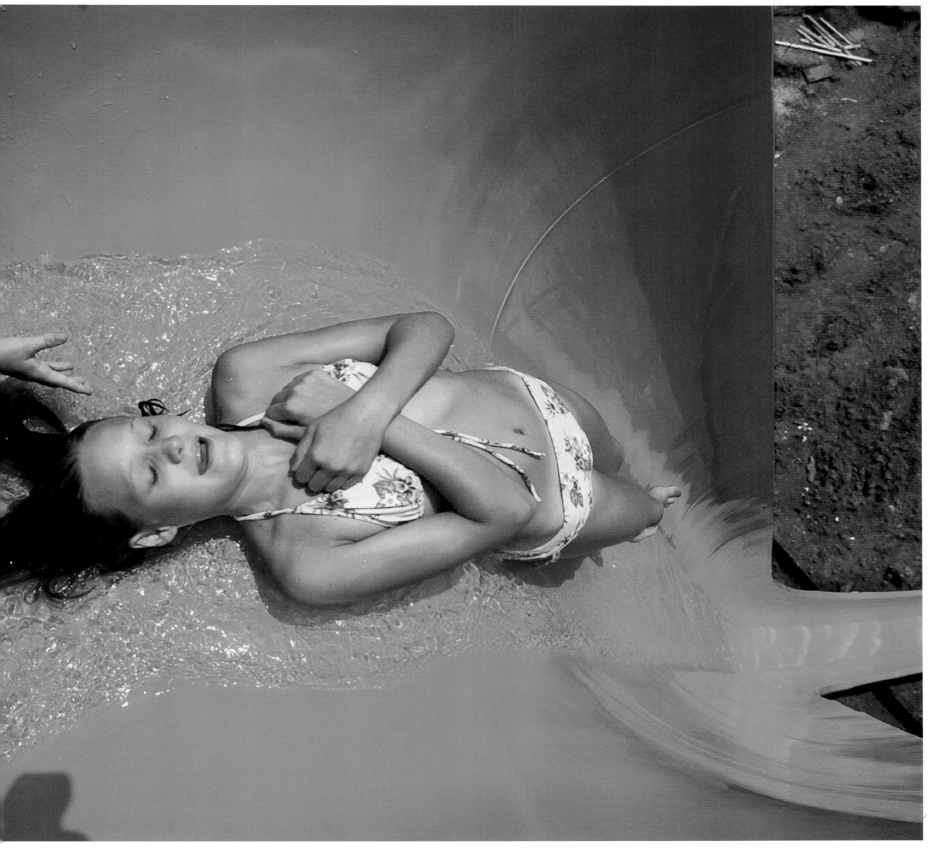

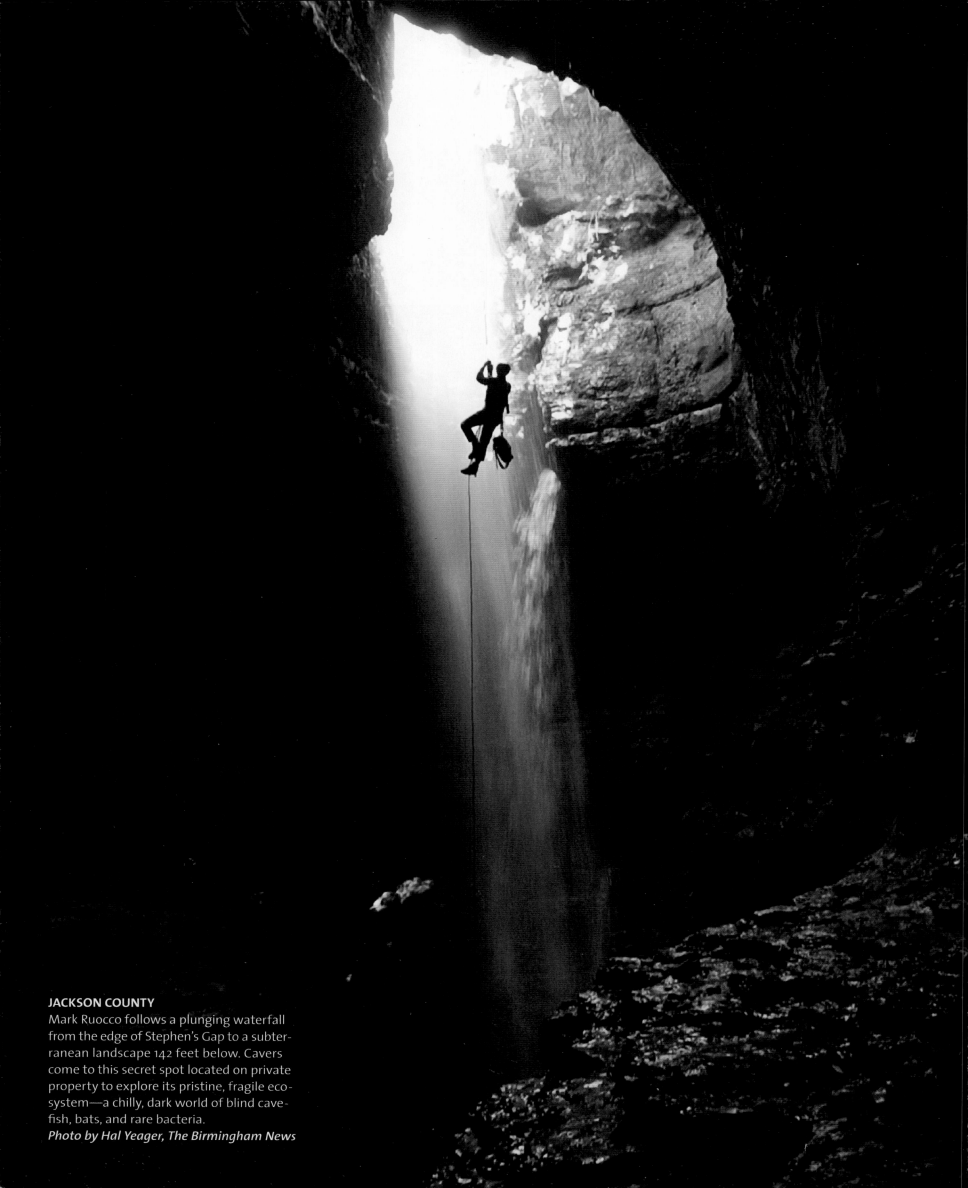

JACKSON COUNTY

Mark Ruocco follows a plunging waterfall from the edge of Stephen's Gap to a subterranean landscape 142 feet below. Cavers come to this secret spot located on private property to explore its pristine, fragile ecosystem—a chilly, dark world of blind cavefish, bats, and rare bacteria.

Photo by Hal Yeager, The Birmingham News

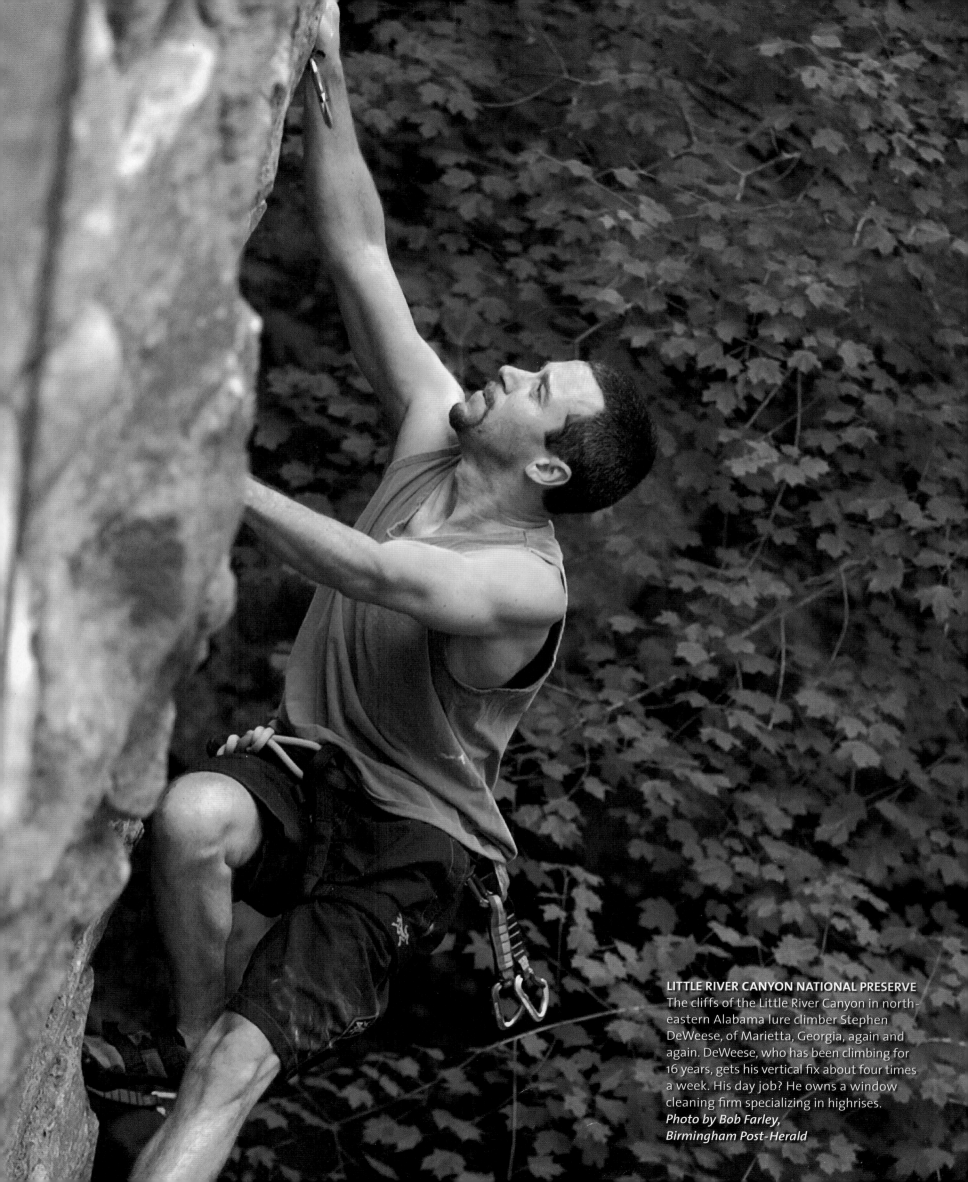

LITTLE RIVER CANYON NATIONAL PRESERVE
The cliffs of the Little River Canyon in north-eastern Alabama lure climber Stephen DeWeese, of Marietta, Georgia, again and again. DeWeese, who has been climbing for 16 years, gets his vertical fix about four times a week. His day job? He owns a window cleaning firm specializing in highrises.
Photo by Bob Farley,
Birmingham Post-Herald

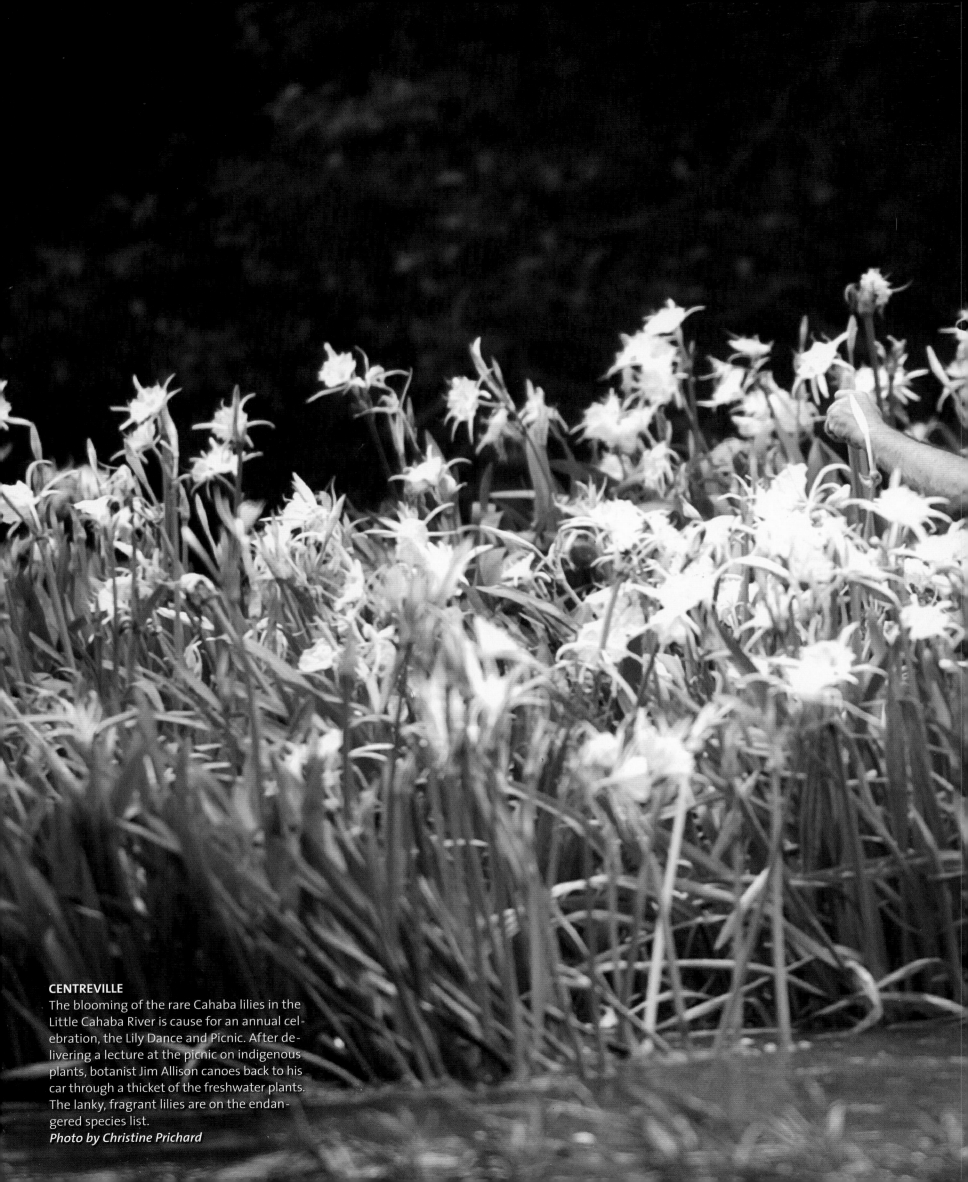

CENTREVILLE
The blooming of the rare Cahaba lilies in the Little Cahaba River is cause for an annual celebration, the Lily Dance and Picnic. After delivering a lecture at the picnic on indigenous plants, botanist Jim Allison canoes back to his car through a thicket of the freshwater plants. The lanky, fragrant lilies are on the endangered species list.
Photo by Christine Prichard

ST. CLAIR SPRINGS

White's Mountain Bluegrass Park keeps traditional music and buck dancing alive and kicking. Tommy and Sybil White host two festivals a year on their 40 acres. Replete with foot-stomping music, old-fashioned dancing, and homemade food, the Whites' down-home fests draw folks from all over the country.
Photo by Joe Songer,
The Birmingham News

BIRMINGHAM

In 1991, at the age of 31, guitarist Eric Essix was the youngest inductee into the Alabama Jazz Hall of Fame. A decade later, he's returned to the blues and gospel he learned in church choir. "Everything I did always had that bluesy, rock feel to it," he says. "Now, instead of just hinting at it, it's right in your face."
Photo by Tamika Moore,
The Birmingham News

ST. CLAIR SPRINGS

Musicians jam at White's Mountain Bluegrass Park, northeast of Birmingham. "It's a great place to get away from the world we live in today," says guitar player Alex Thompson (right front), a regular at the bluegrass socials for the past three years.
Photo by Joe Songer,
The Birmingham News

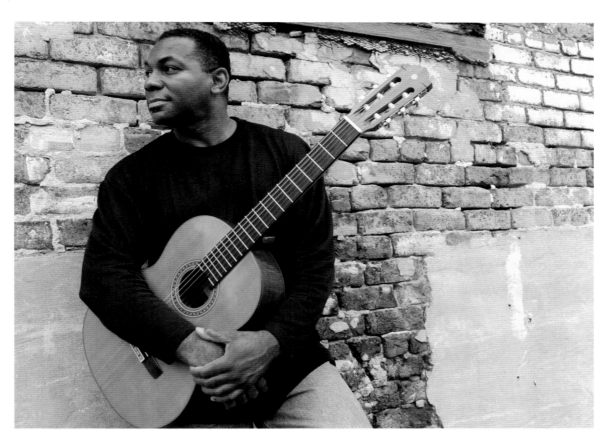

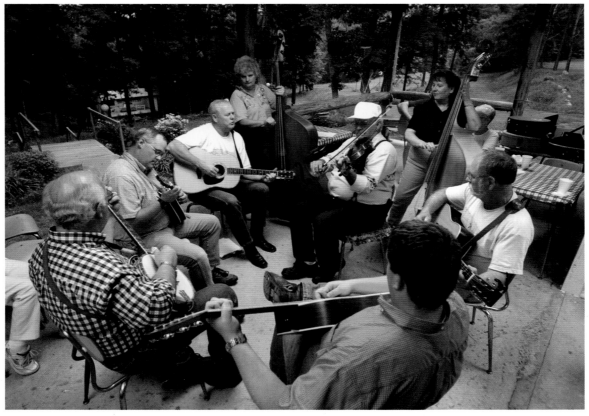

What is a softball team suited-up for the state high school championship supposed to do when it rains? Go to Express at Eastdale Mall, perhaps? Some of the Auburn High team took to the racks, but Tanna Fontes, Ashley Pruitt, and Katie Martin sit the inning out.
Photo by E. Vasha Hunt

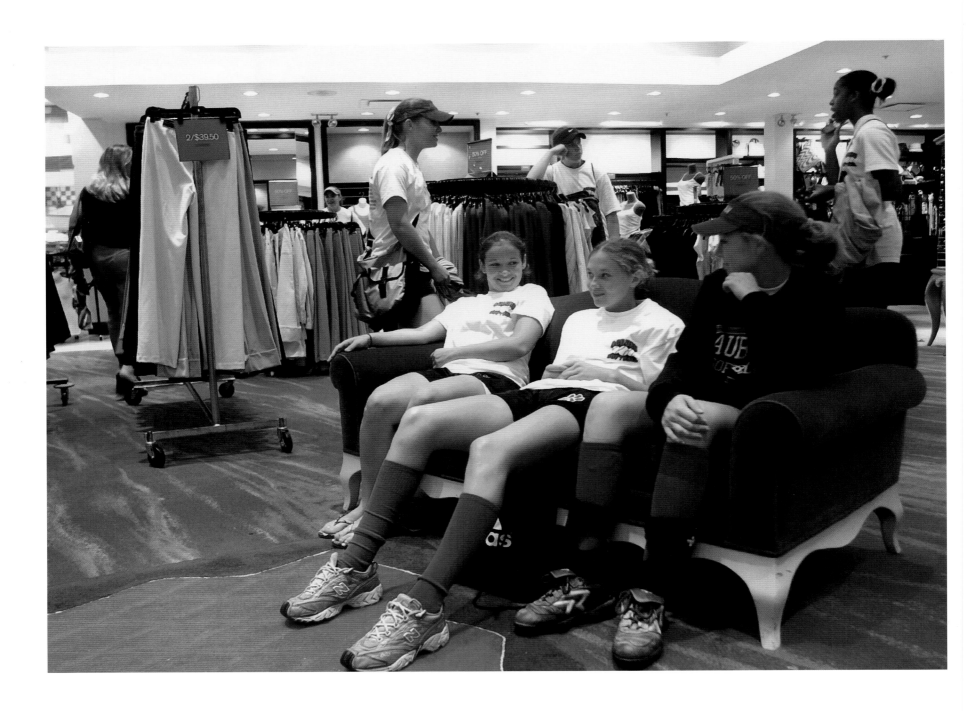

BIRMINGHAM
Kids from Wenonah Elementary School strain
in a tug-of-war at Camp Birmingham. Held at
Woodlawn High School, the six-week summer
program is run by Birmingham City Schools.
Photo by Philip Barr, The Birmingham News

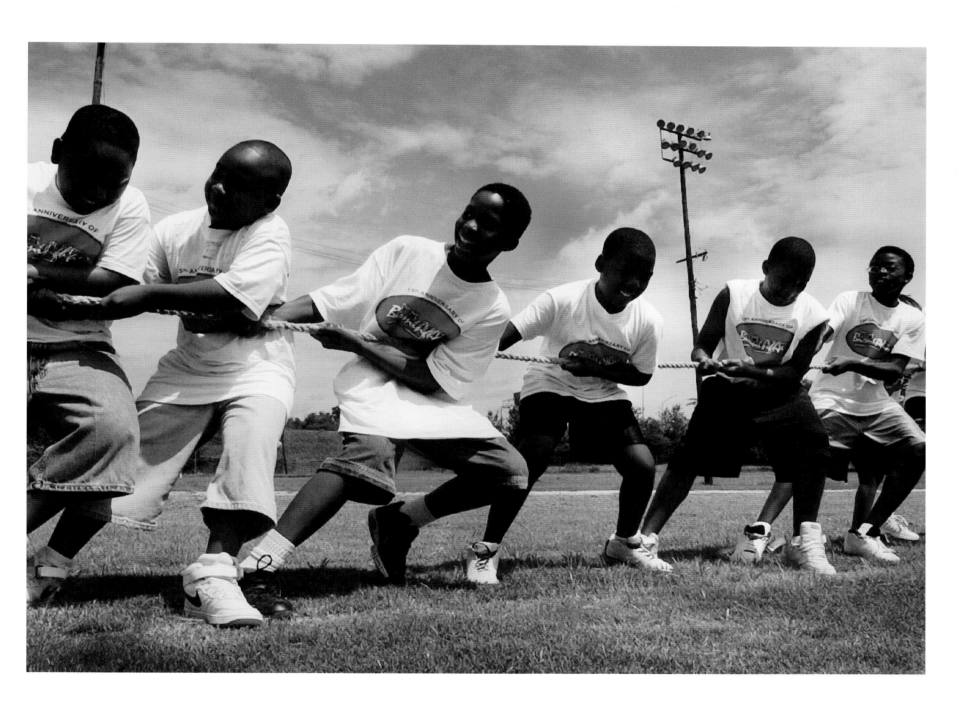

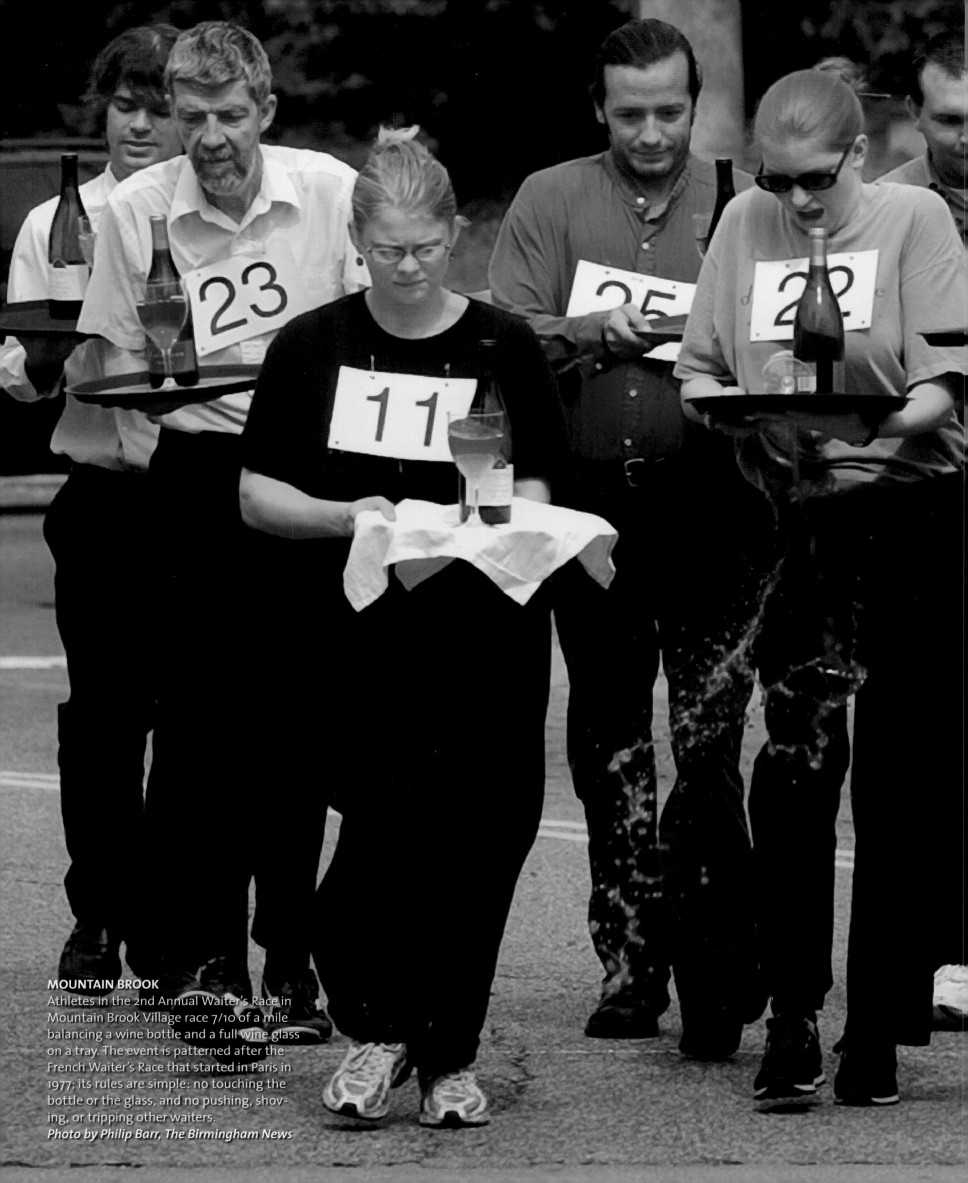

MOUNTAIN BROOK
Athletes in the 2nd Annual Waiter's Race in
Mountain Brook Village race 7/10 of a mile
balancing a wine bottle and a full wine glass
on a tray. The event is patterned after the
French Waiter's Race that started in Paris in
1977; its rules are simple: no touching the
bottle or the glass, and no pushing, shov-
ing, or tripping other waiters.
Photo by Philip Barr, The Birmingham News

BIRMINGHAM
George Barber, Jr., waves the green flag to begin the Barber 250, the first race at the new, $54 million Barber Motorsports Park. Opening the racetrack—and an adjacent vintage motorsport museum—was the fulfillment of a lifelong dream for Barber.
Photo by Joe Songer, The Birmingham News

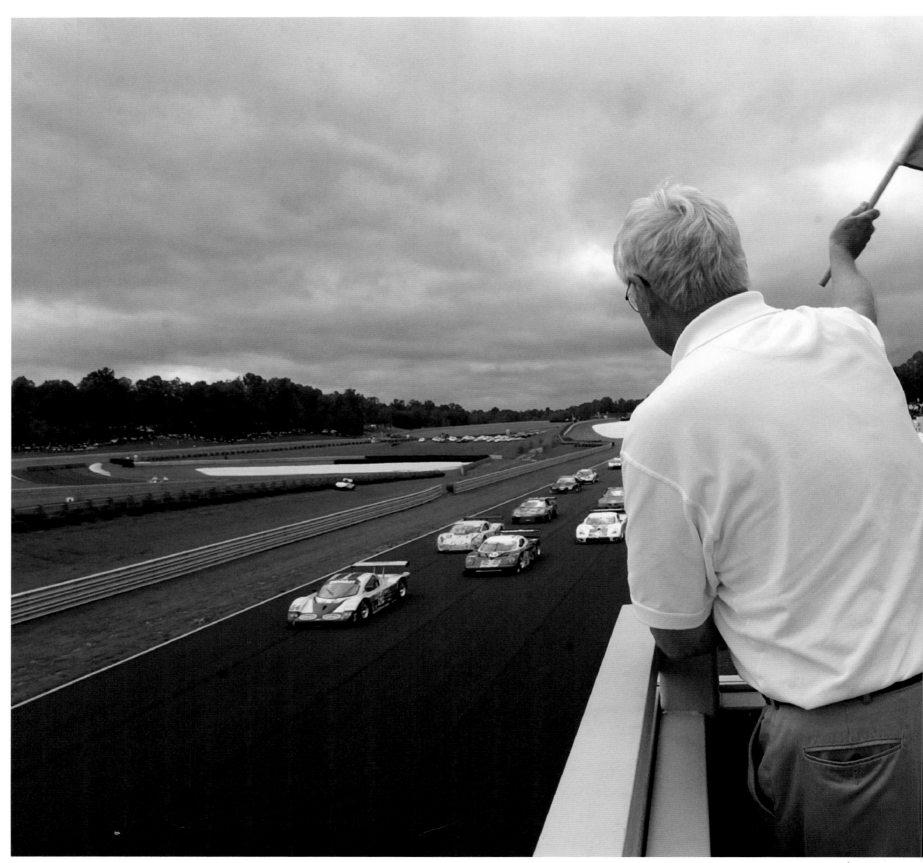

TALLADEGA

Members of Jeff Green's pit crew go tumbling after his car got spun during the NASCAR EA Sports 500 at the Talladega Superspeedway.
Photo by Mark Almond, The Birmingham News

BIRMINGHAM

Driver Sylvain Tremblay pulls off his fire retardant headgear after winning the Barber Twin 200 Grand-Am Series race on opening weekend at Barber Motorsports Park. It's the first time that the Rolex Sports Car Series and the Grand-Am Series have held races in Alabama.
Photo by Joe Songer, The Birmingham News

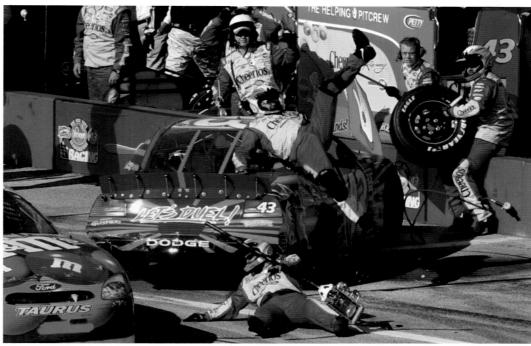

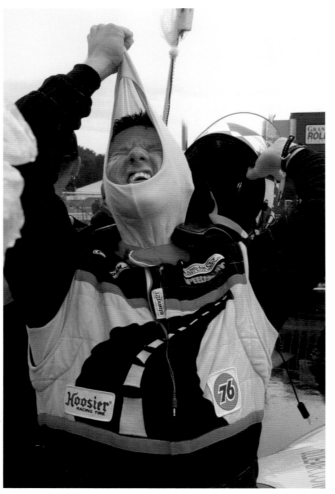

NORTH SHELBY COUNTY

The Church of the Highlands in Birmingham sponsors an internship program for college students called "twentyfourseven." The program prepares young Christian leaders for local and global ministry. According to Pastor Layne Schranz (in mid-air), twentyfourseven focuses on the spiritual, intellectual, and—as this soccer match in Heardmont Park demonstrates—the physical.

Photo by Frank Couch, The Birmingham News

MONTGOMERY

Senior Chris Looney tries not to get flattened as his teammates celebrate Clay-Chalkville High School's first state baseball championship. The Cougars beat the Baker High School Hornets of Mobile with an 8–0, 3–2 sweep in the best-of-three series at Paterson Field.

Photo by Mark Almond, The Birmingham News

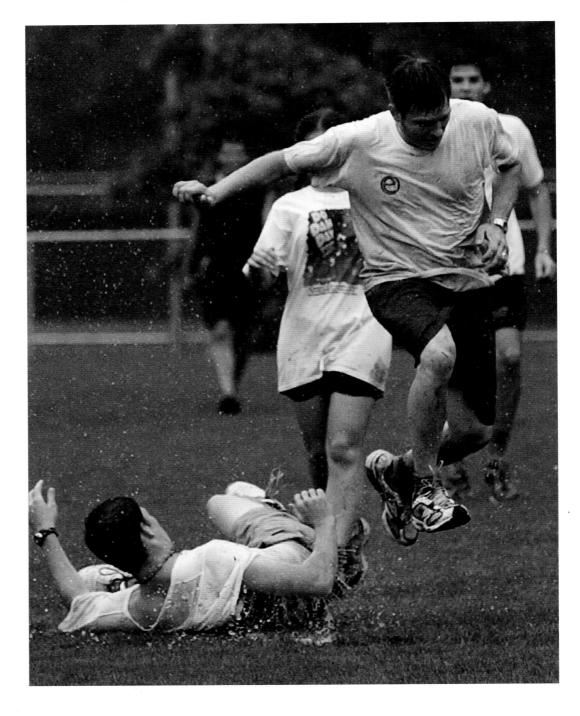

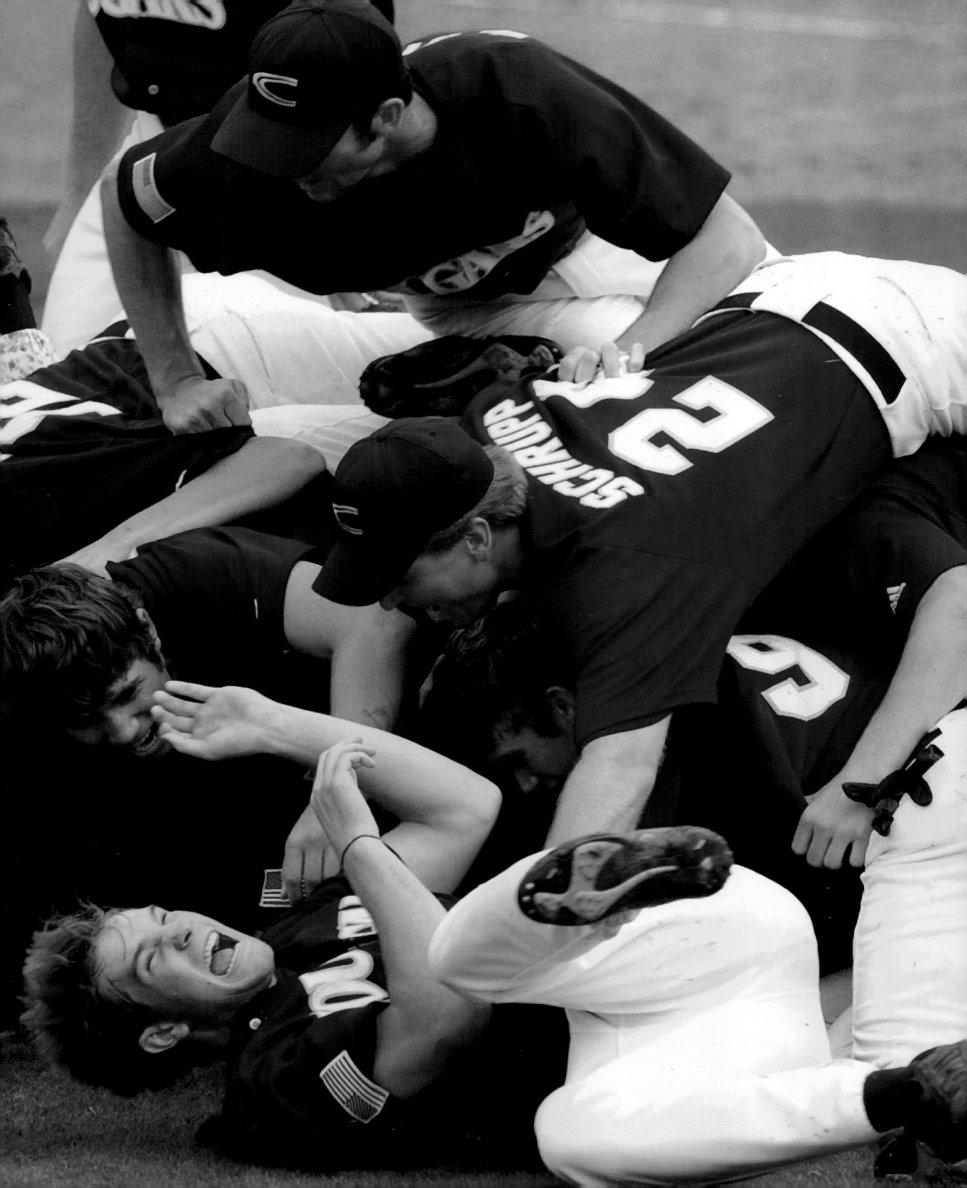

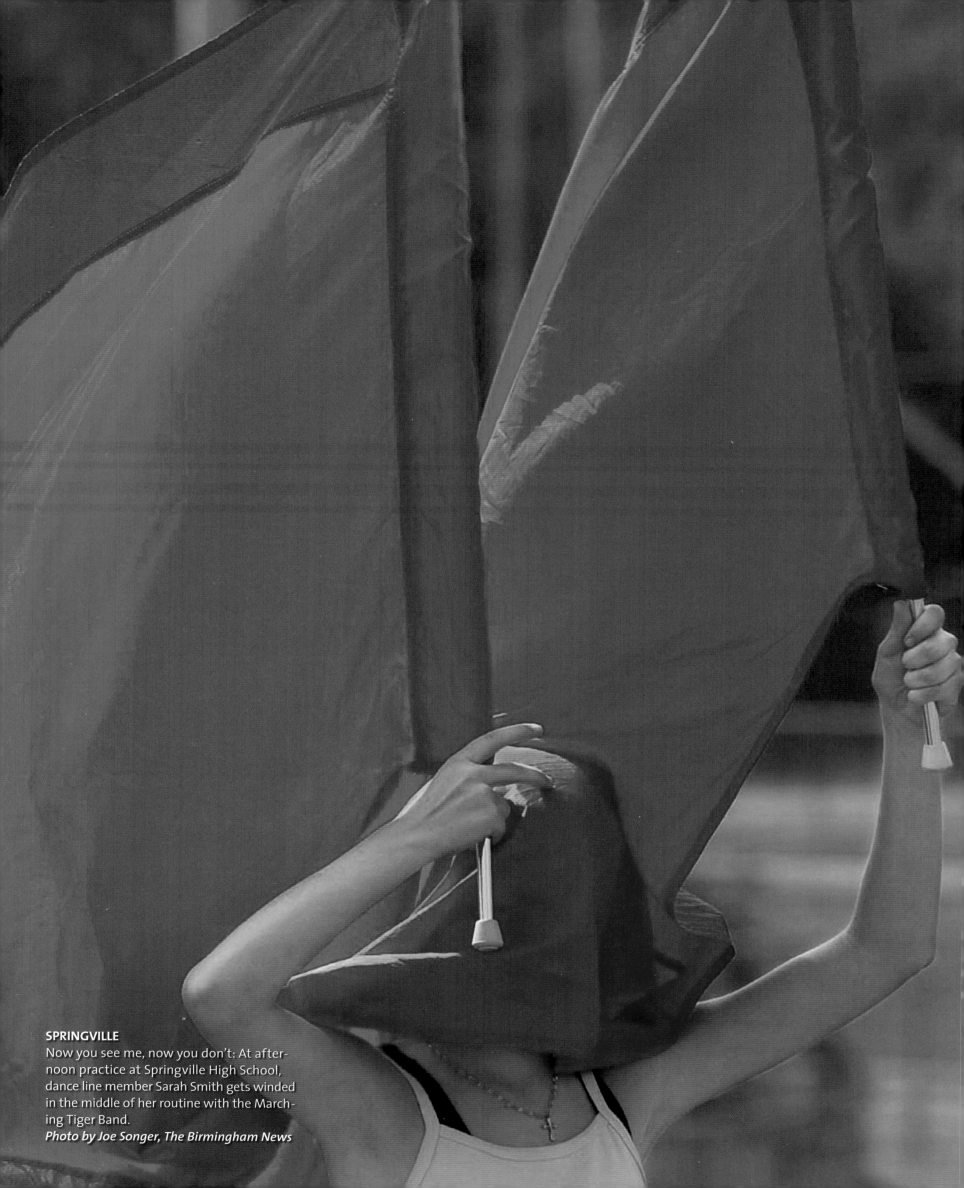

SPRINGVILLE
Now you see me, now you don't: At afternoon practice at Springville High School, dance line member Sarah Smith gets winded in the middle of her routine with the Marching Tiger Band.
Photo by Joe Songer, The Birmingham News

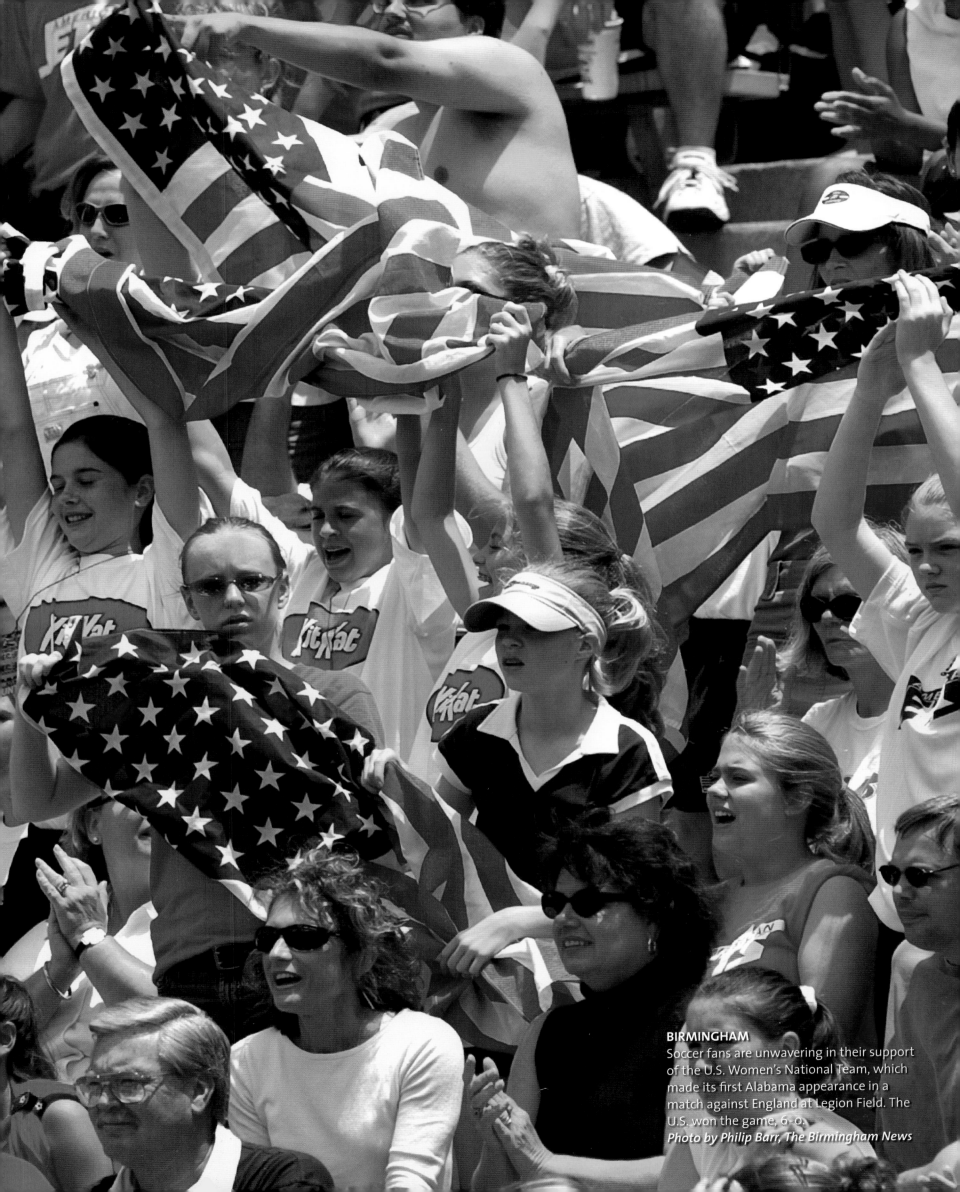

BIRMINGHAM
Soccer fans are unwavering in their support of the U.S. Women's National Team, which made its first Alabama appearance in a match against England at Legion Field. The U.S. won the game, 6-0.
Photo by Philip Barr, The Birmingham News

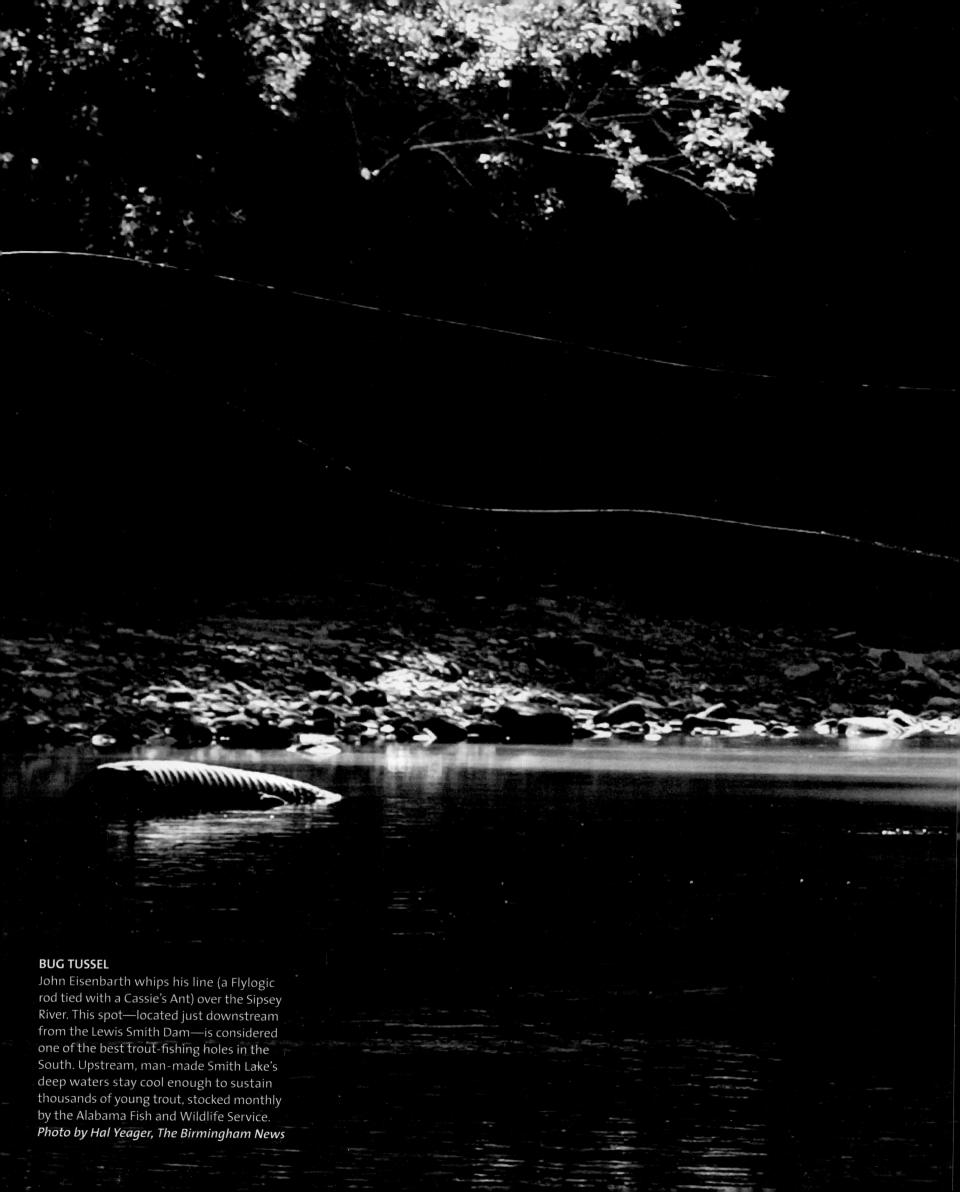

BUG TUSSEL
John Eisenbarth whips his line (a Flylogic rod tied with a Cassie's Ant) over the Sipsey River. This spot—located just downstream from the Lewis Smith Dam—is considered one of the best trout-fishing holes in the South. Upstream, man-made Smith Lake's deep waters stay cool enough to sustain thousands of young trout, stocked monthly by the Alabama Fish and Wildlife Service.
Photo by Hal Yeager, The Birmingham News

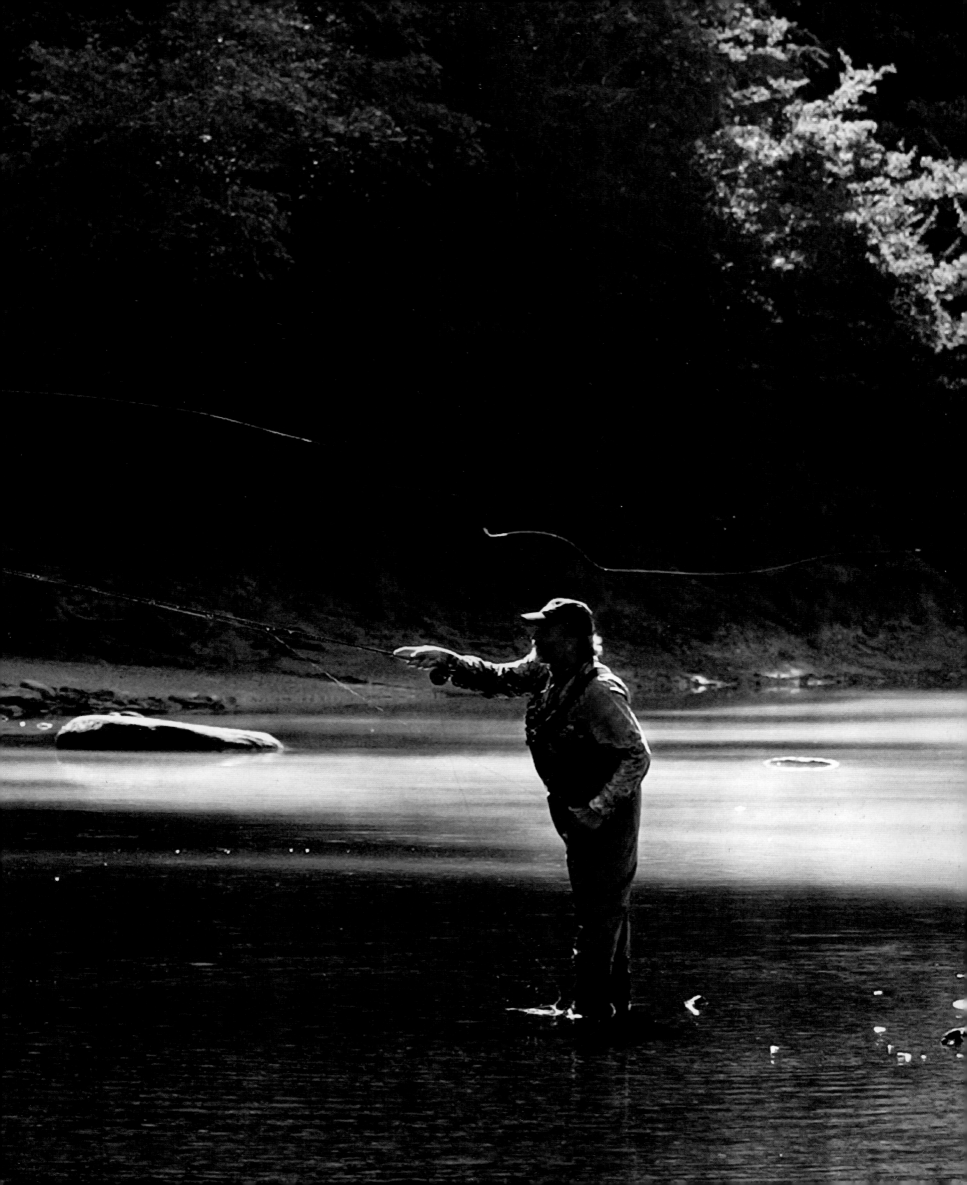

Touchdown! In the Comfort Inn stadium, the National Electric Football Tournament pits uniformed contestants David Nickles of Oxford, Alabama, against Fran Henderson, of Jacksonville, Florida. In the decades-old game, contestants set up players on a field that vibrates when switched on. After each "play," the field is turned off, and contestants position their players for the next turn.

Photo by Charles Nesbitt, The Birmingham News

ORANGE BEACH

Brooke Grissom, a 17-year-old born with cerebral palsy, beams as *Good Times II* first mate Andy McKinnell shows her a red snapper she caught on a deep sea fishing trip sponsored by the United Special Sportsmen Alliance. The national nonprofit solicits donations so that disabled and terminally ill youth can get a crack at some outdoor recreation.

Photo by Joe Songer, The Birmingham News

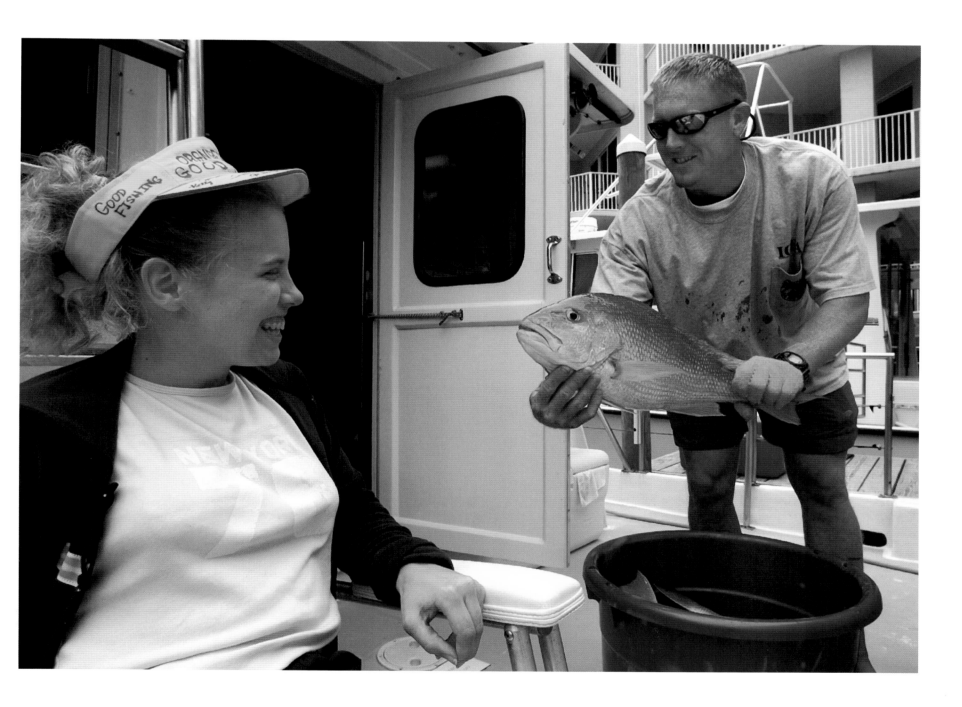

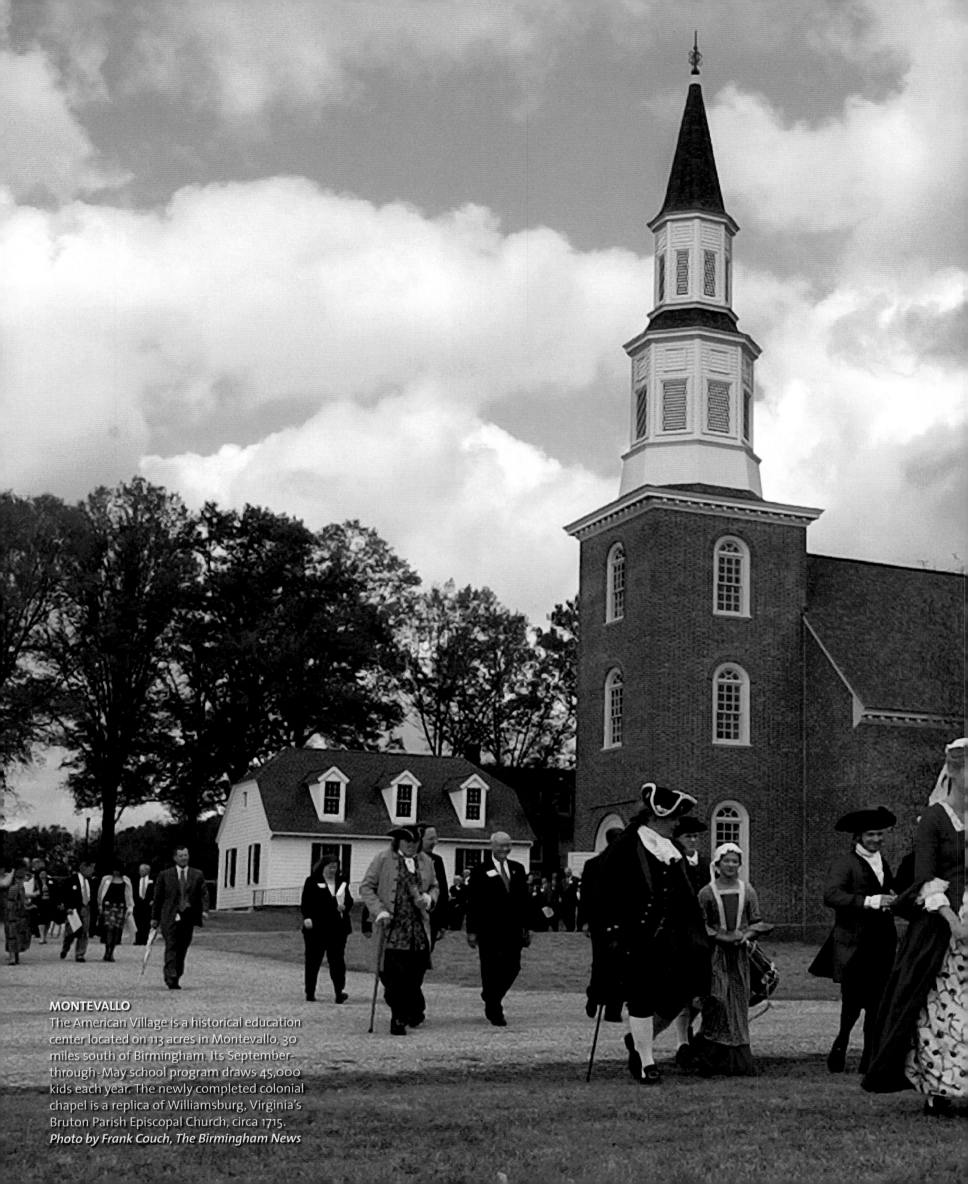

MONTEVALLO

The American Village is a historical education center located on 113 acres in Montevallo, 30 miles south of Birmingham. Its September-through-May school program draws 45,000 kids each year. The newly completed colonial chapel is a replica of Williamsburg, Virginia's Bruton Parish Episcopal Church, circa 1715.

Photo by Frank Couch, The Birmingham News

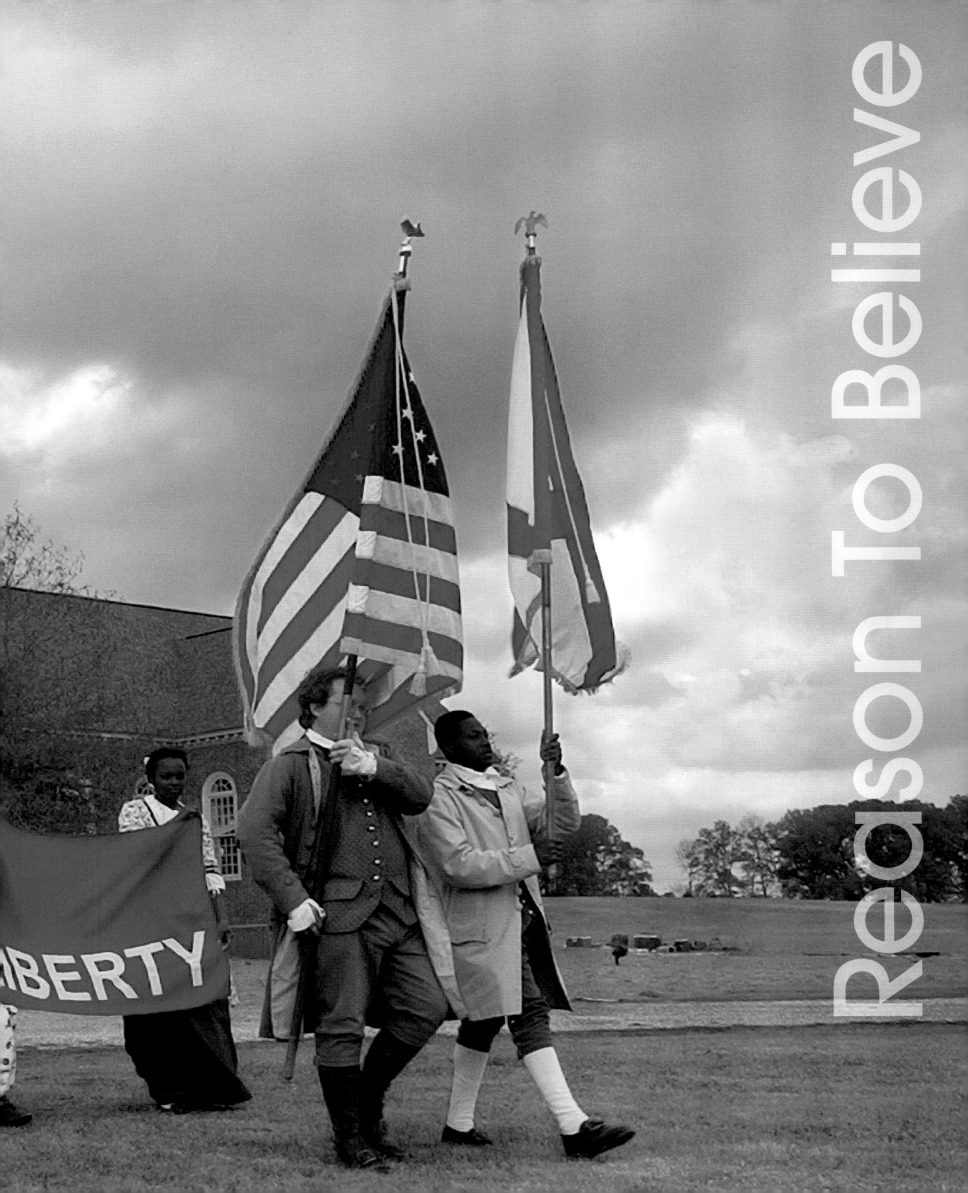

Reason To Believe

LIBERTY

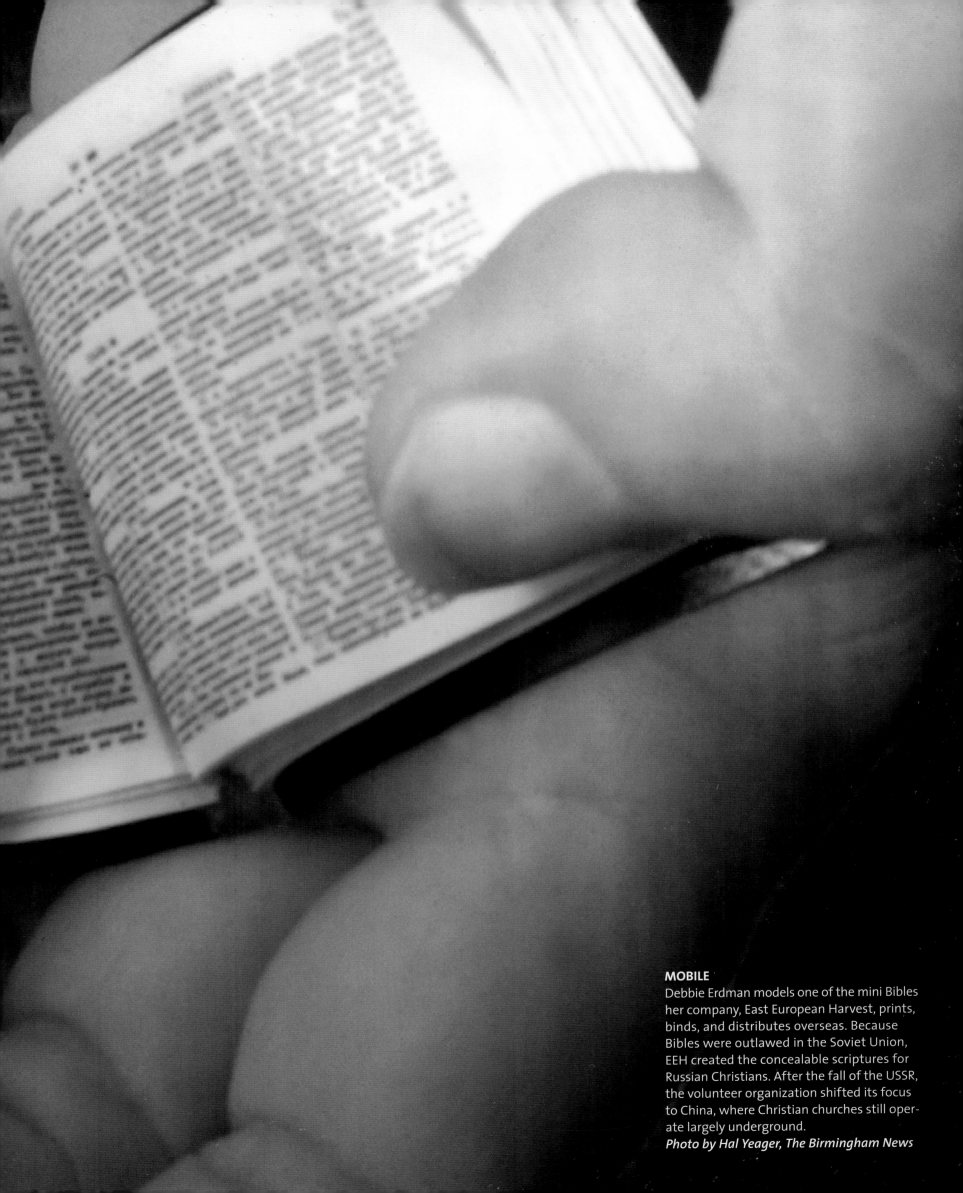

MOBILE

Debbie Erdman models one of the mini Bibles her company, East European Harvest, prints, binds, and distributes overseas. Because Bibles were outlawed in the Soviet Union, EEH created the concealable scriptures for Russian Christians. After the fall of the USSR, the volunteer organization shifted its focus to China, where Christian churches still operate largely underground.

Photo by Hal Yeager, The Birmingham News

MONTGOMERY

In 1956, as racial tensions mounted, young activists, including Reverend Martin Luther King, Jr., gathered in the basement of the Dexter Avenue King Church to plan the Montgomery bus boycott. The protest quickly drained Montgomery's public transit system of revenue. The following year, a landmark U.S. Supreme Court decision ended segregation on public buses.

Photos by Hal Yeager, The Birmingham News

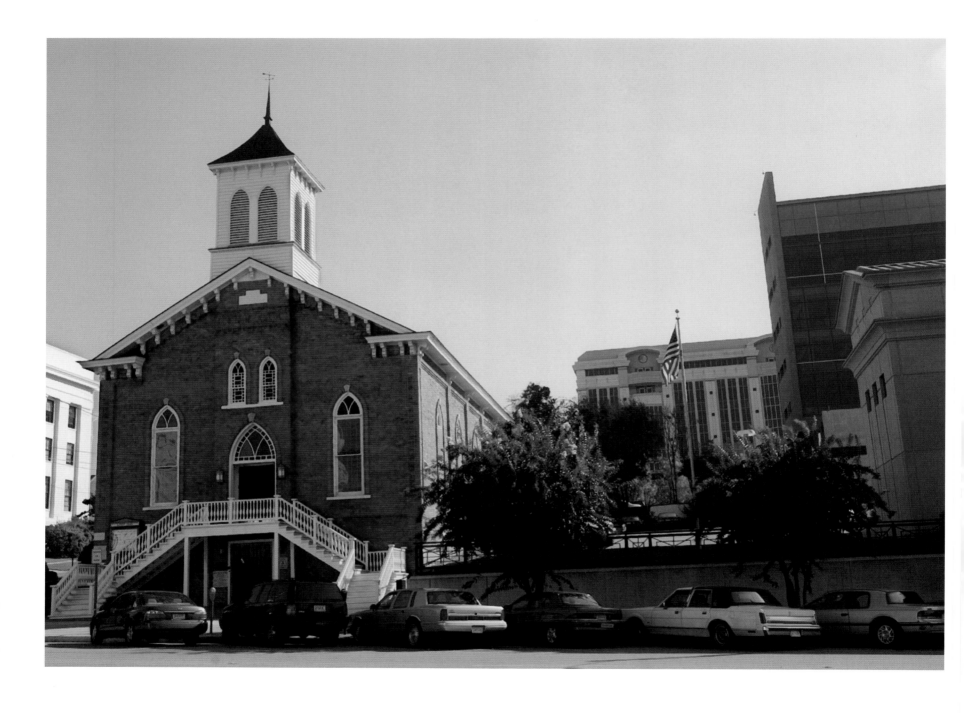

BIRMINGHAM

While Reverend Martin Luther King, Jr., is the most remembered face of the civil rights movement, dozens of lesser-known ministers played critical roles in the struggle, mobilizing their congregations and communities. This monument in Kelly Ingram Park pays tribute to their valor and their piety.

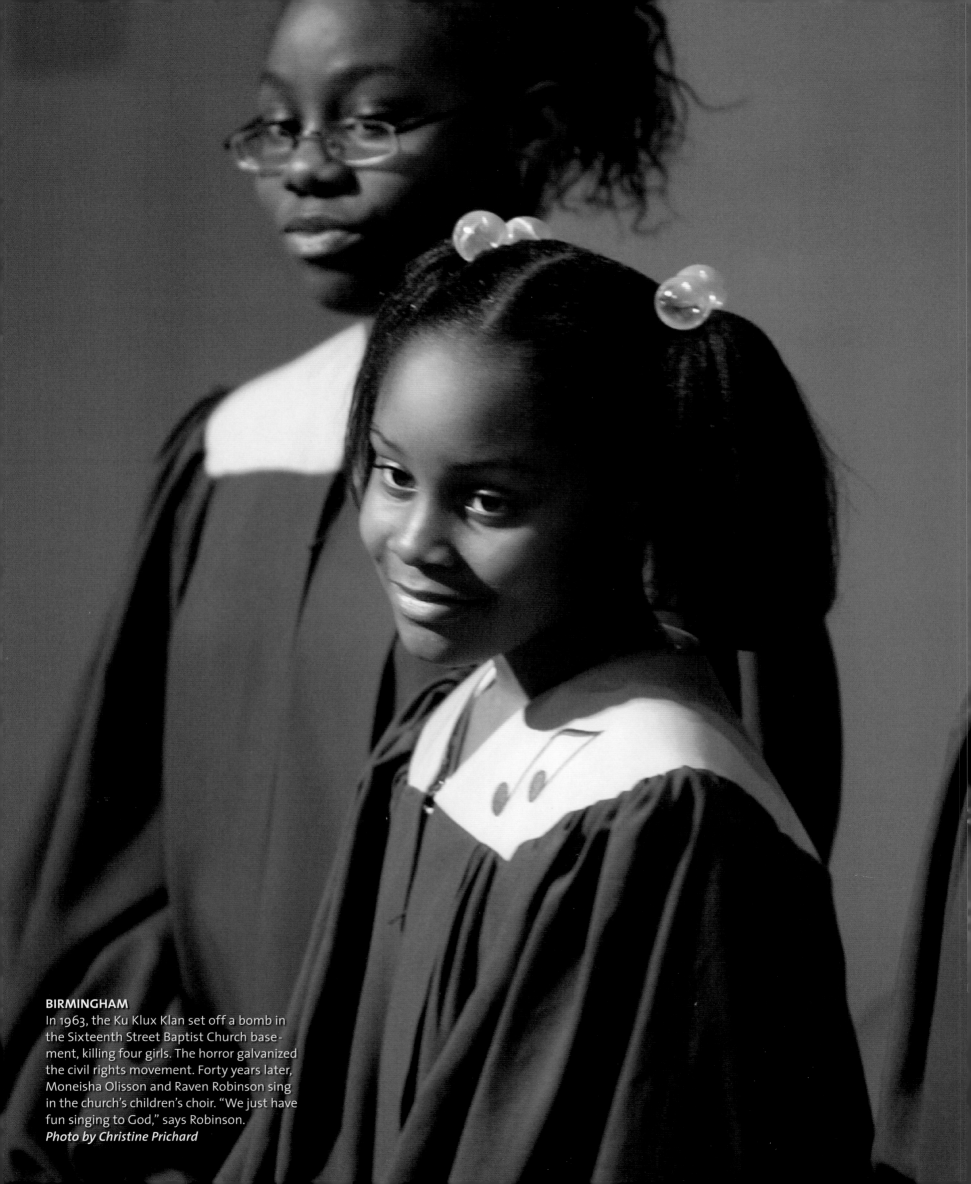

BIRMINGHAM
In 1963, the Ku Klux Klan set off a bomb in the Sixteenth Street Baptist Church basement, killing four girls. The horror galvanized the civil rights movement. Forty years later, Moneisha Olisson and Raven Robinson sing in the church's children's choir. "We just have fun singing to God," says Robinson.
Photo by Christine Prichard

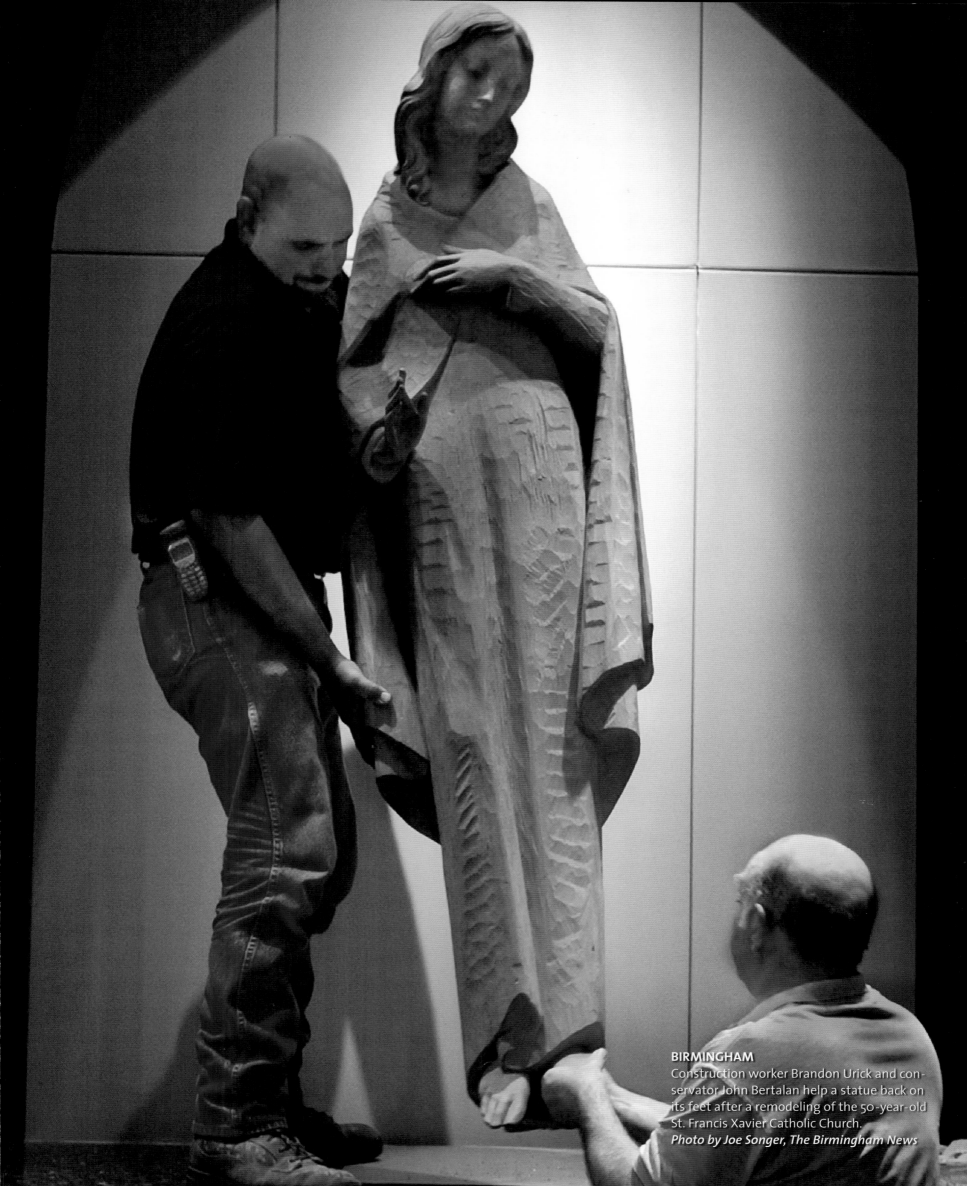

BIRMINGHAM
Construction worker Brandon Urick and conservator John Bertalan help a statue back on its feet after a remodeling of the 50-year-old St. Francis Xavier Catholic Church.
Photo by Joe Songer, The Birmingham News

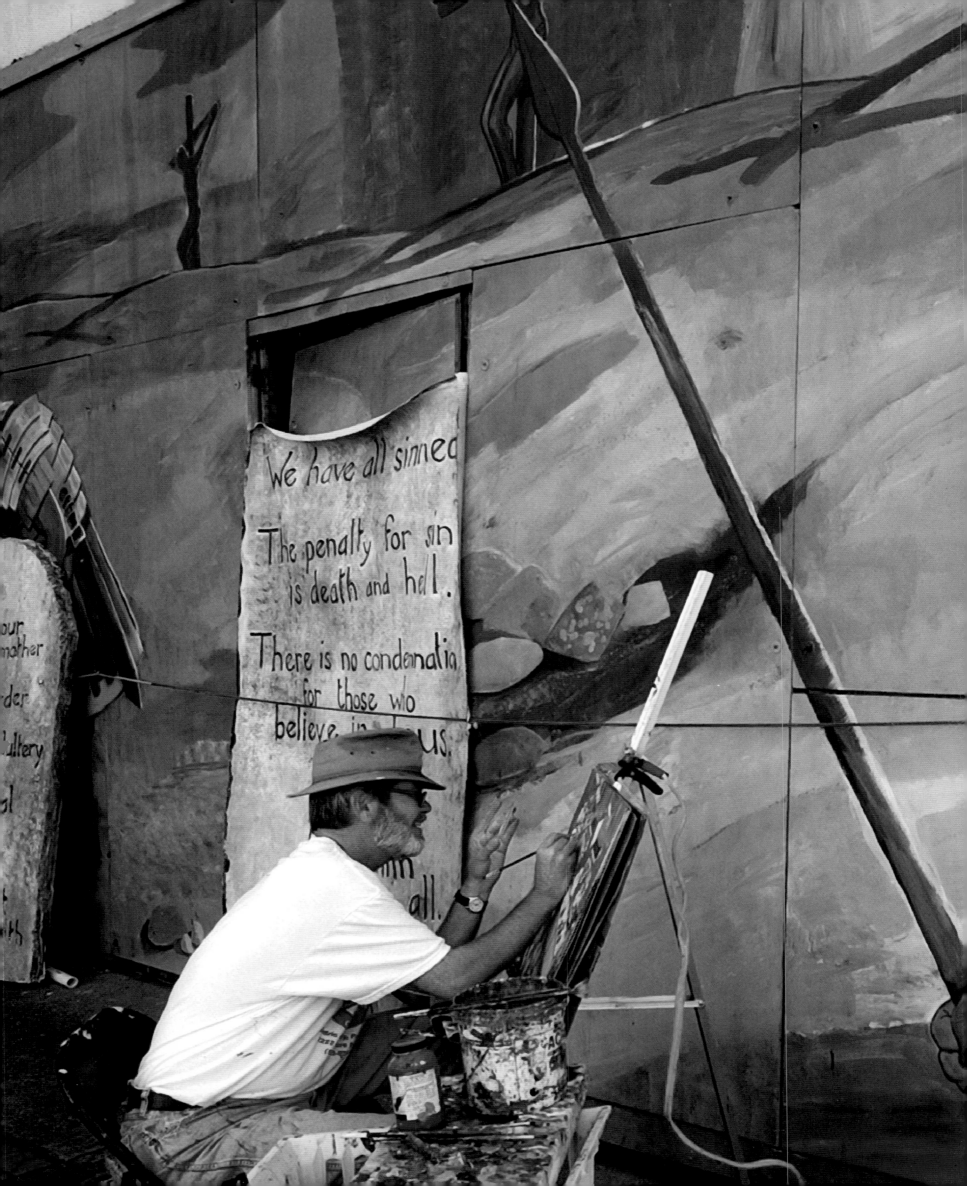

MONTGOMERY
Bob Adams's mural at the corner of Dexter Avenue and Terry Street in downtown Montgomery illustrates themes of "sin, righteousness, and judgment." The retiree occasionally sells smaller pieces, but is reticent to do so. "I try to tell people about the gospel through my paintings, so it's kind of awkward shifting gears and making money off of them," he says.
Photo by Hal Yeager, The Birmingham News

BIRMINGHAM
Once each year at Mount Olive Baptist Church in downtown Birmingham, the young people are given free rein to conduct services and Sunday school. The spirit is infectious, and Brieyanna Pearson gets a big hug from her cousin Trinita Hall, the pastor's daughter.
Photos by Philip Barr, The Birmingham News

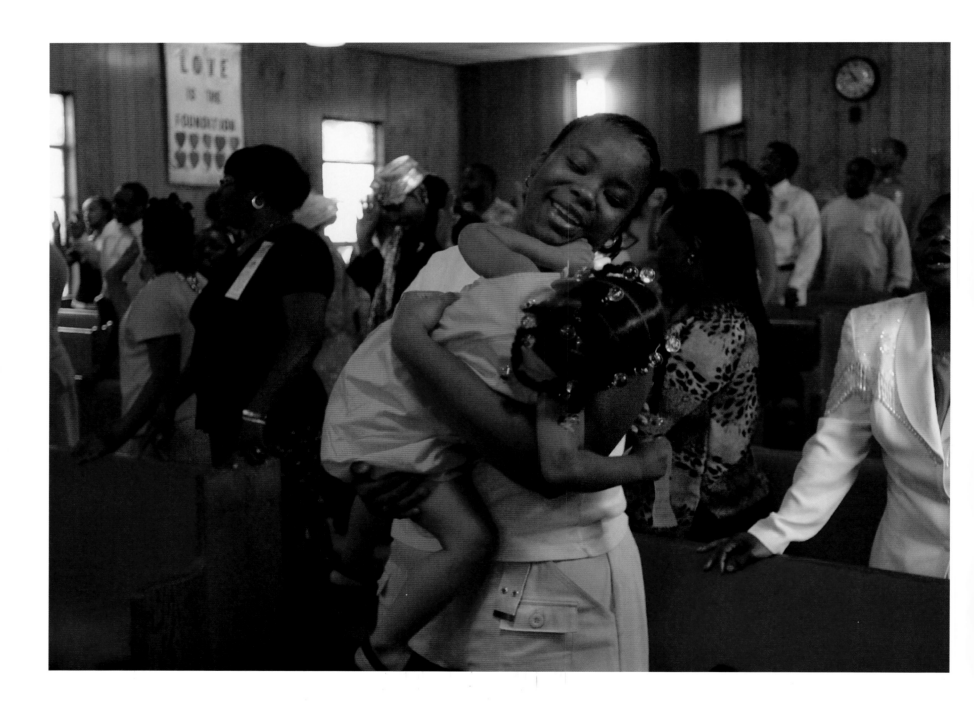

BIRMINGHAM

All in the Family: Annie Henley-Ridgeway grew
up attending Mount Olive Baptist Church, then
moved across town to Peace Baptist Church
when her father became minister there in 1975.
Last year, she became a Peace Baptist minister,
but returns to Mount Olive to praise the Lord and
visit her son Andre, a minister at Mount Olive.

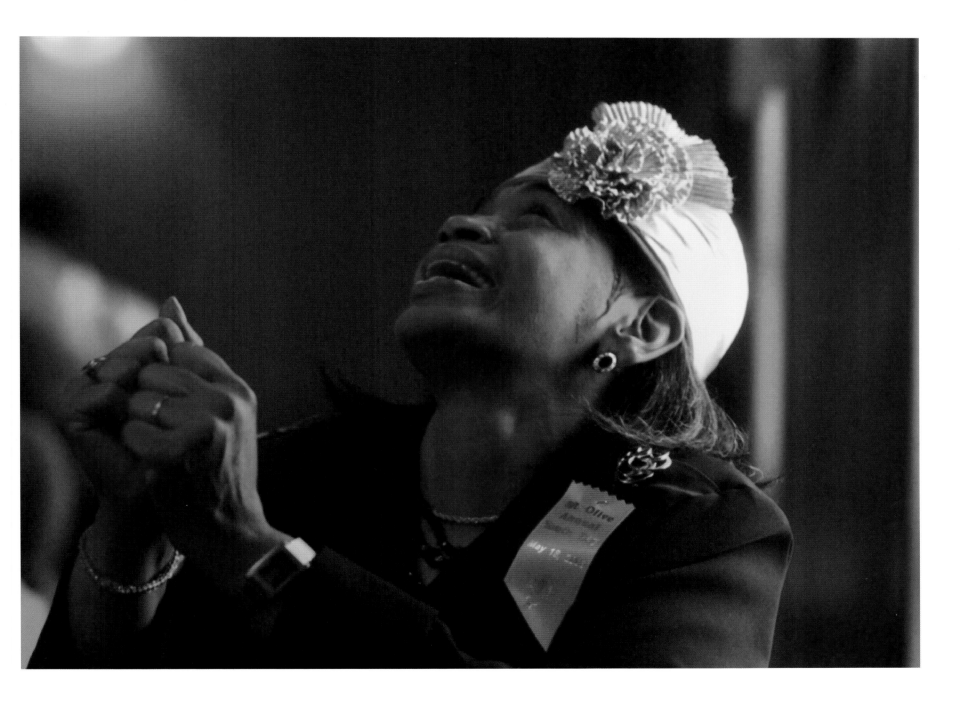

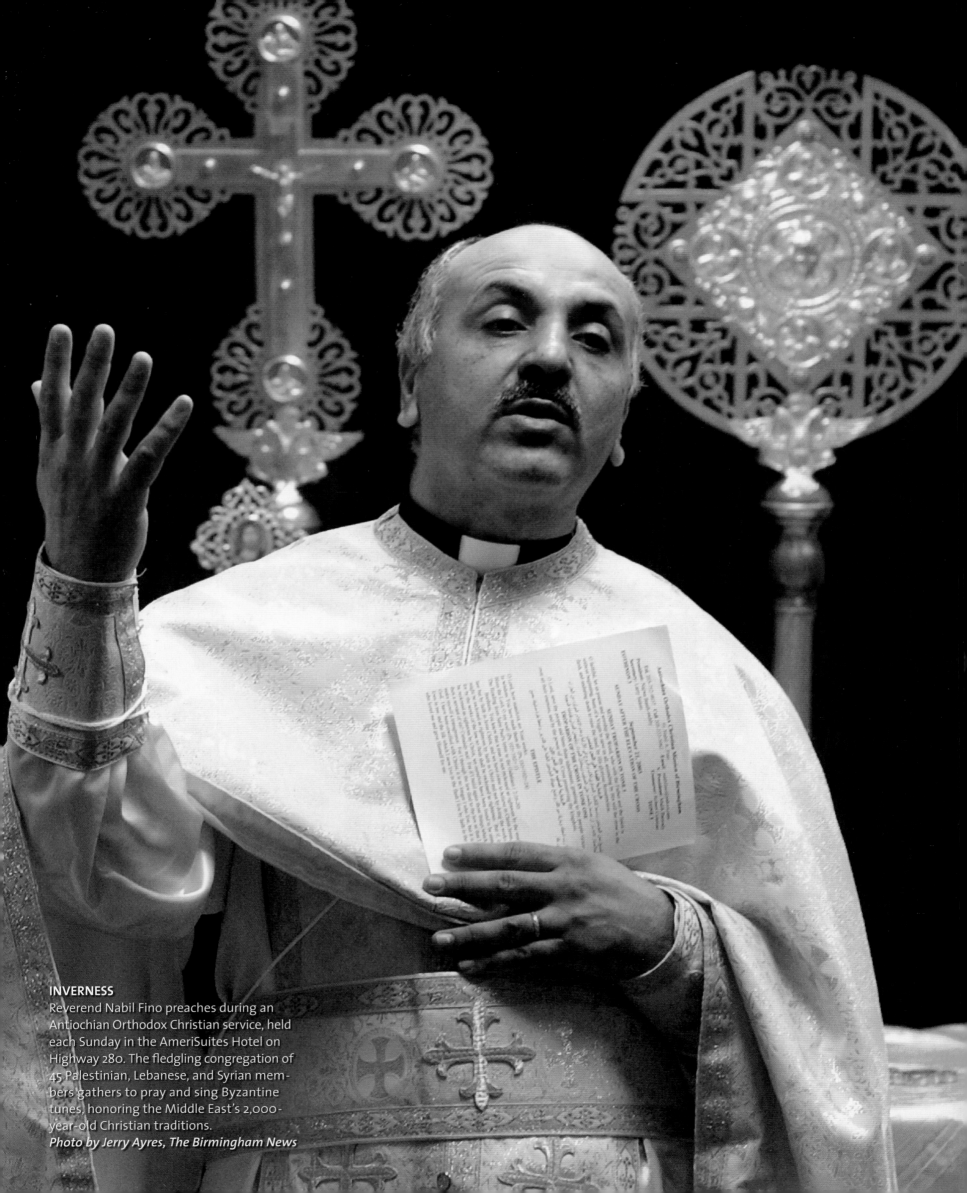

INVERNESS

Reverend Nabil Fino preaches during an
Antiochian Orthodox Christian service, held
each Sunday in the AmeriSuites Hotel on
Highway 280. The fledgling congregation of
45 Palestinian, Lebanese, and Syrian mem-
bers gathers to pray and sing Byzantine
tunes, honoring the Middle East's 2,000-
year-old Christian traditions.
Photo by Jerry Ayres, The Birmingham News

BIRMINGHAM
Along with lots of noise and rain, a string
of thunderstorms delivered a beautiful rain-

POWELL CROSSROADS

In the Sand Mountain area of northeastern Alabama, James Hatfield preaches at Old Straight Creek Holiness Church. What distinguishes his preaching? "I ain't got nothing special about it but the Bible," the former construction worker says. In some services, he'll handle a rattlesnake or a copperhead, but not this evening. "I've been bit," he allows.

Photo by Bob Farley, Birmingham Post-Herald

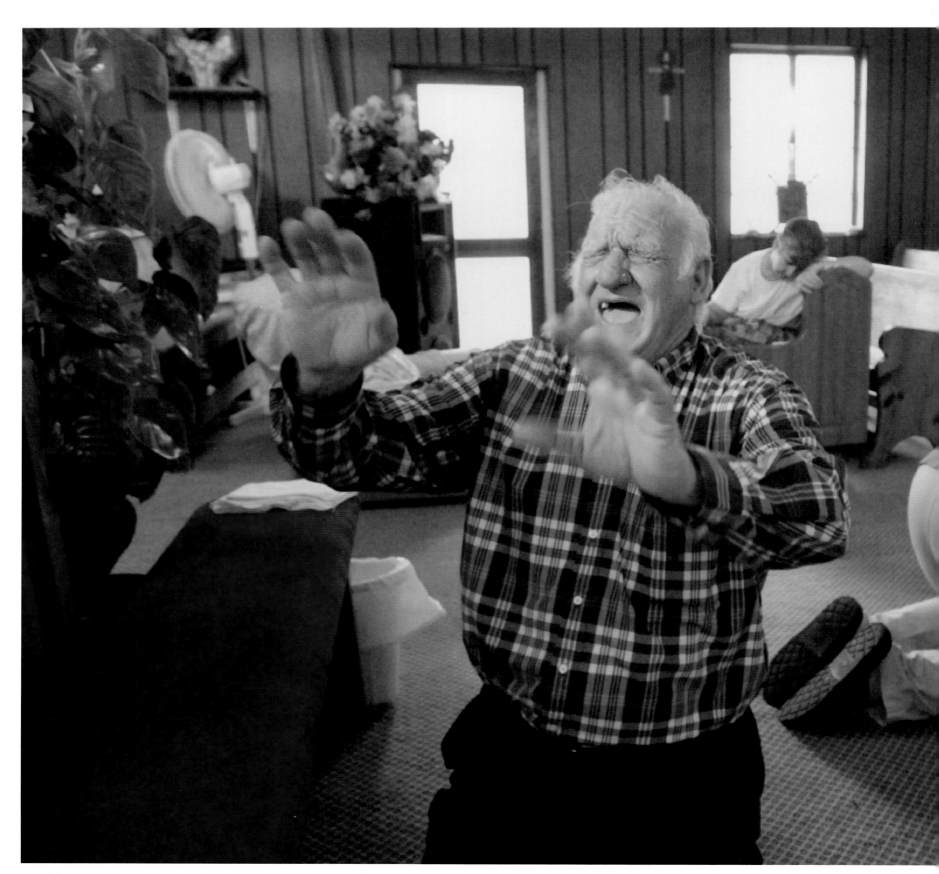

HEFLIN

Jim Sheppard lends his tenor to Sacred Harp sing-
ing whenever and wherever he can. Also called
shape-note singing, the music can be traced to
Reformation psalmody. Participants form a square
and take turns leading songs. He and his wife
Shelbie have sung Sacred Harp their whole lives.
Photo by J. Mark Gooch

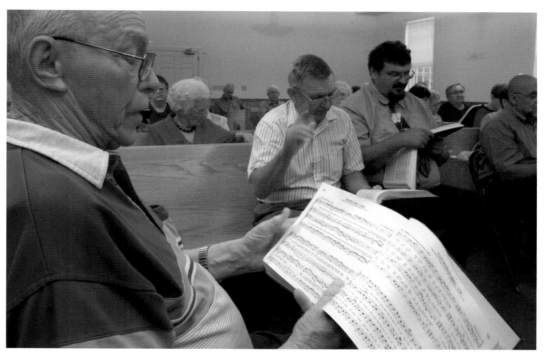

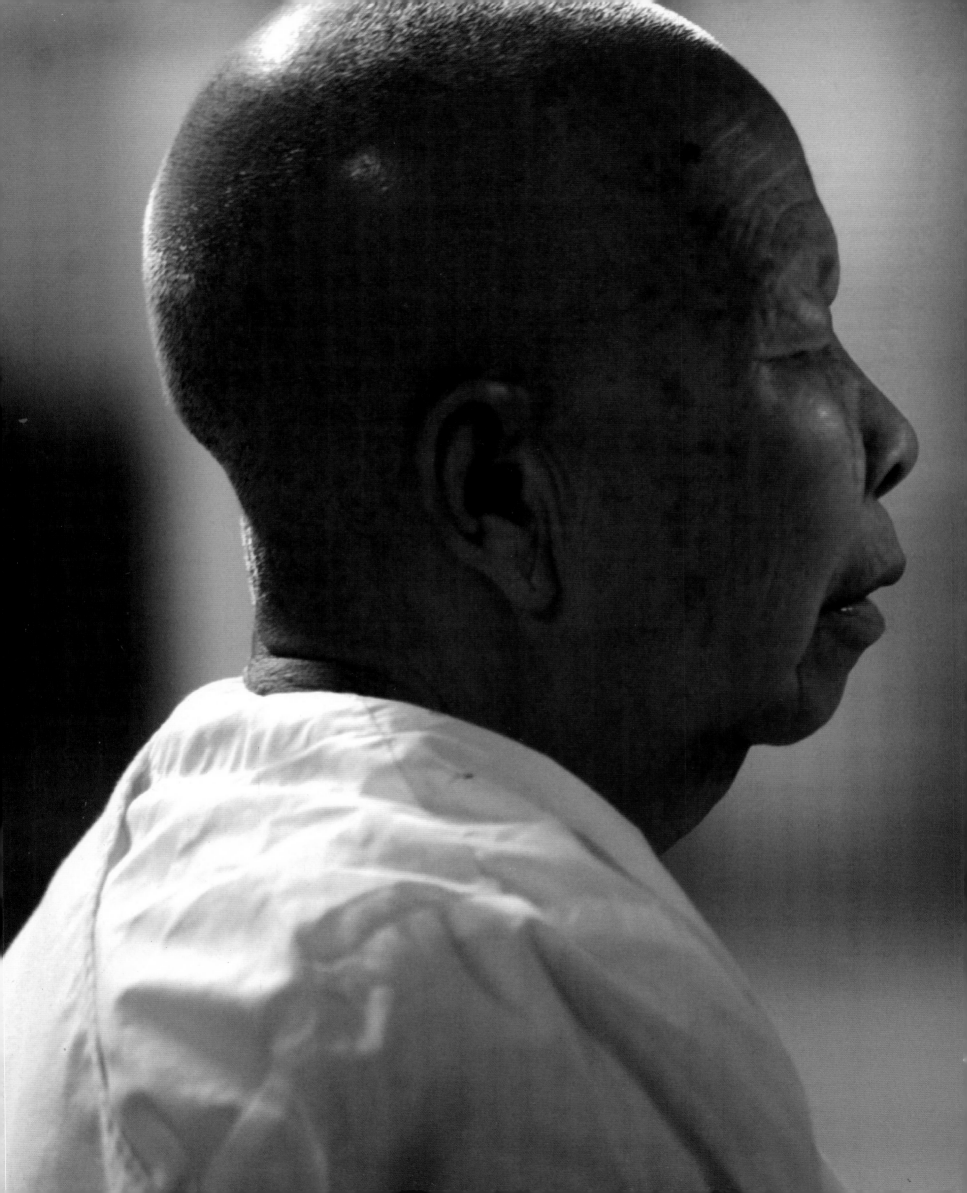

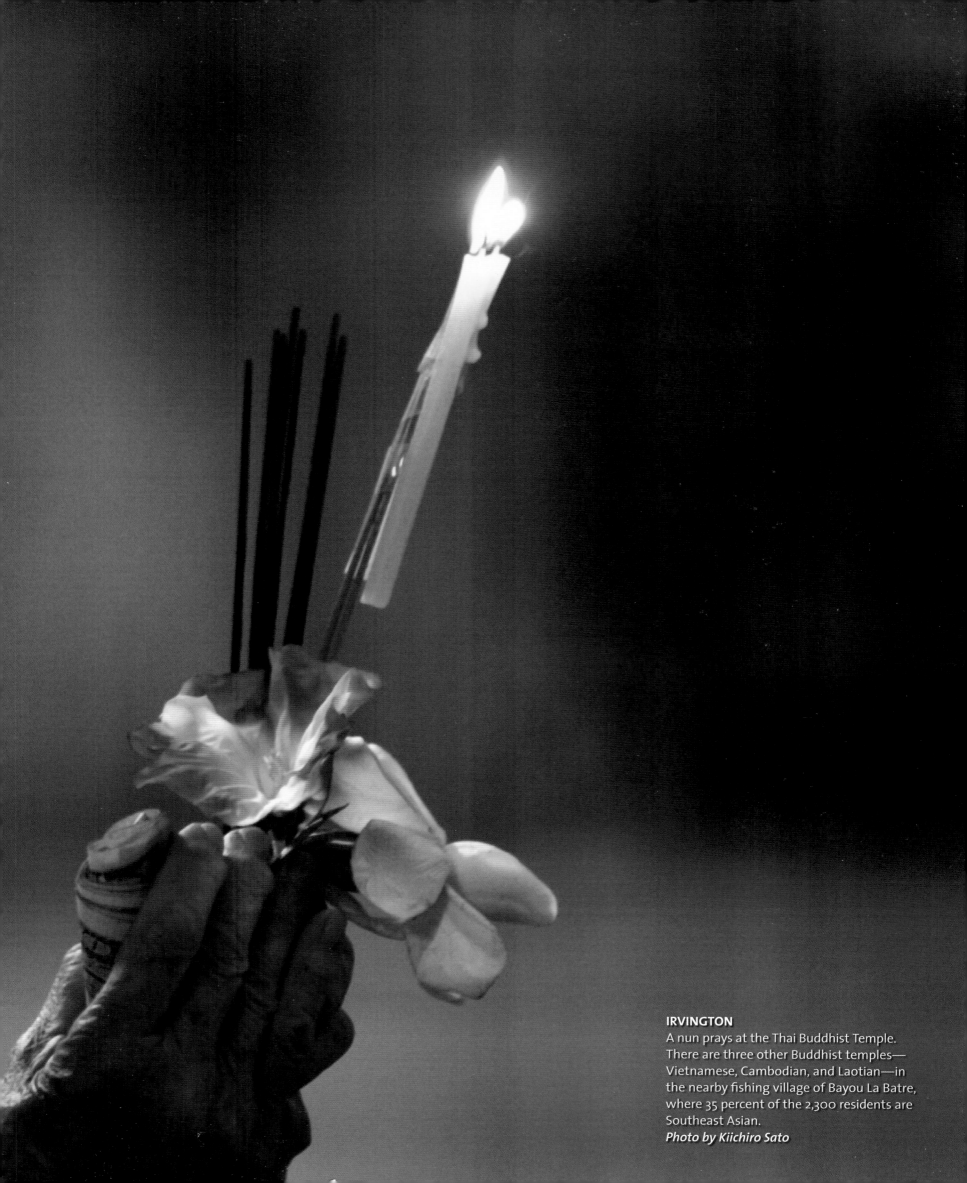

IRVINGTON
A nun prays at the Thai Buddhist Temple. There are three other Buddhist temples—Vietnamese, Cambodian, and Laotian—in the nearby fishing village of Bayou La Batre, where 35 percent of the 2,300 residents are Southeast Asian.
Photo by Kiichiro Sato

MOBILE

The USS *Alabama* was mothballed at a naval shipyard in Bremerton, Washington, after serving in the Pacific in World War II. In 1964, school children, corporations, and the state of Alabama raised $1 million to tug the 40,000-ton ship 5,600 miles back to her home state. Today, the *Alabama* is one of the state's most visited tourist attractions.

Photo by Hal Yeager, The Birmingham News

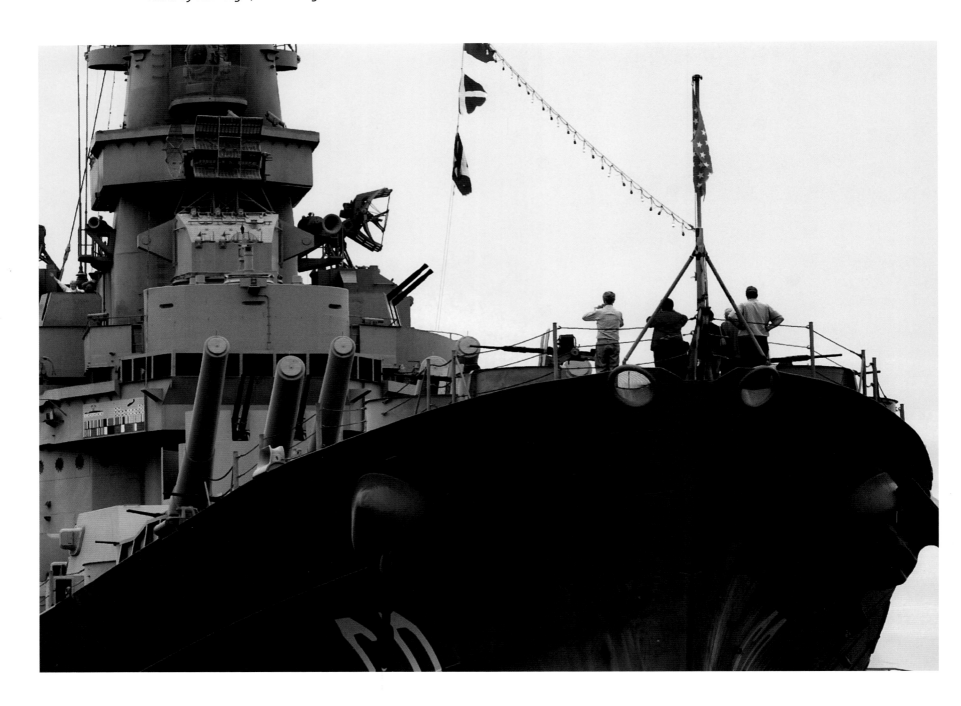

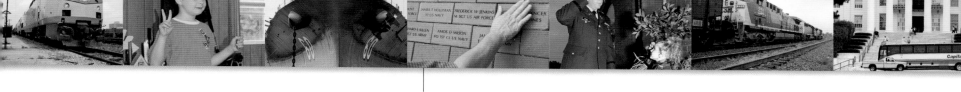

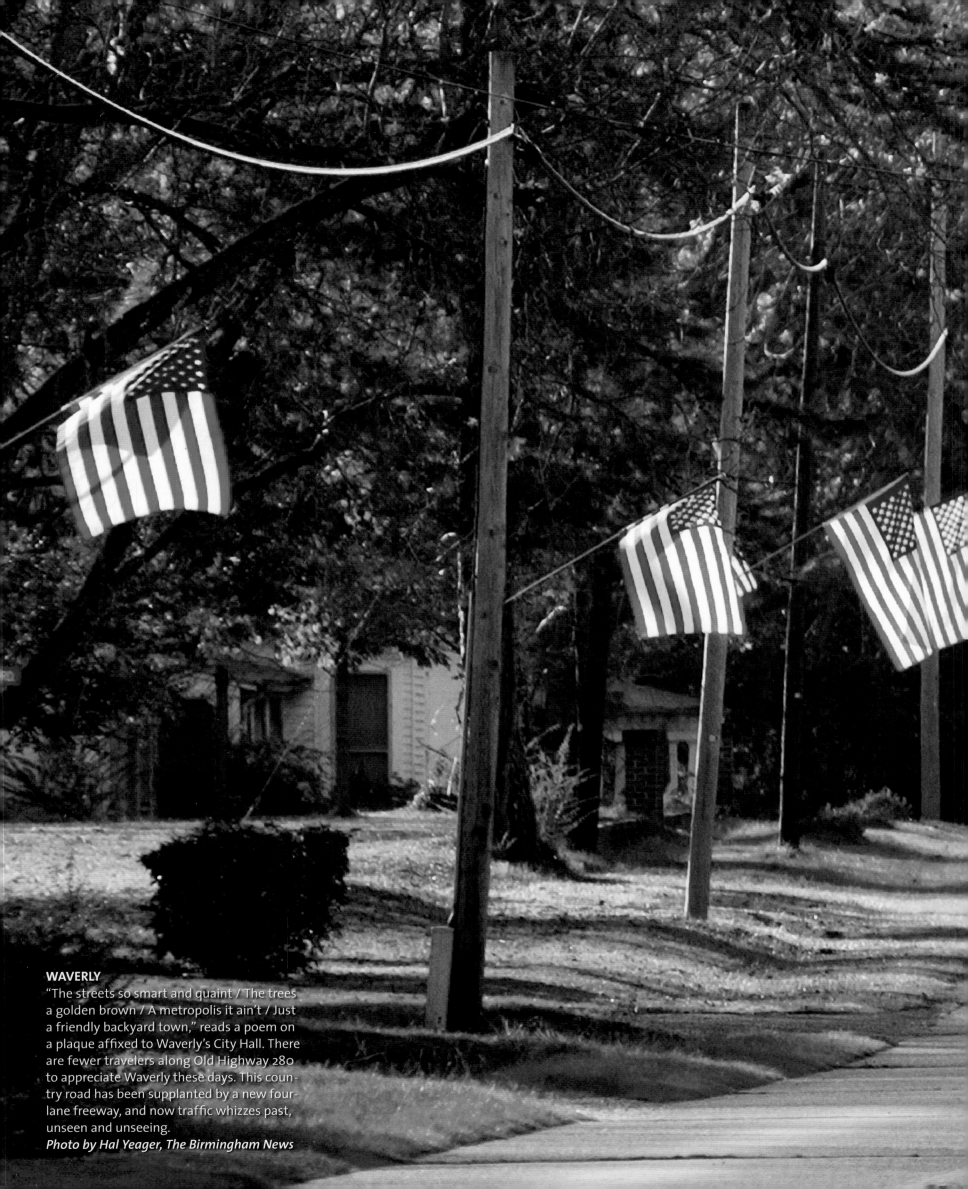

WAVERLY

"The streets so smart and quaint / The trees a golden brown / A metropolis it ain't / Just a friendly backyard town," reads a poem on a plaque affixed to Waverly's City Hall. There are fewer travelers along Old Highway 280 to appreciate Waverly these days. This country road has been supplanted by a new four-lane freeway, and now traffic whizzes past, unseen and unseeing.

Photo by Hal Yeager, The Birmingham News

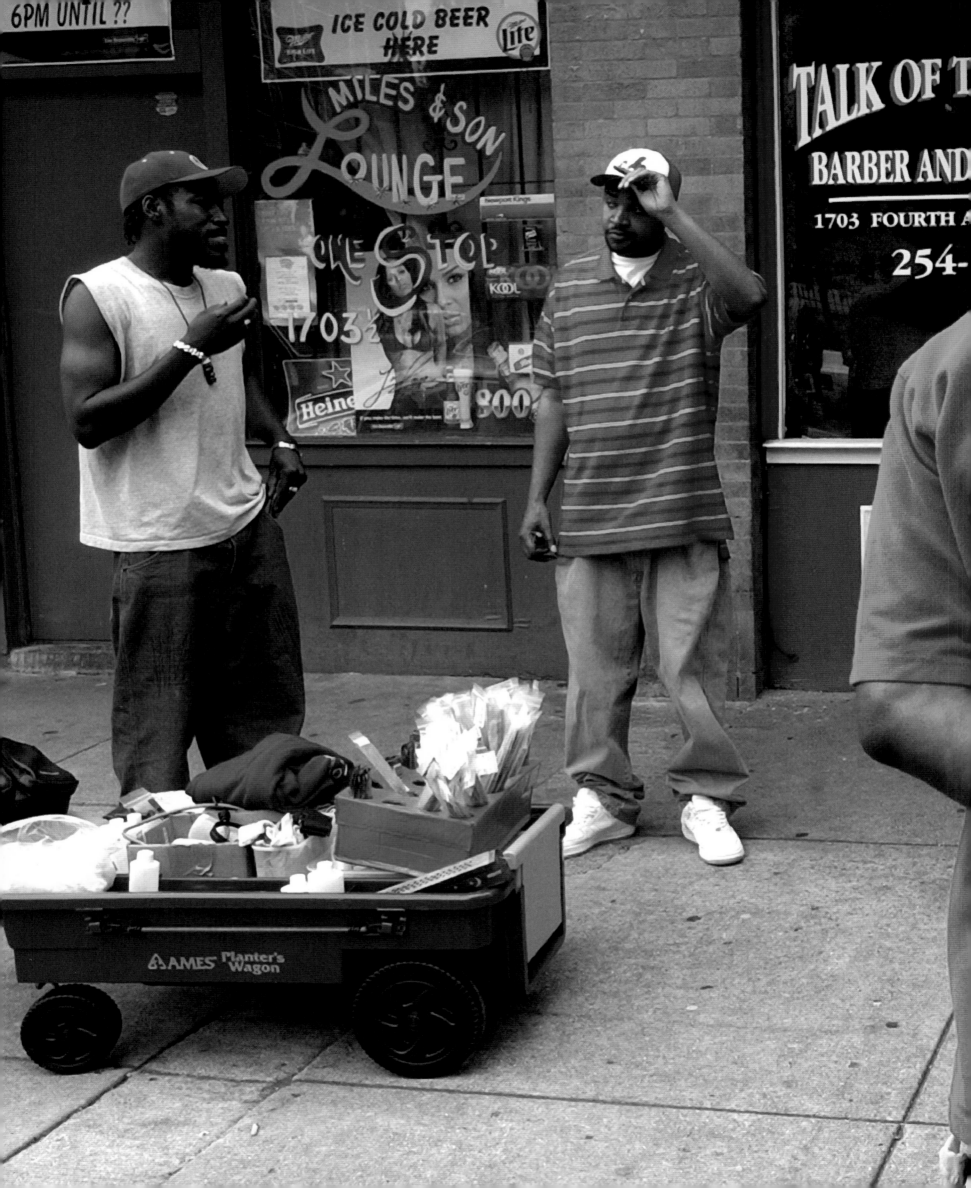

TALK OF THE TOWN

BARBER AND STYLE SHOP

1703 FOURTH AVENUE NORTH

254-9736

BIRMINGHAM
On Fourth Avenue North, Down Low Brown (far left) sells his homemade incense, air freshener, and deodorant. Although the 28-year-old businessman and amateur rapper owns a store, he says he prefers to get outside where he can mingle with people to sell his goods. "I stick to the streets like gum on my feet," he says.
Photo by Christine Prichard

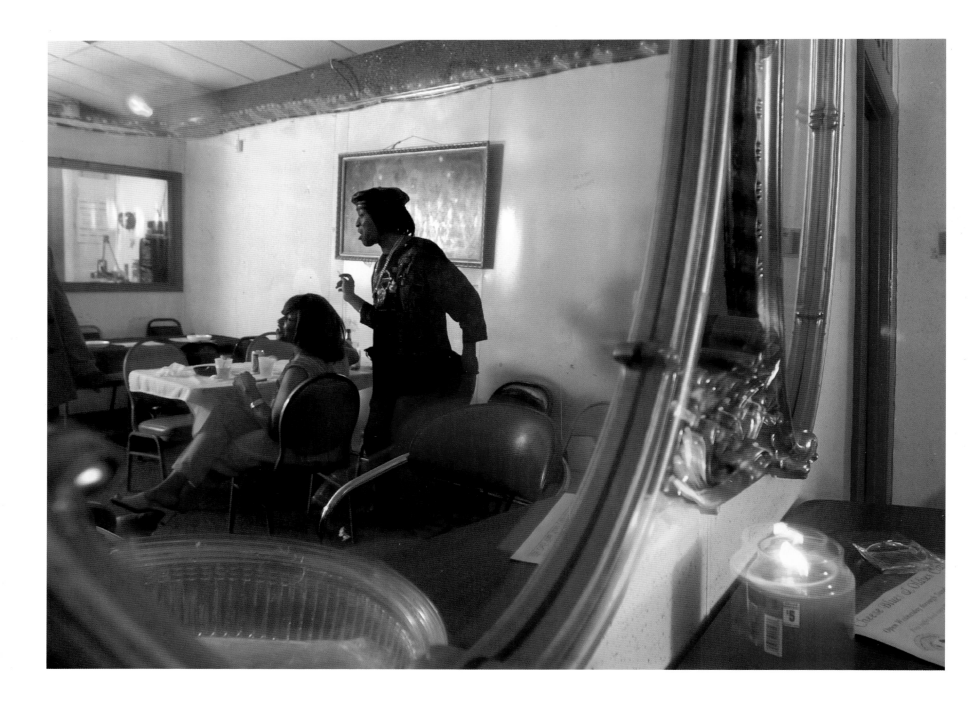

BIRMINGHAM
Patrons at Cheese's Blues and Oldies Club are reflected in dance hall mirrors. The funky nightclub adds spice to Birmingham's historic, black-run Fourth Avenue North district, which developed in the early 20th century during the days of Jim Crow segregation.
Photos by Christine Pritchard

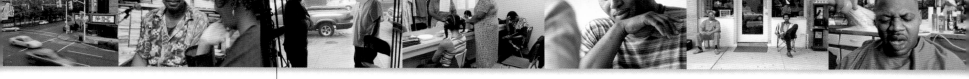

BIRMINGHAM

Although one out of four Alabamians is black, until Clinton Simpson, Jr., (right) opened his Alabama College of Barber Instruction in 1989, he says the state had only one black barber school. Simpson, a third-generation barber who has been in the business for 40 years, chats with a homeless patron who comes on Fridays when haircuts are free.

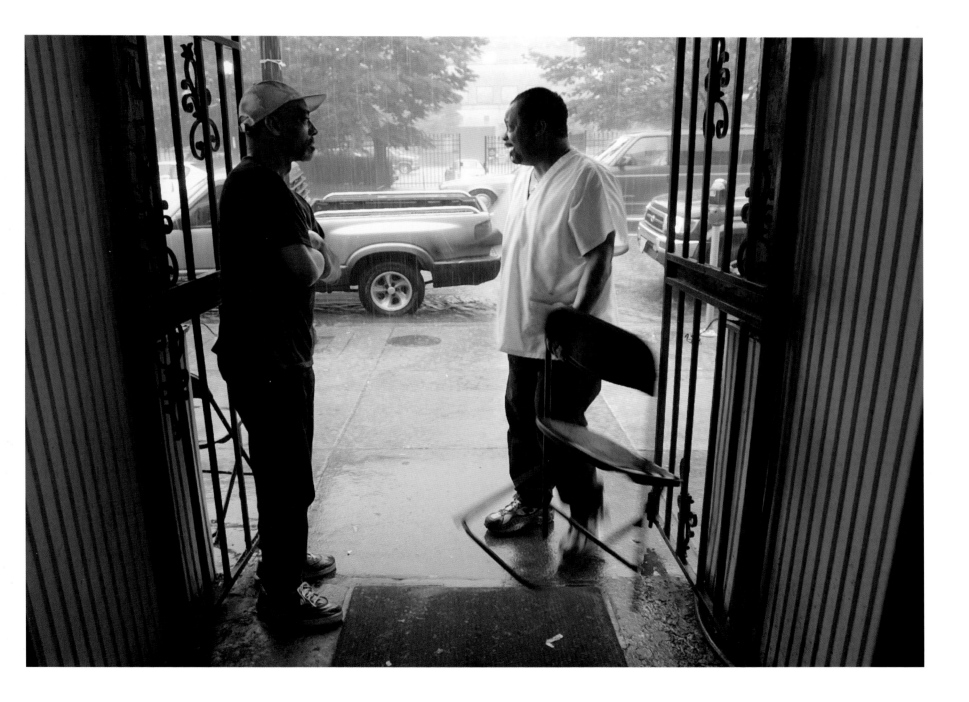

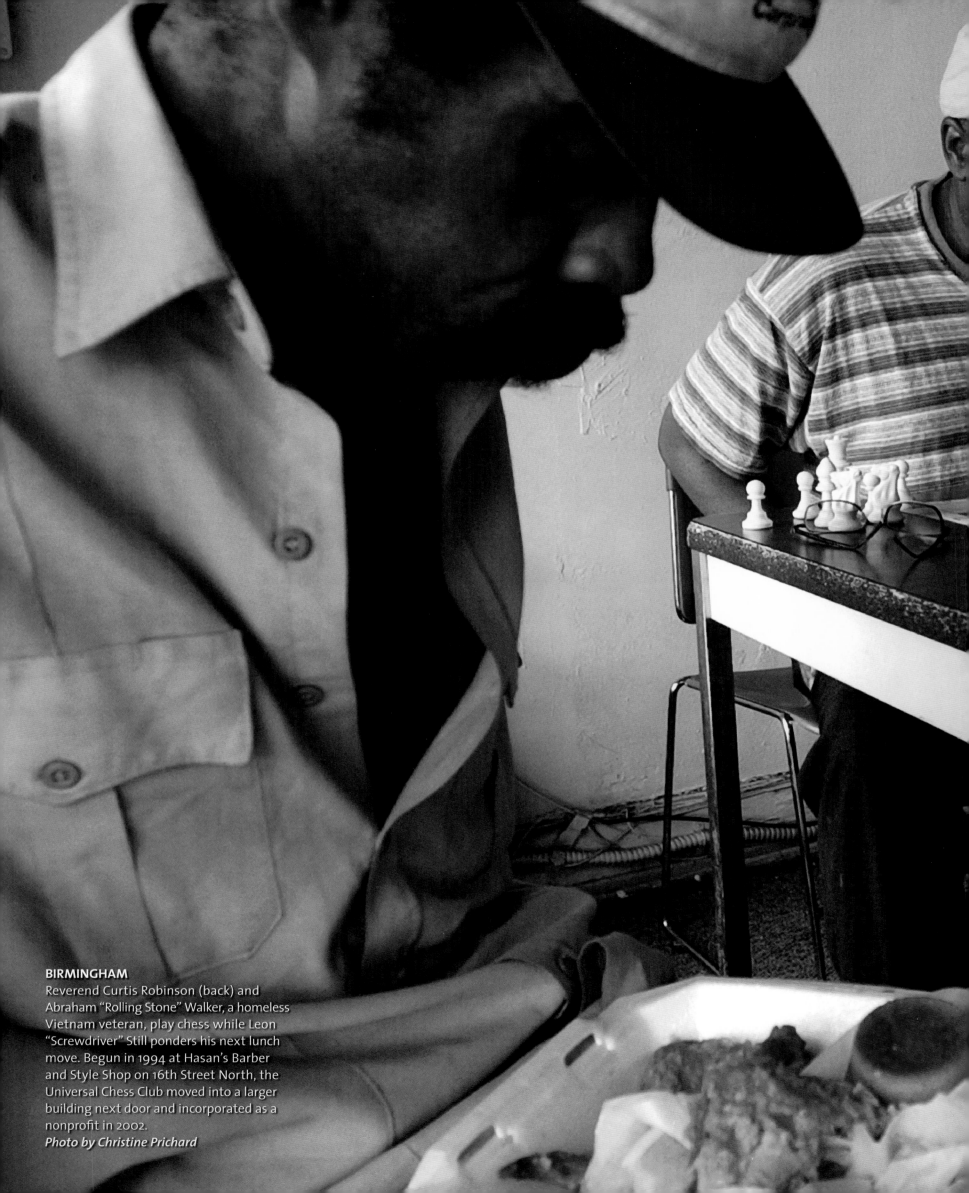

BIRMINGHAM
Reverend Curtis Robinson (back) and Abraham "Rolling Stone" Walker, a homeless Vietnam veteran, play chess while Leon "Screwdriver" Still ponders his next lunch move. Begun in 1994 at Hasan's Barber and Style Shop on 16th Street North, the Universal Chess Club moved into a larger building next door and incorporated as a nonprofit in 2002.
Photo by Christine Prichard

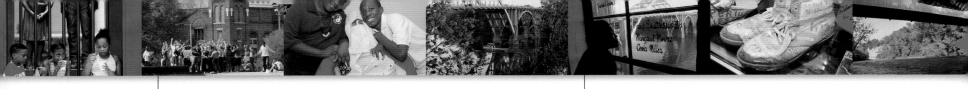

BIRMINGHAM

A group of visiting teens gather for prayer next to the Sixteenth Street Baptist Church, the site of one of 50 racially motivated bombings that rocked Birmingham between 1947 and 1965.
Photos by Hal Yeager, The Birmingham News

SELMA

In 1993, the National Voting Rights Museum and Institute opened in a building formerly occupied by the Selma White Citizens Council. Through the window, visitors can see the Edmund Pettus Bridge, where police once met voting rights protestors with tear gas and batons.

Ralph A...

Marie Foster
John Lewis
Fannie L. Hamer

...eese

Andrew Young
Bernard Lee
Worth Long

Fred Shuttlesworth
Margaret Moore
Ceola Miller

Cooper

P. H. Leland

ALEXANDER CITY
To symbolize Alabama's mineral wealth and manufacturing might, civic leaders sent a 56-foot colossus of the Roman god Vulcan to the 1904 St. Louis World's Fair. But after years atop a pedestal overlooking downtown Birmingham, the god of fire and iron needed a checkup. Here, ironworkers Mike Nolen and Randall Clayton load the giant's restored leg for shipment back to Birmingham.
Photo by Philip Barr, The Birmingham News

EUFAULA
Fendall Hall's original owner, New Yorker Edward Young, came to Eufaula in the 1850s to make his fortune. The 18-year-old entrepreneur opened a sawmill, built a toll bridge over the Chattahoochee, and used the profits to establish a cotton broker- age. "One way or another he got everyone's money," says Dawn Thomas, a seventh-genera- tion Young descendant and mansion site director.
Photo by Hal Yeager, The Birmingham News

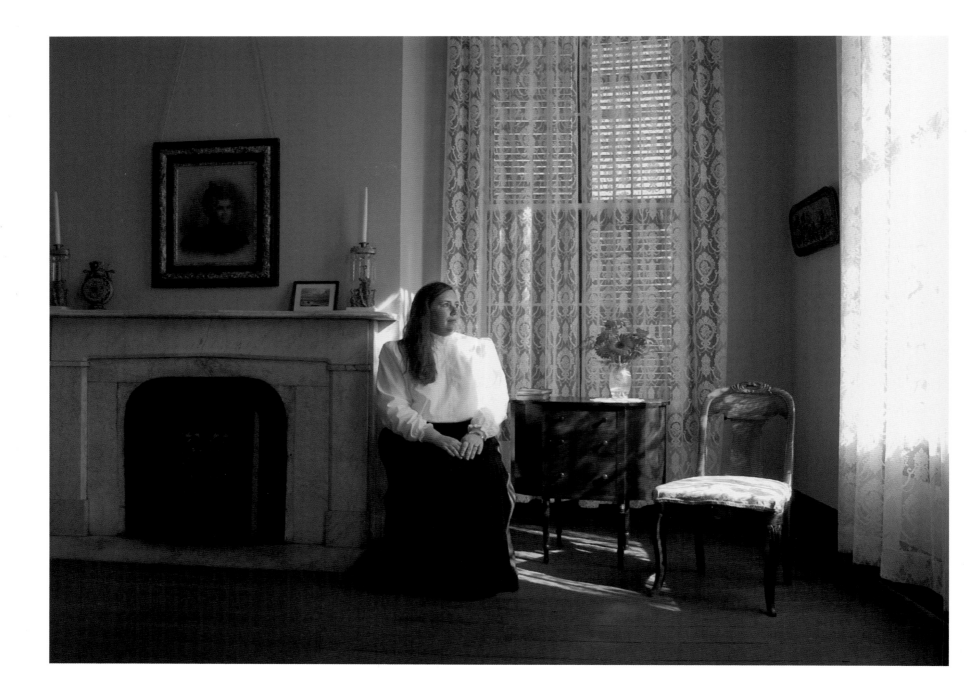

FLORENCE

At 79, Noble Liles, a retired elementary school custodian, enjoys his daily walk and meet-and-greet along the streets of Florence. The third of 18 children, he never married or had children of his own, but a large extended family appreciates his upbeat nature.

Photo by Steven T. King

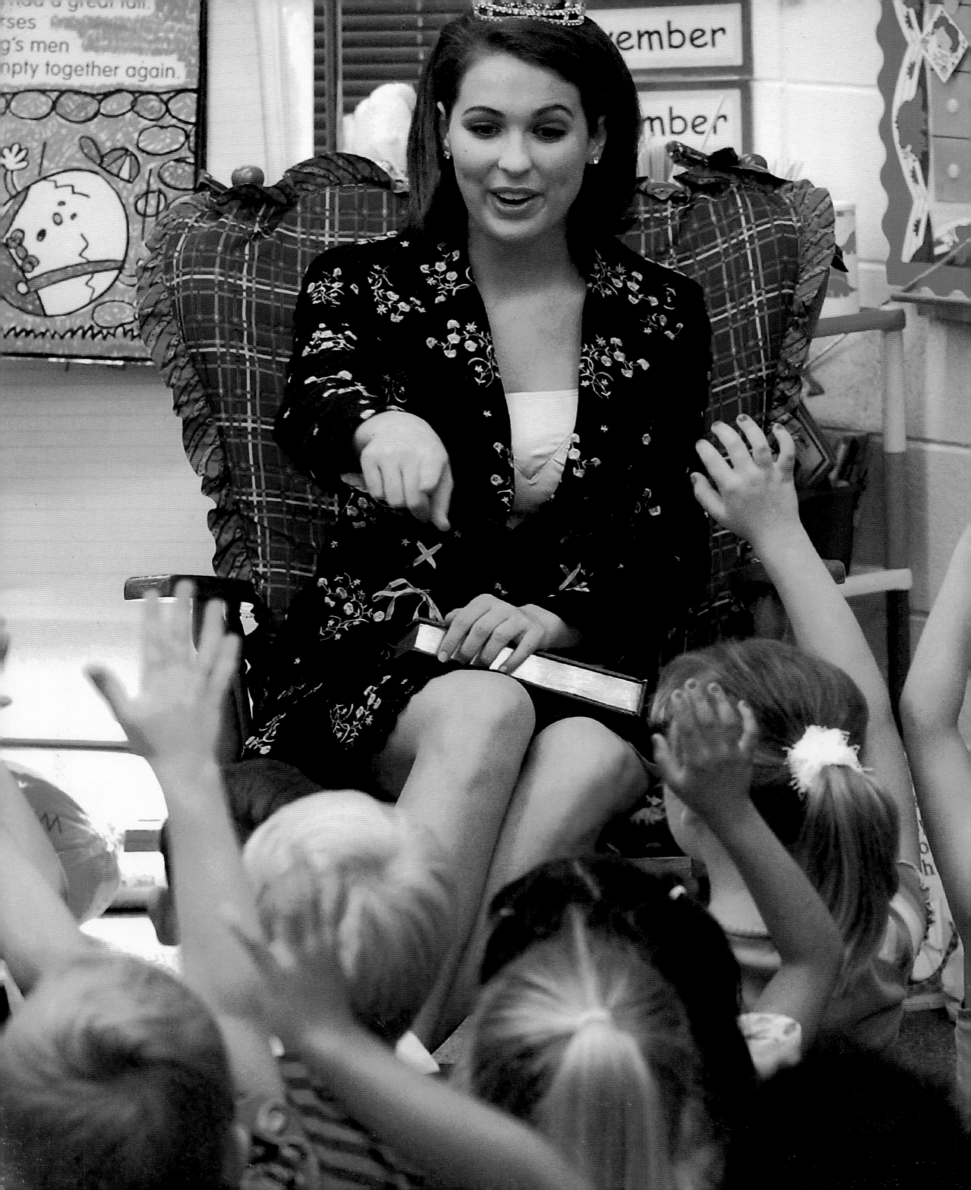

HOOVER

Proving that a crown works for day wear, Scarlotte Deupree reads to a kindergarten class at Inverness Elementary School. Deupree, Miss Alabama 2002, was the first runner-up in the Miss America pageant.

Photo by Charles Nesbitt, The Birmingham News

MONTGOMERY

"Hank left a big impact all over the world," says Beth Birtle, manager of the Hank Williams Museum. Nowhere is his impact more apparent than in Williams's home state, where two museums are dedicated to his career. Exactly 128 of his hits, including "Cold, Cold Heart" and "Lost Highway," adorn this wall in the downtown museum.

Photo by Hal Yeager, The Birmingham News

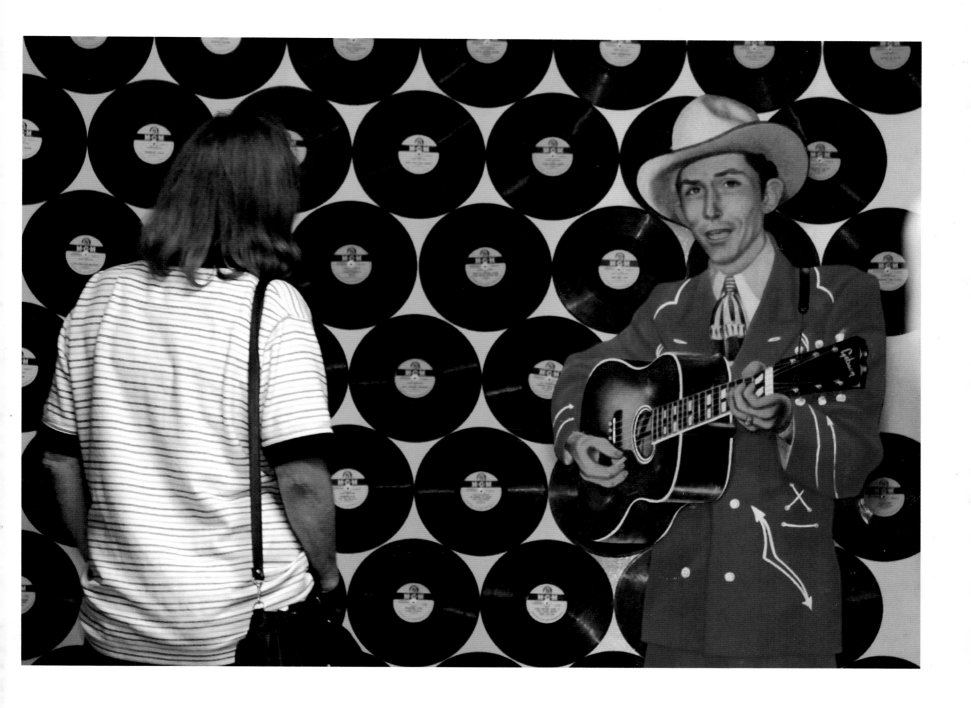

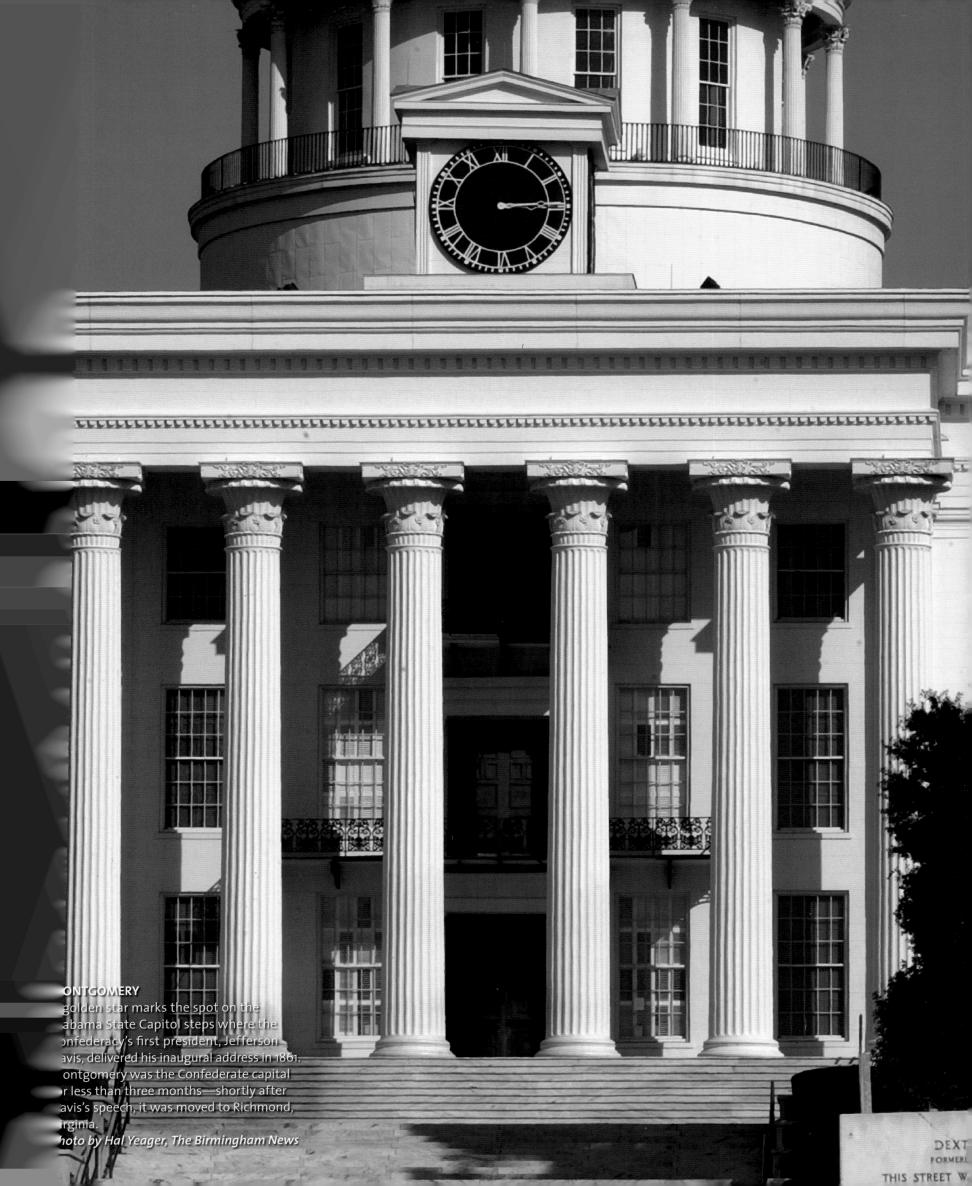

MONTGOMERY

A golden star marks the spot on the Alabama State Capitol steps where the Confederacy's first president, Jefferson Davis, delivered his inaugural address in 1861. Montgomery was the Confederate capital for less than three months—shortly after Davis's speech, it was moved to Richmond, Virginia.

Photo by Hal Yeager, The Birmingham News

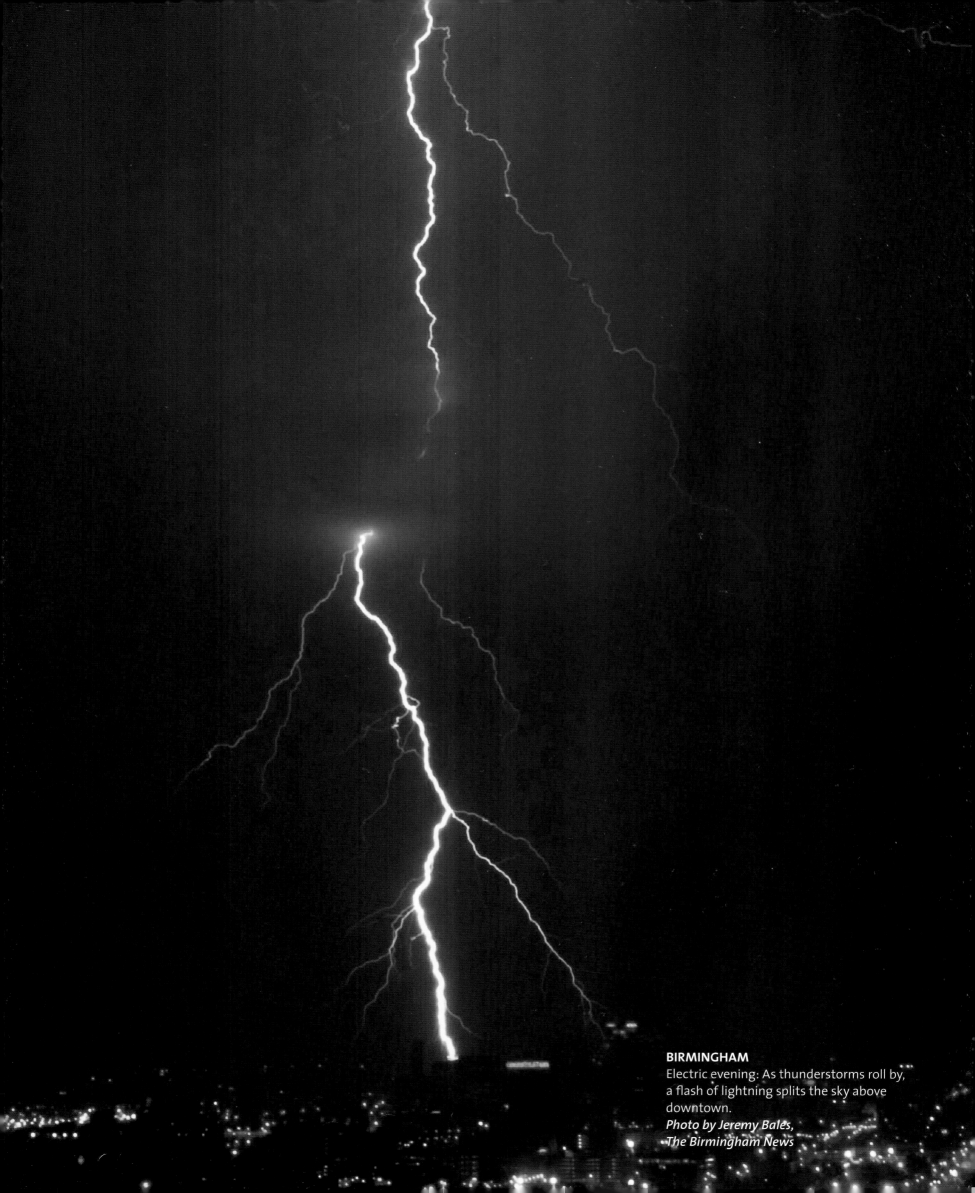

BIRMINGHAM
Electric evening: As thunderstorms roll by,
a flash of lightning splits the sky above
downtown.
Photo by Jeremy Bales,
The Birmingham News

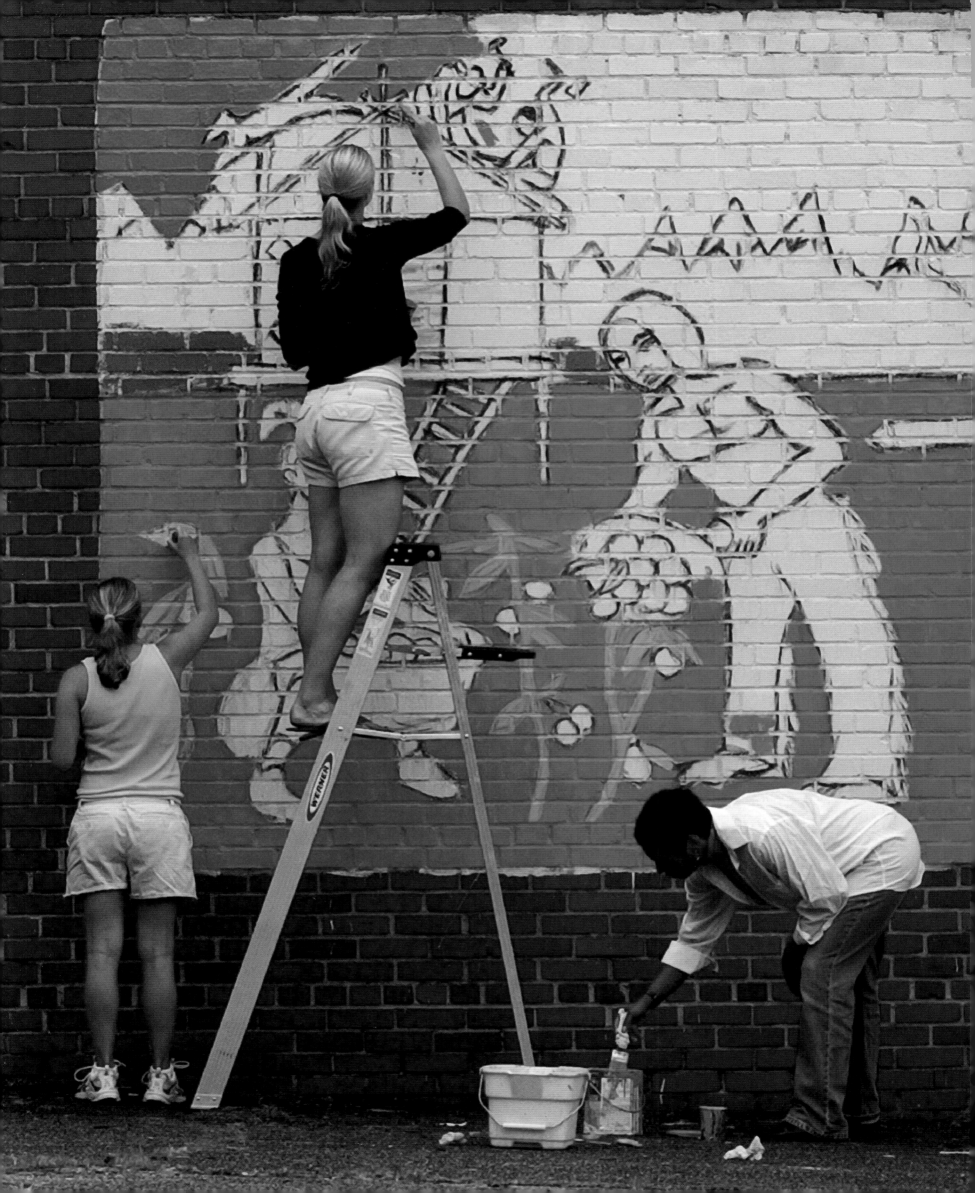

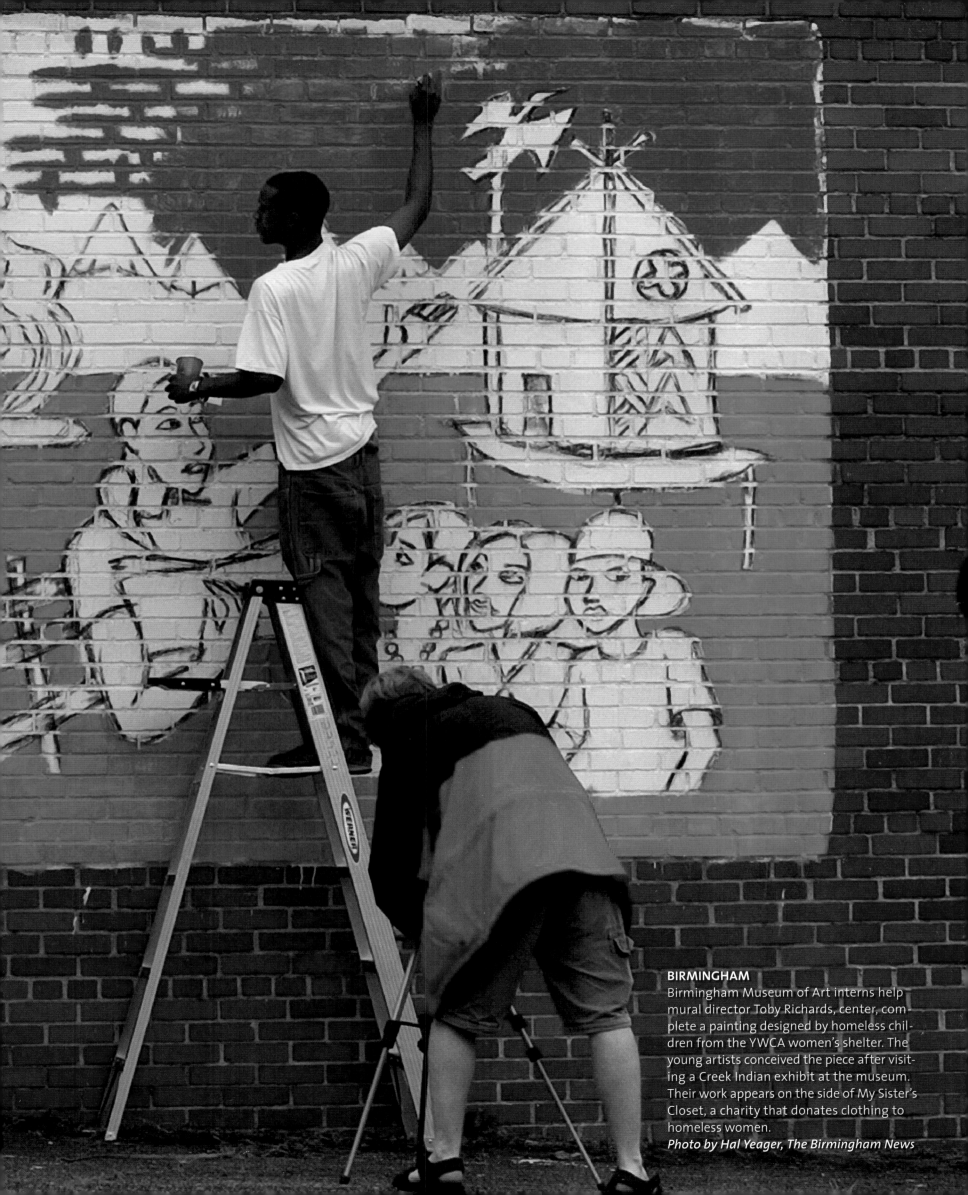

BIRMINGHAM

Birmingham Museum of Art interns help mural director Toby Richards, center, complete a painting designed by homeless children from the YWCA women's shelter. The young artists conceived the piece after visiting a Creek Indian exhibit at the museum. Their work appears on the side of My Sister's Closet, a charity that donates clothing to homeless women.

Photo by Hal Yeager, The Birmingham News

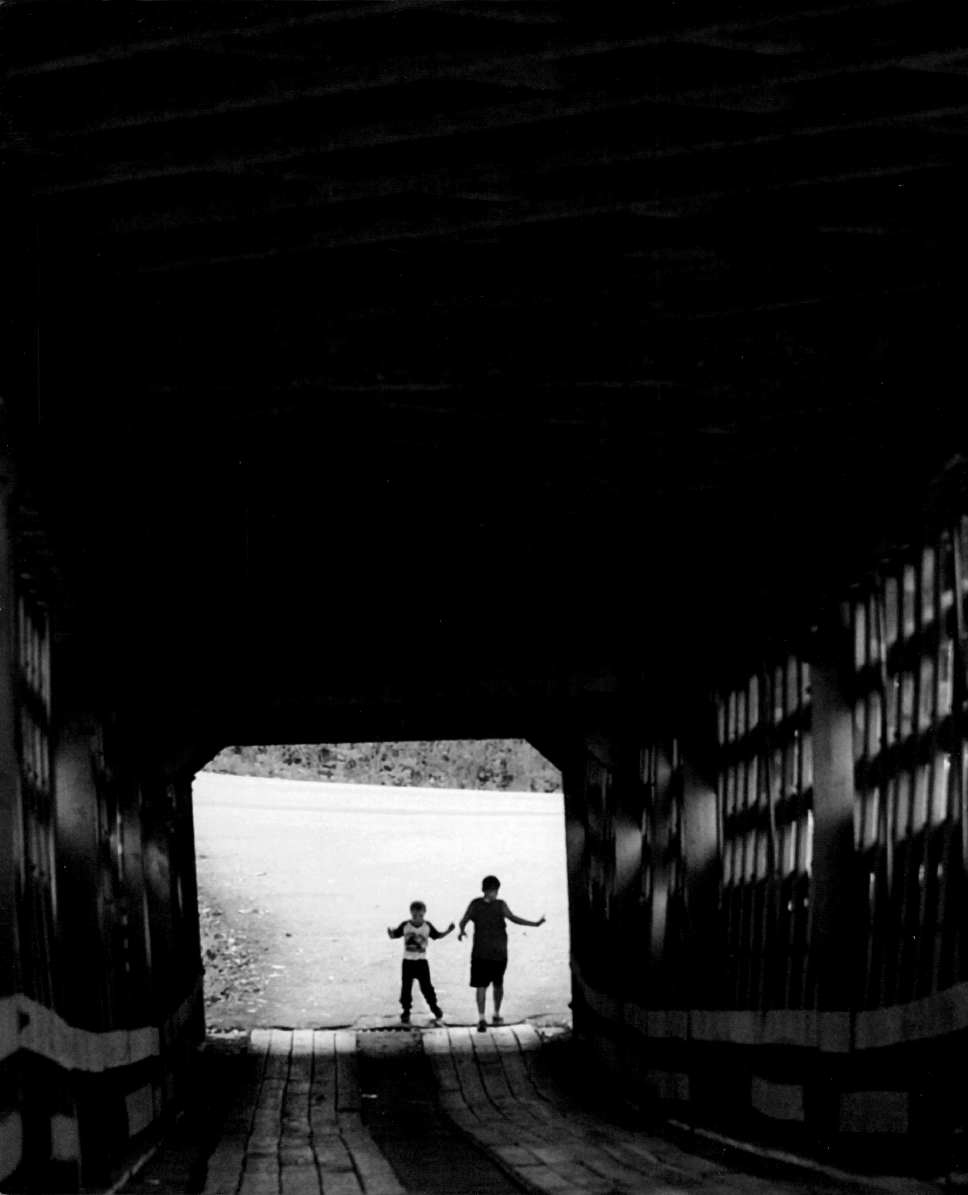

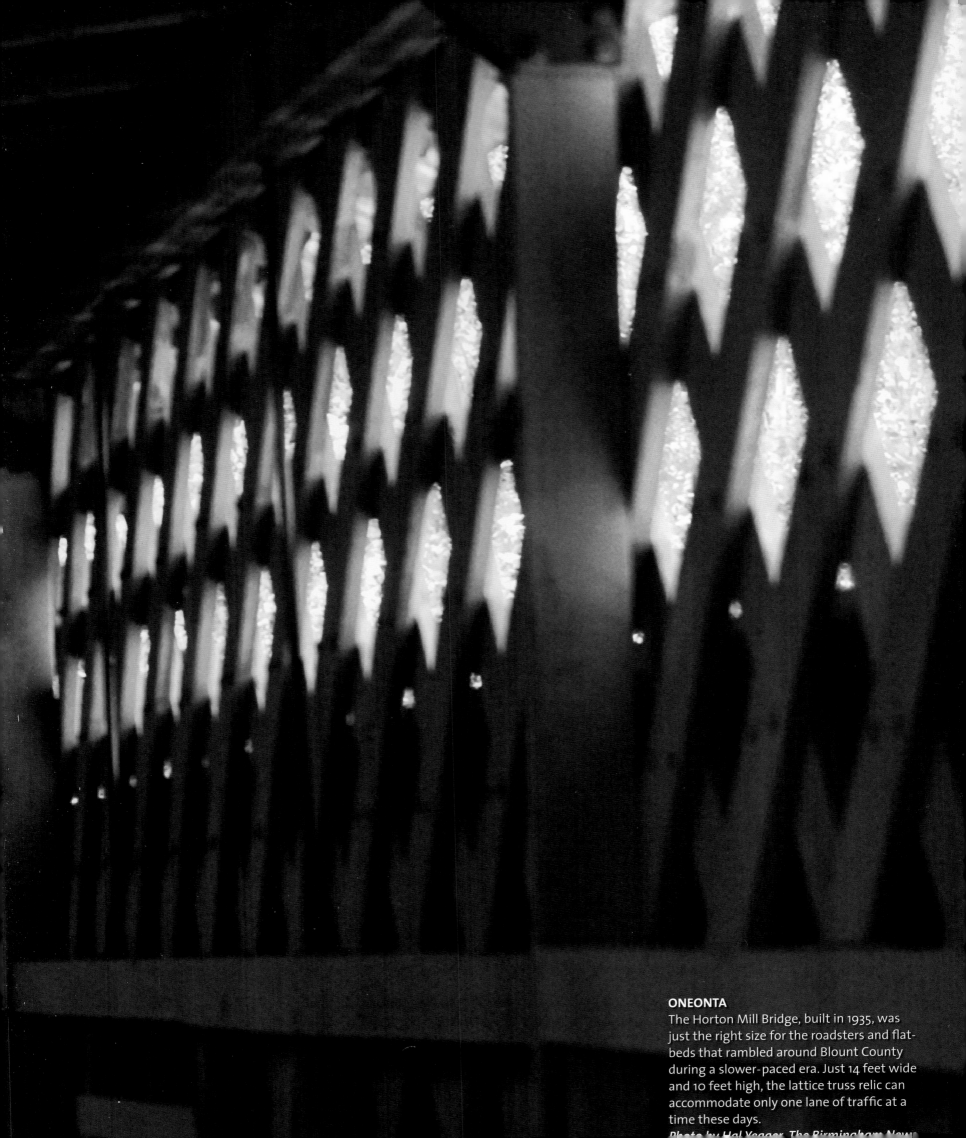

ONEONTA

The Horton Mill Bridge, built in 1935, was just the right size for the roadsters and flat-beds that rambled around Blount County during a slower-paced era. Just 14 feet wide and 10 feet high, the lattice truss relic can accommodate only one lane of traffic at a time these days.

How It Worked

The week of May 12-18, 2003, more than 25,000 professional and amateur photographers spread out across the nation to shoot over a million digital photographs with the goal of capturing the essence of daily life in America.

The professional photographers were equipped with Adobe Photoshop and Adobe Album software, Olympus C-5050 digital cameras, and Lexar Media's high-speed compact flash cards.

The 1,000 professional contract photographers plus another 5,000 stringers and students sent their images via FTP (file transfer protocol) directly to the *America 24/7* website. Meanwhile, thousands of amateur photographers uploaded their images to Snapfish's servers.

At *America 24/7*'s Mission Control headquarters, located at CNET in San Francisco, dozens of picture editors from the nation's most prestigious publications culled the images down to 25,000 of the very best, using Photo Mechanic by Camera Bits. These photos were transferred into Webware's ActiveMedia Digital Asset Management (DAM) system, which served as a central image library and enabled the designers to track, search, distribute, and reformat the images for the creation of the 51 books, foreign language editions, web and magazine syndication, posters, and exhibitions.

Once in the DAM, images were optimized (and in some cases resampled to increase image resolution) using Adobe Photoshop. Adobe InDesign and Adobe InCopy were used to design and produce the 51 books, which were edited and reviewed in multiple locations around the world in the form of Adobe Acrobat PDFs. Epson Stylus printers were used for photo proofing and to produce large-format images for exhibitions. The companies providing support for the *America 24/7* project offer many of the essential components for anyone building a digital darkroom. We encourage you to read more on the following pages about their respective roles in making *America 24/7* possible.

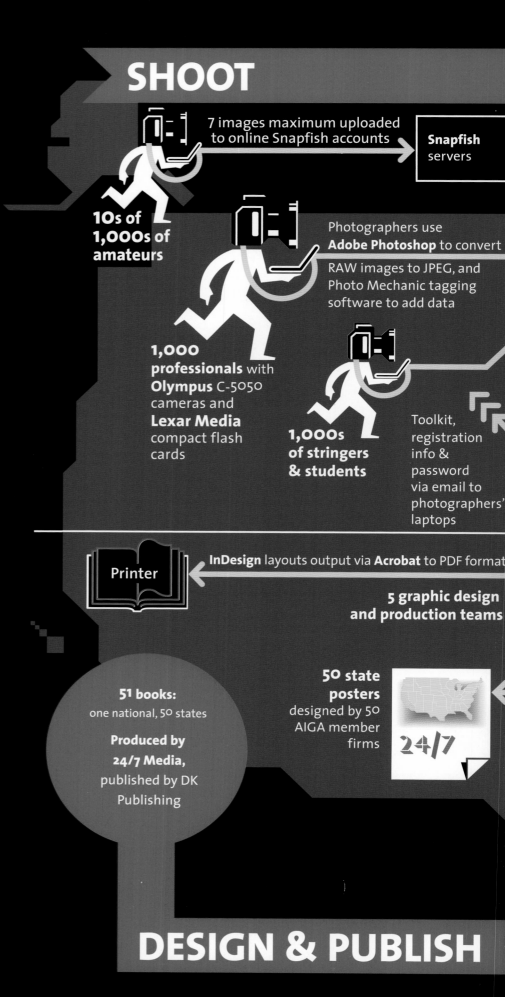

SHOOT

7 images maximum uploaded to online Snapfish accounts → **Snapfish** servers

10s of 1,000s of amateurs

Photographers use **Adobe Photoshop** to convert RAW images to JPEG, and Photo Mechanic tagging software to add data

1,000 professionals with **Olympus** C-5050 cameras and **Lexar Media** compact flash cards

1,000s of stringers & students

Toolkit, registration info & password via email to photographers' laptops

Printer ← **InDesign** layouts output via **Acrobat** to PDF format

5 graphic design and production teams

51 books: one national, 50 states

Produced by 24/7 Media, published by DK Publishing

50 state posters designed by 50 AIGA member firms

24/7

DESIGN & PUBLISH

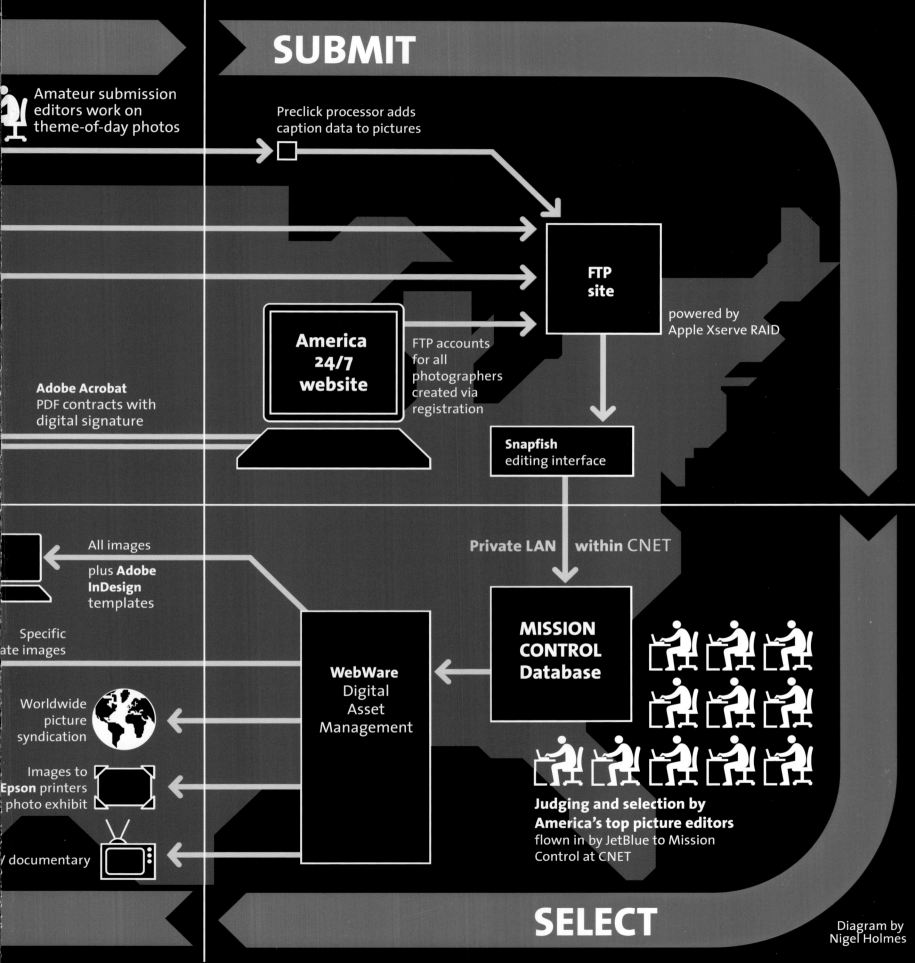

SUBMIT

Amateur submission editors work on theme-of-day photos

Preclick processor adds caption data to pictures

FTP site

powered by Apple Xserve RAID

Adobe Acrobat PDF contracts with digital signature

America 24/7 website

FTP accounts for all photographers created via registration

Snapfish editing interface

All images

plus **Adobe InDesign** templates

Private LAN **within** CNET

Specific ate images

WebWare Digital Asset Management

MISSION CONTROL Database

Worldwide picture syndication

Images to **Epson** printers photo exhibit

Judging and selection by America's top picture editors flown in by JetBlue to Mission Control at CNET

/ documentary

SELECT

Diagram by Nigel Holmes

About Our Sponsors

America 24/7 gave digital photographers of all levels the opportunity to share their visions of what it means to live in the United States. This project was made possible by a digital photography revolution that is dramatically changing and improving picture-taking for professionals and amateurs alike. And an Adobe product, Photoshop®, has been at the center of this sea change.

Adobe's products reflect our customers' passion for the creative process, be it the photographer, graphic designer, layout artist, or printer. Adobe is the Publishing and Imaging Software Partner for *America 24/7* and products such as Adobe InDesign®, Photoshop, Acrobat®, and Illustrator® were used to produce this stunning book in a matter of weeks. We hope that our software has helped do justice to the mythic images, contributed by well-known photographers and the inspired hobbyist.

Adobe is proud to be a lead sponsor of *America 24/7*, a project that celebrates the vibrancy of the American spirit: the same spirit that helped found Adobe and inspires our employees and customers to deliver the very best.

Bruce Chizen
President and CEO
Adobe Systems Incorporated

OLYMPUS

Olympus, a global technology leader in designing precision healthcare solutions and innovative consumer electronics, is proud to be the official digital camera sponsor of *America 24/7*. The opportunity to introduce Americans from coast to coast to the thrill, excitement, and possibility of digital photography makes the vision behind this book a perfect fit for Olympus, a leader in digital cameras since 1996.

For most people, the essence of digital photography is best grasped through firsthand experience with the technology, which is precisely what *America 24/7* is about. We understand that direct experience is the pathway to inspiration, and welcome opportunities like this sponsorship to bring the power of the digital experience into the lives of people everywhere. To Olympus, *America 24/7* offers a platform to help realize a core mission: to deliver and make accessible the power of the digital experience to millions of American photographers, amateurs, and professionals alike.

The 1,000 professional photographers contracted to shoot on the America 24/7 project were all equipped with Olympus C-5050 digital cameras. Like all Olympus products, the C-5050 is offered by a company well known for designing, manufacturing, and servicing products used by professionals to perform their work, every day. Olympus is a customer-centric company committed to working one-to-one with a diverse group of professionals. From biomedical researchers who use our clinical microscopes, to doctors who perform life-saving procedures with our endoscopes, to professional photographers who use cameras in their daily work, Olympus is a trusted brand.

The digital imaging technology involved with *America 24/7* has enabled the soul of America to be visually conveyed, not just by professional observers, but by the American public who participated in this project—the very people who collectively breath life into this country's existence each day.

We are proud to be enabling so many photographers to capture the pictures on these pages that tell the story of who we are as a nation. From sea to shining sea, digital imagery allows us to connect to one another in ways we never dreamed possible.

At Olympus, our ideas have proliferated as rapidly as technology has evolved. We have channeled these visions into breakthrough products and solutions to meet the demands of our changing world-products like microscopes, endoscopes, and digital voice recorders, supported by the highly regarded training, educational, and consulting services we offer our customers.

Today, 83 years after we introduced our first microscope, we remain as young, as curious, and as committed as ever.

LEXAR Media™

Lexar Media has grown from the digital photography revolution, which is why we are proud to have supplied the digital memory cards used in the America 24/7 project. Lexar Media's high-performance memory cards utilize our unique and patented controller coupled with high-speed flash memory from Samsung, the world's largest flash memory supplier. This powerful combination brings out the ultimate performance of any digital camera.

Photographers who demand the most from their equipment choose our products for their advanced features like write speeds up to 40X, Write Acceleration technology for enabled cameras, and Image Rescue, which recovers previously deleted or lost images. Leading camera manufacturers bundle Lexar Media digital memory cards with their cameras because they value its performance and reliability.

Lexar Media is at the forefront of digital photography as it transforms picture-taking worldwide, and we will continue to be a leader with new and innovative solutions for professionals and amateurs alike.

Snapfish, which developed the technology behind the *America 24/7* amateur photo event, is a leading online photo service, with more than 5 million members and 100 million photos posted online. Snapfish enables both film and digital camera owners to share, print, and store their most important photo memories, at prices that cannot be equaled. Digital camera users upload photos into a password-protected online album for free. Users can also order film-quality prints on professional photographic paper for as low as 25¢. Film camera users get a full set of prints, plus online sharing and storage, for just $2.99 per roll.

Founded in 1995, eBay created a powerful platform for the sale of goods and services by a passionate community of individuals and businesses. On any given day, there are millions of items across thousands of categories for sale on eBay. eBay enables trade on a local, national and international basis with customized sites in markets around the world.

Through an array of services, such as its payment solution provider PayPal, eBay is enabling global e-commerce for an ever-growing online community.

JetBlue Airways is proud to be *America 24/7's* preferred carrier, flying photographers, photo editors, and organizers across the United States.

Winner of Condé Nast Traveler's Readers' Choice Awards for Best Domestic Airline 2002, JetBlue provides friendly service and low fares for travelers in 22 cities in nine states across America.

On behalf of JetBlue's 5,000 crew members, we're excited to be involved in this remarkable project, and for the opportunity to serve American travelers each and every day, coast to coast, 24/7.

DIGITAL POND

Digital Pond has been a leading creator of large graphic displays for museums, corporations, trade shows, retail environments and fine art since 1992.

We were proud to bring together our creative, print and display capabilities to produce signage and displays for mission control, critical retouching for numerous key images for the book, and art galleries for the New York Public Library and Bryant Park.

The Pond's team and SplashPic® Online service enabled us to nimbly design, produce and install over 200 large graphic panels in two NYC locations within the truly "24/7" production schedule of less than ten days.

WebWare Corporation is pleased to be a major sponsor of the America 24/7 project. We take pride in being part of a groundbreaking adventure that is stretching the boundaries—and the imagination—in digital photography, digital asset management, publishing, news, and global events.

Our ActiveMedia Enterprise™ digital asset management software is the "nerve center" of *America 24/7*, the central repository for managing, sharing, and collaborating on the project's photographs. From photo editors and book publishers to 24/7's media relations and marketing personnel, ActiveMedia provides the application support that links all facets of the project team to the content worldwide.

WebWare helps Global 2000 firms securely manage, reuse, and distribute media assets locally or globally. Its suite of ActiveMedia software products provide powerful media services platforms for integrating rich media into content management systems marketing and communication portals; web publishing systems; and e-commerce portals.

Google's mission is to organize the world's information and make it universally accessible and useful.

With our focus on plucking just the right answer from an ocean of data, we were naturally drawn to the America 24/7 project. The book you hold is a compendium of images of American life distilled from thousands of photographs and infinite possibilities. Are you looking for emotion? Narrative? Shadows? Light? It's all here, thanks to a multitude of photographers and writers creating links between you, the reader, and a sea of wonderful stories. We celebrate the connections that constitute the human experience and are pleased to help engender them. And we're pleased to have been a small part of this project, which captures the results of that interaction so vividly, so dynamically, and so dramatically.

Special thanks to additional contributors: FileMaker, Apple, Camera Bits, LaCie, Now Software, Preclick, Outpost Digital, Xerox, Microsoft, WoodWing Software, net-linx Publishing Solutions, and Radical Media. The Savoy Hotel, San Francisco; The Pan Pacific, San Francisco; Four Seasons Hotel, San Francisco; and The Queen Anne Hotel. Photography editing facilities were generously hosted by CNET Networks, Inc.

Participating Photographers

Coordinator: Walt Stricklin, Director of Photography, *The Birmingham News*

Mark Almond, *The Birmingham News*
Jerry Ayres, *The Birmingham News*
Steve Barnette, *The Birmingham News*
Philip Barr, *The Birmingham News*
Jeremy Bales, *The Birmingham News*
Frank Couch, *The Birmingham News*
Austin Dare
Butch Dill, *The Birmingham News*
Donna Dougan
Bob Farley, *Birmingham Post-Herald*
Will Gamble
J. Mark Gooch
E. Vasha Hunt
Steven T. King
Jamie Martin
Michael Mercier, *The Huntsville Times*
Tamika Moore, *The Birmingham News*

Charles Nesbitt, *The Birmingham News*
Glenn Nettleton
David Owens
Richard Pearson
Christine Prichard
Kiichiro Sato
Mark Schlapbach
Eric Schwartz
Karim Shamsi-Basha, *Portico Magazine*
Dallas Smith
Joe Songer, *The Birmingham News*
Bill Starling, *Mobile Register*
Beverly Taylor, *The Birmingham News*
Gary Tramontina
Patrick Witty
Hal Yeager, *The Birmingham News*

The majority of images in this book were shot during the week of May 12–18, 2003, but, in the interest of full disclosure, we wish to inform you that we took some additional photographs during October 2003, and some of those images also appear herein.

Thumbnail Picture Credits

Credits for thumbnail photographs are listed by the page number and are in order from left to right.

19 Bernard Troncale, *The Birmingham News*
Hal Yeager, *The Birmingham News*
Hal Yeager, *The Birmingham News*
Hal Yeager, *The Birmingham News*
Hal Yeager, *The Birmingham News*
Hal Yeager, *The Birmingham News*
Hal Yeager, *The Birmingham News*

20 Bill Starling, *Mobile Register*
Steven T. King
Bill Starling, *Mobile Register*
Bill Starling, *Mobile Register*
Bill Starling, *Mobile Register*
Steven T. King
Bill Starling, *Mobile Register*

22 Michael Mercier, *The Huntsville Times*
Hal Yeager, *The Birmingham News*
Karim Shamsi-Basha, *Portico Magazine*
Emanuel Neiconi, Neiconi Photography
Michael Mercier, *The Huntsville Times*
J. Mark Gooch
Nan Butler

23 Steven T. King
Philip Barr, *The Birmingham News*
Tamika Moore, *The Birmingham News*
Patrick Witty
Tamika Moore, *The Birmingham News*
Bob Farley, *Birmingham Post-Herald*
Hal Yeager, *The Birmingham News*

26 Christine Prichard
Philip Barr, *The Birmingham News*
Karim Shamsi-Basha, *Portico Magazine*
Christine Prichard
Christine Prichard
Karim Shamsi-Basha, *Portico Magazine*
Christine Prichard

27 Christine Prichard
Bob Farley, *Birmingham Post-Herald*
Christine Prichard
Karim Shamsi-Basha, *Portico Magazine*
Bob Farley, *Birmingham Post-Herald*
Karim Shamsi-Basha, *Portico Magazine*
Bob Farley, *Birmingham Post-Herald*

30 Philip Barr, *The Birmingham News*
Joe Songer, *The Birmingham News*
Philip Barr, *The Birmingham News*
Philip Barr, *The Birmingham News*
Philip Barr, *The Birmingham News*
Philip Barr, *The Birmingham News*
Philip Barr, *The Birmingham News*

32 Hal Yeager, *The Birmingham News*
Tamika Moore, *The Birmingham News*
Beverly Taylor, *The Birmingham News*
Beverly Taylor, *The Birmingham News*
Jamie Martin
J. Mark Gooch
J. Mark Gooch

33 Steven T. King
Karim Shamsi-Basha, *Portico Magazine*
Michael Mercier, *The Huntsville Times*
Nan Butler
Tamika Moore, *The Birmingham News*
Michael Mercier, *The Huntsville Times*
J. Mark Gooch

44 E. Vasha Hunt
Hal Yeager, *The Birmingham News*
E. Vasha Hunt
E. Vasha Hunt
E. Vasha Hunt
E. Vasha Hunt
E. Vasha Hunt

45 E. Vasha Hunt
E. Vasha Hunt
Hal Yeager, *The Birmingham News*
E. Vasha Hunt
Geremea Fioravanti
E. Vasha Hunt
E. Vasha Hunt

46 J. Mark Gooch
Michael Mercier, *The Huntsville Times*
Bill Starling, *Mobile Register*
J. Mark Gooch
Richard Pearson
Bill Starling, *Mobile Register*
Richard Pearson

47 Michael Mercier, *The Huntsville Times*
Richard Pearson
Bill Starling, *Mobile Register*
Michael Mercier, *The Huntsville Times*
Hal Yeager, *The Birmingham News*
Bill Starling, *Mobile Register*
Michael Mercier, *The Huntsville Times*

50 Gary Tramontina
Michael Mercier, *The Huntsville Times*
Gary Tramontina
Gary Tramontina
Michael Mercier, *The Huntsville Times*
Gary Tramontina
Michael Mercier, *The Huntsville Times*

51 Gary Tramontina
Gary Tramontina
Michael Mercier, *The Huntsville Times*
Gary Tramontina
Gary Tramontina
Michael Mercier, *The Huntsville Times*
Gary Tramontina

52 Charles Nesbitt, *The Birmingham News*
Philip Barr, *The Birmingham News*
Jamie Martin
Philip Barr, *The Birmingham News*
Jamie Martin
Philip Barr, *The Birmingham News*
Michael Mercier, *The Huntsville Times*

53 Jamie Martin
Jamie Martin
Nan Butler
Jamie Martin
Hal Yeager, *The Birmingham News*
Hal Yeager, *The Birmingham News*
Hal Yeager, *The Birmingham News*

56 Gary Tramontina
Joe Songer, *The Birmingham News*
Gary Tramontina
Joe Songer, *The Birmingham News*
Gary Tramontina
J. Mark Gooch
Gary Tramontina

57 Frank Couch, *The Birmingham News*
Joe Songer, *The Birmingham News*
Joe Songer, *The Birmingham News*
Joe Songer, *The Birmingham News*
Joe Songer, *The Birmingham News*
Joe Songer, *The Birmingham News*
Joe Songer, *The Birmingham News*

58 E. Vasha Hunt
Steve Barnette, *The Birmingham News*
Jerry Ayres, *The Birmingham News*
Hal Yeager, *The Birmingham News*
Hal Yeager, *The Birmingham News*
Hal Yeager, *The Birmingham News*
E. Vasha Hunt

59 Hal Yeager, *The Birmingham News*
Karim Shamsi-Basha, *Portico Magazine*
Philip Barr, *The Birmingham News*
E. Vasha Hunt
Hal Yeager, *The Birmingham News*
Philip Barr, *The Birmingham News*
Philip Barr, *The Birmingham News*

60 Tamika Moore, *The Birmingham News*
Tamika Moore, *The Birmingham News*
Karim Shamsi-Basha, *Portico Magazine*
Emanuel Neiconi, Neiconi Photography
Karim Shamsi-Basha, *Portico Magazine*
Frank Couch, *The Birmingham News*
Karim Shamsi-Basha, *Portico Magazine*

61 Emanuel Neiconi, Neiconi Photography
Steve Barnette, *The Birmingham News*
Karim Shamsi-Basha, *Portico Magazine*
Karim Shamsi-Basha, *Portico Magazine*
Karim Shamsi-Basha, *Portico Magazine*
Karim Shamsi-Basha, *Portico Magazine*
Karim Shamsi-Basha, *Portico Magazine*

64 Joe Songer, *The Birmingham News*
Charles Nesbitt, *The Birmingham News*
Bernard Troncale, *The Birmingham News*
Charles Nesbitt, *The Birmingham News*
Hal Yeager, *The Birmingham News*
J. Mark Gooch
Hal Yeager, *The Birmingham News*

65 Hal Yeager, *The Birmingham News*
J. Mark Gooch
Gary Tramontina
Gary Tramontina
Steve Barnette, *The Birmingham News*
Jeremy Bales, *The Birmingham News*
J. Mark Gooch

66 Nan Butler
Frank Couch, *The Birmingham News*
Frank Couch, *The Birmingham News*
Beverly Taylor, *The Birmingham News*
Frank Couch, *The Birmingham News*
Nan Butler
Bernard Troncale, *The Birmingham News*

67 Tamika Moore, *The Birmingham News*
Nan Butler
Tamika Moore, *The Birmingham News*
Philip Barr, *The Birmingham News*
J. Mark Gooch
Steven T. King
Steven T. King

72 Joe Songer, *The Birmingham News*
Mark Almond, *The Birmingham News*
Philip Barr, *The Birmingham News*
Philip Barr, *The Birmingham News*
Mark Almond, *The Birmingham News*
Hal Yeager, *The Birmingham News*
Joe Songer, *The Birmingham News*

74 Charles Nesbitt, *The Birmingham News*
Charles Nesbitt, *The Birmingham News*
Mark Almond, *The Birmingham News*
Frank Couch, *The Birmingham News*
Christine Prichard
Stephanie Bullock
Joe Songer, *The Birmingham News*

75 Stephanie Bullock
Jamie Martin
Christine Prichard
Jamie Martin
Steve Barnette, *The Birmingham News*
Jeremy Bales, *The Birmingham News*
Philip Barr, *The Birmingham News*

81 Nan Butler
Joe Songer, *The Birmingham News*
Mark Almond, *The Birmingham News*
Tamika Moore, *The Birmingham News*
Joe Songer, *The Birmingham News*
Joe Songer, *The Birmingham News*
Christine Prichard

82 Philip Barr, *The Birmingham News*
Butch Dill, *The Birmingham News*
Charles Nesbitt, *The Birmingham News*
E. Vasha Hunt
Beverly Taylor, *The Birmingham News*
E. Vasha Hunt
Butch Dill, *The Birmingham News*

83 E. Vasha Hunt
Bob Farley, *Birmingham Post-Herald*
E. Vasha Hunt
Philip Barr, *The Birmingham News*
Bob Farley, *Birmingham Post-Herald*
Hal Yeager, *The Birmingham News*
Tamika Moore, *The Birmingham News*

86 Joe Songer, *The Birmingham News*
Joe Songer, *The Birmingham News*
Joe Songer, *The Birmingham News*
Joe Songer, *The Birmingham News*
Joe Songer, *The Birmingham News*
Joe Songer, *The Birmingham News*
Joe Songer, *The Birmingham News*

87 Joe Songer, *The Birmingham News*
Joe Songer, *The Birmingham News*
Mark Almond, *The Birmingham News*
Joe Songer, *The Birmingham News*
Joe Songer, *The Birmingham News*
Joe Songer, *The Birmingham News*
Joe Songer, *The Birmingham News*

88 Philip Barr, *The Birmingham News*
Frank Couch, *The Birmingham News*
Butch Dill, *The Birmingham News*
Steven T. King
Mark Almond, *The Birmingham News*
Karim Shamsi-Basha, *Portico Magazine*
Alan Mothner, www.alanmothner.com

94 Butch Dill, *The Birmingham News*
Charles Nesbitt, *The Birmingham News*
Hal Yeager, *The Birmingham News*
Charles Nesbitt, *The Birmingham News*
Joe Songer, *The Birmingham News*
Hal Yeager, *The Birmingham News*
Douglas Smoot

95 Emanuel Neiconi, Neiconi Photography
Joe Songer, *The Birmingham News*
Nan Butler
Nan Butler
Tamika Moore, *The Birmingham News*
Mark Almond, *The Birmingham News*
Nan Butler

100 Kiichiro Sato
Beverly Taylor, *The Birmingham News*
Kiichiro Sato
Hal Yeager, *The Birmingham News*
Kiichiro Sato
Hal Yeager, *The Birmingham News*
Kiichiro Sato

101 Gary Tramontina
Kiichiro Sato
Bernard Troncale, *The Birmingham News*
Kiichiro Sato
Hal Yeager, *The Birmingham News*
Kiichiro Sato
Gary Tramontina

106 Christine Prichard
Christine Prichard
Philip Barr, *The Birmingham News*
Philip Barr, *The Birmingham News*
Geremea Fioravanti
Christine Prichard
Christine Prichard

107 Philip Barr, *The Birmingham News*
Christine Prichard
Philip Barr, *The Birmingham News*
Philip Barr, *The Birmingham News*
Christine Prichard
Christine Prichard
Geremea Fioravanti

110 Michael Mercier, *The Huntsville Times*
Bob Farley, *Birmingham Post-Herald*
Michael Mercier, *The Huntsville Times*
Bob Farley, *Birmingham Post-Herald*
Nan Butler
J. Mark Gooch
Bob Farley, *Birmingham Post-Herald*

111 Bob Farley, *Birmingham Post-Herald*
Bob Farley, *Birmingham Post-Herald*
Joe Songer, *The Birmingham News*
J. Mark Gooch
Steven T. King
Bob Farley, *Birmingham Post-Herald*
Bob Farley, *Birmingham Post-Herald*

114 Hal Yeager, *The Birmingham News*
Hal Yeager, *The Birmingham News*
Philip Barr, *The Birmingham News*
Emanuel Neiconi, Neiconi Photography
Hal Yeager, *The Birmingham News*
Stephanie Bullock
Emanuel Neiconi, Neiconi Photography

115 Emanuel Neiconi, Neiconi Photography
Stephanie Bullock
Hal Yeager, *The Birmingham News*
Philip Barr, *The Birmingham News*
Michael Mercier, *The Huntsville Times*
Emanuel Neiconi, Neiconi Photography
Nan Butler

120 Christine Prichard
Christine Prichard
Christine Prichard
Christine Prichard
Christine Prichard
Christine Prichard
Christine Prichard

121 Christine Prichard
Christine Prichard
Christine Prichard
Christine Prichard
Christine Prichard
Christine Prichard
Christine Prichard

124 Charles Nesbitt, *The Birmingham News*
Hal Yeager, *The Birmingham News*
Hal Yeager, *The Birmingham News*
Hal Yeager, *The Birmingham News*
Hal Yeager, *The Birmingham News*
Hal Yeager, *The Birmingham News*
Bob Farley, *Birmingham Post-Herald*

128 Charles Nesbitt, *The Birmingham News*
Emanuel Neiconi, Neiconi Photography
Hal Yeager, *The Birmingham News*
Emanuel Neiconi, Neiconi Photography
Hal Yeager, *The Birmingham News*
J. Mark Gooch
Hal Yeager, *The Birmingham News*

129 Karim Shamsi-Basha, *Portico Magazine*
Michael Mercier, *The Huntsville Times*
Karim Shamsi-Basha, *Portico Magazine*
Emanuel Neiconi, Neiconi Photography
Steven T. King
Geremea Fioravanti
Steven T. King

131 Patrick Witty
Charles Nesbitt, *The Birmingham News*
J. Mark Gooch
Gary Tramontina
Hal Yeager, *The Birmingham News*
Hal Yeager, *The Birmingham News*
Karim Shamsi-Basha, *Portico Magazine*

Staff

The *America 24/7* series was imagined years ago by our friend Oscar Dystel, a publishing legend whose vision and enthusiasm have been a source of great inspiration.

We also wish to express our gratitude to our truly visionary publisher, DK.

Rick Smolan, Project Director
David Elliot Cohen, Project Director

Administrative
Katya Able, Operations Director
Gina Privitere, Communications Director
Chuck Gathard, Technology Director
Kim Shannon, Photographer Relations Director
Erin O'Connor, Photographer Relations Intern
Leslie Hunter, Partnership Director
Annie Polk, Publicity Manager
John McAlester, Website Manager
Alex Notides, Office Manager
C. Thomas Hardin, State Photography Coordinator

Design
Brad Zucroff, Creative Director
Karen Mullarkey, Photography Director
Judy Zimola, Production Manager
David Simoni, Production Designer
Mary Dias, Production Designer
Heidi Madison, Associate Picture Editor
Don McCartney, Production Designer
Diane Dempsey Murray, Production Designer
Jan Rogers, Associate Picture Editor
Bill Shore, Production Designer and Image Artist
Larry Nighswander, Senior Picture Editor
Bill Marr, Sarah Leen, Senior Picture Editors
Peter Truskier, Workflow Consultant
Jim Birkenseer, Workflow Consultant

Editorial
Maggie Canon, Managing Editor
Curt Sanburn, Senior Editor
Teresa L. Trego, Production Editor
Lea Aschkenas, Writer
Olivia Boler, Writer
Korey Capozza, Writer
Beverly Hanly, Writer
Bridgett Novak, Writer
Alison Owings, Writer
Fred Raker, Writer
Joe Wolff, Writer
Elise O'Keefe, Copy Chief
Will Hector, Copy Editor
Daisy Hernández, Copy Editor
Jennifer Wolfe, Copy Editor

Infographic Design
Nigel Holmes

Literary Agent
Carol Mann, The Carol Mann Agency

Legal Counsel
Barry Reder, Coblentz, Patch, Duffy & Bass, LLP
Phil Feldman, Coblentz, Patch, Duffy & Bass, LLP
Gabe Perle, Ohlandt, Greeley, Ruggiero & Perle, LLP
Jon Hart, Dow, Lohnes & Albertson, PLLC
Mike Hays, Dow, Lohnes & Albertson, PLLC
Stephen Pollen, Warshaw Burstein, Cohen, Schlesinger & Kuh, LLP
Rick Pappas

Accounting and Finance
Rita Dulebohn, Accountant
Robert Powers, Calegari, Morris & Co. Accountants
Eugene Blumberg, Blumberg & Associates
Arthur Langhaus, KLS Professional Advisors Group, Inc.

Picture Editors
J. David Ake, Associated Press
Caren Alpert, formerly *Health* magazine
Simon Barnett, *Newsweek*
Caroline Couig, *San Jose Mercury News*
Mike Davis, formerly *National Geographic*
Michel duCille, *Washington Post*
Deborah Dragon, *Rolling Stone*
Victor Fisher, formerly Associated Press
Frank Folwell, *USA Today*
MaryAnne Golon, *Time*
Liz Grady, formerly *National Geographic*
Randall Greenwell, *San Francisco Chronicle*
C. Thomas Hardin, formerly *Louisville Courier-Journal*
Kathleen Hennessy, *San Francisco Chronicle*
Scot Jahn, *U.S. News & World Report*
Steve Jessmore, *Flint Journal*
John Kaplan, University of Florida
Kim Komenich, *San Francisco Chronicle*
Eliane Laffont, *Hachette Filipacchi Media*
Jean-Pierre Laffont, *Hachette Filipacchi Media*
Andrew Locke, MSNBC
Jose Lopez, *The New York Times*
Maria Mann, formerly AFP
Bill Marr, formerly *National Geographic*
Michele McNally, *Fortune*
James Merithew, *San Francisco Chronicle*
Eric Meskauskas, *New York Daily News*
Maddy Miller, *People* magazine
Michelle Molloy, *Newsweek*
Dolores Morrison, *New York Daily News*
Karen Mullarkey, formerly *Newsweek, Rolling Stone, Sports Illustrated*
Larry Nighswander, Ohio University School of Visual Communication
Jim Preston, *Baltimore Sun*
Sarah Rozen, formerly *Entertainment Weekly*
Mike Smith, *The New York Times*
Neal Ulevich, formerly Associated Press

Website and Digital Systems
Jeff Burchell, Applications Engineer

Television Documentary
Sandy Smolan, Producer/Director
Rick King, Producer/Director
Bill Medsker, Producer

Video News Release
Mike Cerre, Producer/Director

Digital Pond
Peter Hogg
Kris Knight
Roger Graham
Philip Bond
Frank De Pace
Lisa Li

Senior Advisors
Jennifer Erwitt, Strategic Advisor
Tom Walker, Creative Advisor
Megan Smith, Technology Advisor
Jon Kamen, Media and Partnership Advisor
Mark Greenberg, Partnership Advisor
Patti Richards, Publicity Advisor
Cotton Coulson, Mission Control Advisor

Executive Advisors
Sonia Land
George Craig
Carole Bidnick

Advisors
Chris Anderson
Samir Arora
Russell Brown
Craig Cline
Gayle Cline
Harlan Felt
George Fisher
Phillip Moffitt
Clement Mok
Laureen Seeger
Richard Saul Wurman

DK Publishing
Bill Barry
Joanna Bull
Therese Burke
Sarah Coltman
Christopher Davis
Todd Fries
Dick Heffernan
Jay Henry
Stuart Jackman
Stephanie Jackson
Chuck Lang
Sharon Lucas
Cathy Melnicki
Nicola Munro
Eunice Paterson
Andrew Welham

Colourscan
Jimmy Tsao
Eddie Chia
Richard Law
Josephine Yam
Paul Koh
Chee Cheng Yeong
Dan Kang

Chief Morale Officer
Goose, the dog

ALABAMA24/7

ALASKA24/7

ARIZONA24/7

ARKANSAS24/7

CALIFORNIA24/7

HAWAII24/7

IDAHO24/7

ILLINOIS24/7

INDIANA24/7

IOWA24/7

MASSACHUSETTS24/7

MICHIGAN24/7

MINNESOTA24/7

MISSISSIPPI24/7

MISSOURI24/7

NEW MEXICO24/7

NEW YORK24/7

NORTH CAROLINA24/7

NORTH DAKOTA24/7

OHIO24/7

SOUTH DAKOTA24/7

TENNESSEE24/7

TEXAS24/7

UTAH24/7

VERMONT24/7